# The
# SPORTING
# HORSE

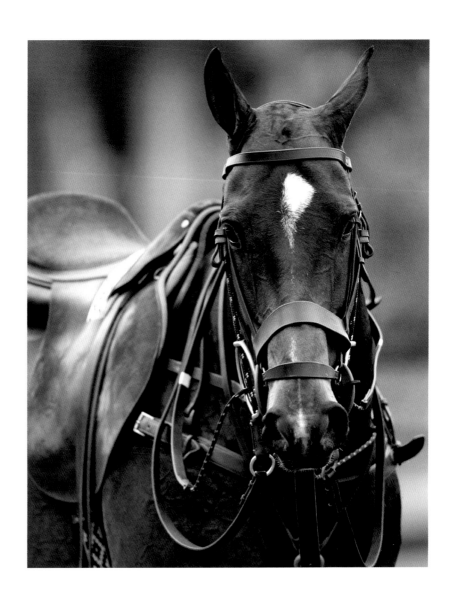

Nicola Jane Swinney is a former newspaper journalist who was hunting editor and later chief subeditor for the 'equestrian bible' Horse & Hound. She is the author of more than twelve books, most of them about horses. She is married and lives in southeast London.

Bob Langrish MBE is one of the world's leading equestrian photographers. After forty-six years of specialization in this field, he has built a library of more than 750,000 pictures. Bob works for top equestrian magazines in some twenty countries around the world and has provided illustrations for more than 150 books.

Brimming with creative inspiration, how-to projects and useful information to enrich your everyday life, Quarto Knows is a favourite destination for those pursuing their interests and passions. Visit our site and dig deeper with our books into your area of interest: Quarto Creates, Quarto Cooks, Quarto Homes, Quarto Lives, Quarto Drives, Quarto Explores, Quarto Gifts, or Quarto Kids.

First published in 2018 by White Lion Publishing
an imprint of The Quarto Group
The Old Brewery, 6 Blundell Street
London N7 9BH
United Kingdom

www.QuartoKnows.com

Text by Nicola Jane Swinney
Edited by Philip de Ste. Croix
Designed by Sue Pressley and Paul Turner, Stonecastle Graphics Ltd

ISBN  978 1 78131 783 9
Ebook ISBN  978 1 78131 854 6

10 9 8 7 6 5 4 3 2 1
2022 2021 2020 2019 2018

Printed in China

# The
# SPORTING
# HORSE

## IN PURSUIT OF EQUINE EXCELLENCE

Nicola Jane Swinney
and Bob Langrish, MBE

Foreword by Jane Holderness-Roddam, CBE, LVO

WHITE
LION
PUBLISHING

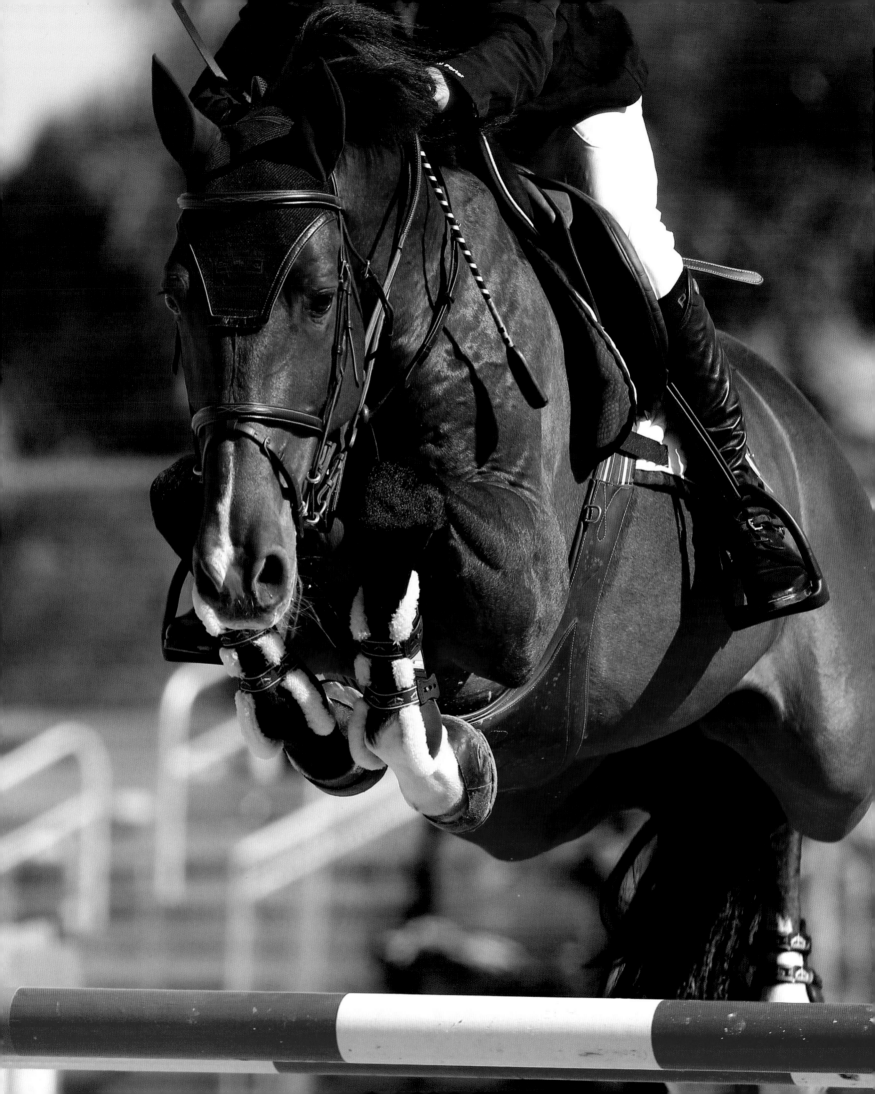

# CONTENTS

# FOREWORD

Having been lucky enough to have won two of the world's most prestigious three-day events, at Badminton and Burghley, and represented Great Britain as the first woman to ride at an Olympic three-day event, winning team gold in Mexico in 1968, I feel privileged to be asked to write this foreword.

The horses and their riders provide so much entertainment within the different sports shown, and the care and attention that goes into their breeding, training and welfare is obvious. This latter aspect is so vital, as not all animals are so lucky. I am proud to have been a Trustee of two worldwide animal charities – World Horse Welfare and The Brooke – who work tirelessly to improve the lot of those horses who do not get looked after, trained or cared for like those depicted in the following pages.

Any form of equestrian sport is a team event – from the breeders to the trainers, grooms to veterinary staff. And at the heart of it all is the partnership of rider and horse. When you are galloping at breakneck speeds, jumping ditches or fences, or amidst the rough-and-tumble of the polo field, you need to be completely attuned to your horse, and they to you. In the most successful partnerships – as I have been privileged enough to experience first-hand – horse and jockey ride as one. They train together, strive together and triumph together.

This is the story that veteran journalist Nicola Jane Swinney tells in *The Sporting Horse*. Spanning a formidable range of equestrian disciplines, she reveals how the horses' natural sporting ability has been refined and perfected through a combination of breeding, training and the building of partnerships.

We are all familiar with the magisterial beauty of the horse, but nowhere is that more evident than in the sporting arena. No other animal can claim to dance with such delicacy, run with such easeful grace, or soar over such heights – all with the weight of a rider on their back! This incredible strength and stamina is captured beautifully by Bob Langrish's evocative photography. Bob has travelled extensively for over forty years, which has resulted in one of the most stunning equestrian archives in the world, capturing everything from the glamour of snow polo in St Moritz, to the gruelling heat of endurance events across the Middle East's desert plains.

Bob has forged incredible relationships with his subjects – rider and horse alike – and you can see these shining through the images. What is captured

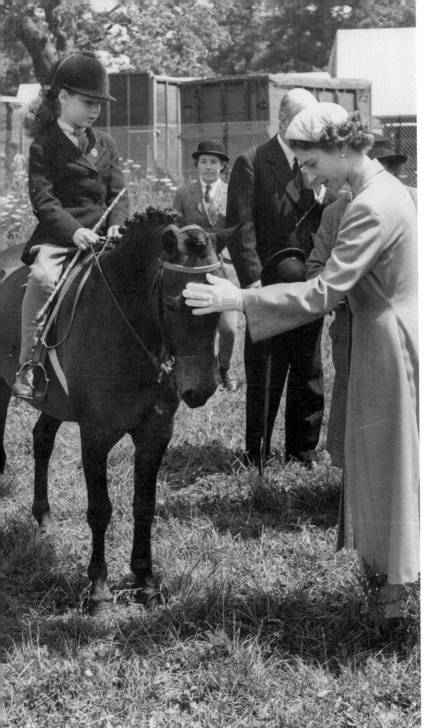

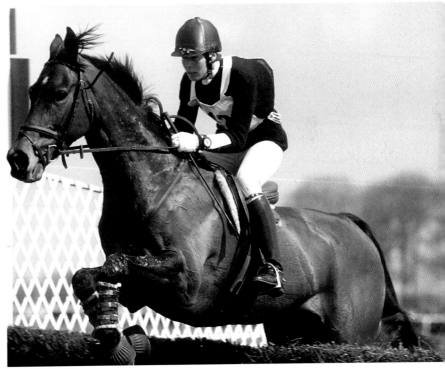

**ABOVE** Jane Holderness-Roddam has enjoyed an exemplary career during which she has met Queen Elizabeth II on a number of occasions (*left*) and competed as part of Britain's three-day event team (*top right*). Her equine partners have included Gelert of Wales; the pair are seen here expertly tackling one of the fences at Badminton in 1986 (*bottom right*).

in this collection, is not just the sporting ability of the horse, but also the spirit of these amazing animals: that indomitable will to please and achieve for their rider; the considered concentration on their faces, ears pricked back for aids in the dressage ring; the sheer determination striding out in the final stretches of a racecourse.

My own career has been built upon the synergy between myself and my talented equine partners, and this collection is a beautiful testimony to that relationship. The horse is our stalwart companion, our most loyal friend, our devoted colleague. Nicola and Bob have brought that touchingly to life here, so we can all celebrate this most enduring of relationships.

Jane Holderness-Roddam, CBE, LVO, British Olympic event rider

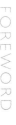

7

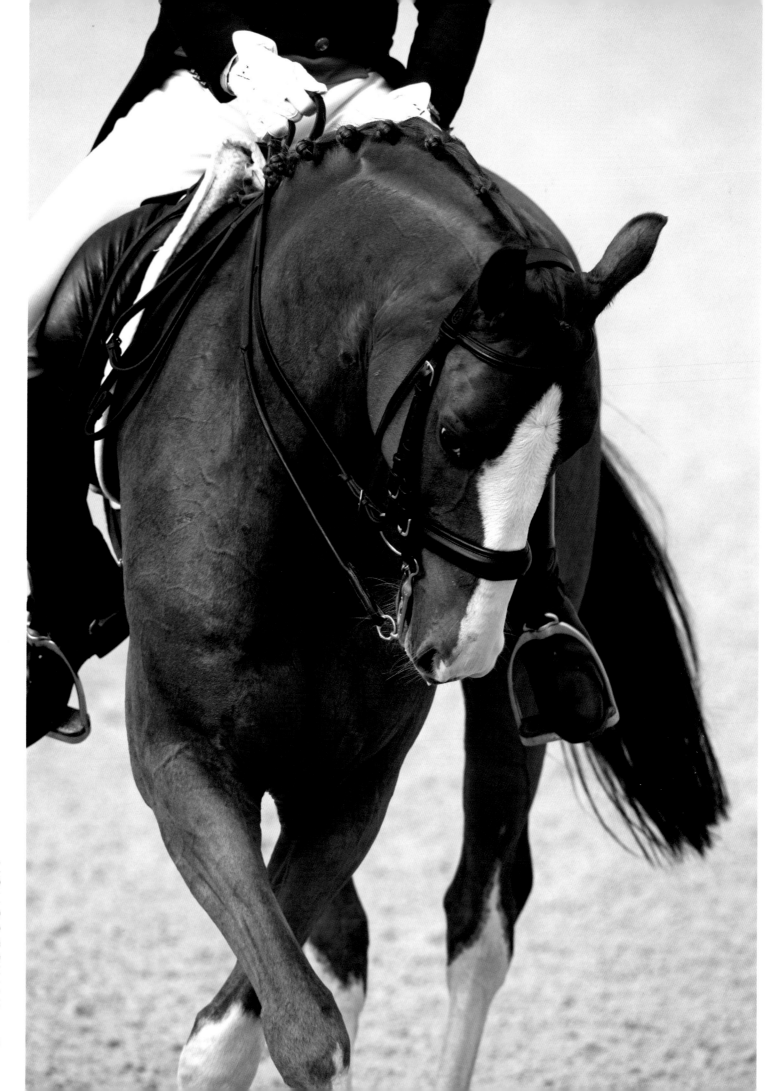

# THE SPORTING HORSE

'Where in this wide world can man find nobility without pride, friendship without envy, or beauty without vanity?' asks Ronald Duncan in his moving poem *The Horse*. 'Here where grace is laced with muscle and strength by gentleness confined.' That the horse is beautiful is undeniable – but it is all the more beautiful for its willingness to do our bidding.

Although it is docile and trainable, we should never forget that the horse is a powerful animal and if it really did not want to do something, nothing we could try would persuade it. That 'grace laced with muscle and strength' is indeed confined by the horse's gentleness – a more calm and biddable creature is hard to imagine.

We form a relationship with our horses that we don't share with any other animal – the dog may be man's best friend but the horse is our equal. Without that special bond, we could not teach the horse to dance with such fluidity and grace, to run with such speed or jump with such power. The horse has hunted for us, fought for us, won us international sporting glory – and all because it is happy to do so.

But what is it about the horse that makes us love it so much? Perhaps it is because we consider our relationship with it more of a partnership than one of dominance? We know that the horse is so much stronger than we are and that we could not coerce it do anything unwillingly.

This book looks at that relationship, as well as how the horse's natural attributes of agility, athleticism, endurance and speed are vital across ten equestrian sports. The agility needed to perform intricate dressage movements, the athleticism to soar over fences, the endurance to gallop across country and the speed to race are explored within these pages. Over the years we have shaped the horse to do what we want it to do – from passage in dressage to rollbacks in reining – by developing particular breeds. But this is not a breed book; it is a celebration of our unique bond with a bigger and stronger animal.

**OPPOSITE** The beauty of dressage – the intricacy of the 'dance' – is entirely dependent on the sense of harmony between horse and rider.

That bond between humankind and the horse goes back millennia. The earliest known equine, the Dawn Horse, existed around 56 million years ago, while cave paintings by early humans from Lascaux in France show beautiful renderings of horses, dating back more than 17,000 years. Even then, people were entranced by this most magical of creatures.

It is not known when humans first looked upon the equine as a conveyance, rather than as a prey animal for food, but it was the Greek cavalry officer Xenophon, who lived between c.430–354 BC, who realized that kindness and understanding – rather than punishment and coercion – were key in the training of a horse. In his acclaimed treatise *On Horsemanship*, about choosing and training a warhorse, he stresses that the training should not be harsh because '... nothing forced can ever be beautiful'. He adds: 'The horse must follow the indication of the aids to display of his own free will all the most beautiful and brilliant qualities.'

It is those brilliant qualities that we try to harness – in every sense – today, without force but with a deep knowledge and understanding of our equine partner. Who knows how horses really think? When they shy at something unexpected in a hedgerow while out hacking, are they simply trying our patience or do they see monsters at every turn? The answer, of course, depends on the individual horse. Like us, they each have their personalities, with loves and hates and seemingly irrational fears. We must never forget that.

The horse has served us for thousands of years; yet its modern role as a leisure and sporting partner is comparatively new. It has enabled us to hunt for food at speed and wars have been fought on its back; it strived for victory with us and it died alongside us. As Duncan's poem reflects: 'He serves without servility; he has fought without enmity. There is nothing so powerful, nothing less violent.'

When we sought to cultivate the land to grow crops, the horse toiled with us, pulling the plough that tilled the fields. When we wanted to travel, it carried us and pulled heavy loads. The fact that motor vehicles were once called 'horseless carriages' and steam trains 'the iron horse' reflects how much we once relied upon the horse for transport and as a beast of burden. And the horse did those things, always, without complaint. The world would have been very different were it not for our relationship with the horse. As Duncan's inspiring poem concludes: 'England's past has been borne on his back. All our history is in his industry. We are his heirs; he is our inheritance.'

We are so lucky; the horse is a wonderful inheritance and we will pass on our love for it to our heirs for the next millennium, and the next. Not even the sleekest vehicle can ever replace the beauty, grace, agility, athleticism or endurance of a living, breathing horse. Our equal in this glorious partnership.

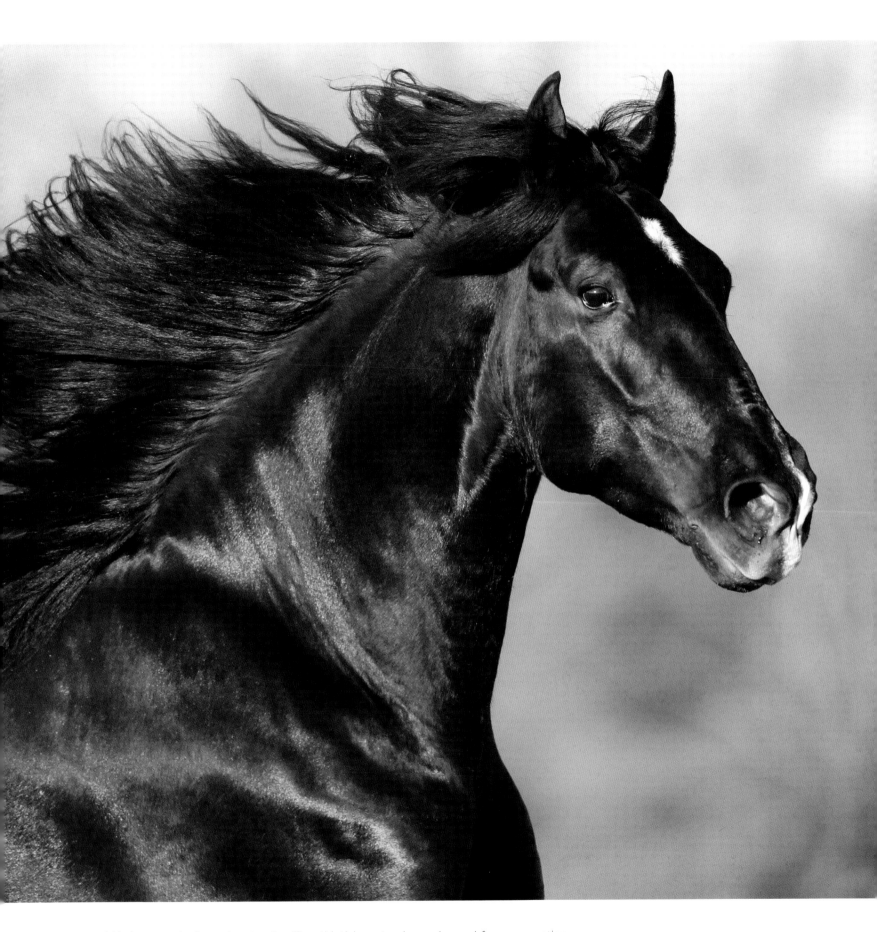

**ABOVE** We harness the horse's natural agility, athleticism, stamina and speed for our sporting pleasure. We revere its power and its beauty, and we cherish its affinity with ourselves that makes it our willing – and equal – partner in the world's great competitive arenas.

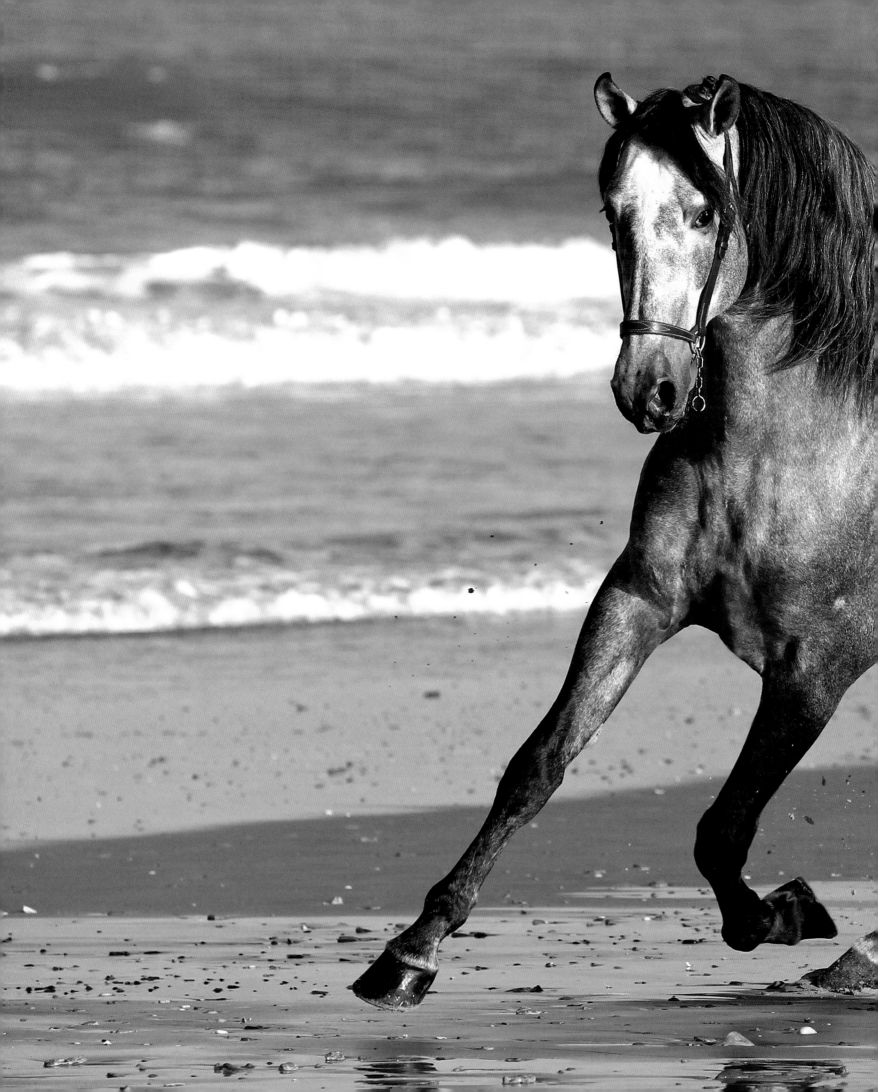

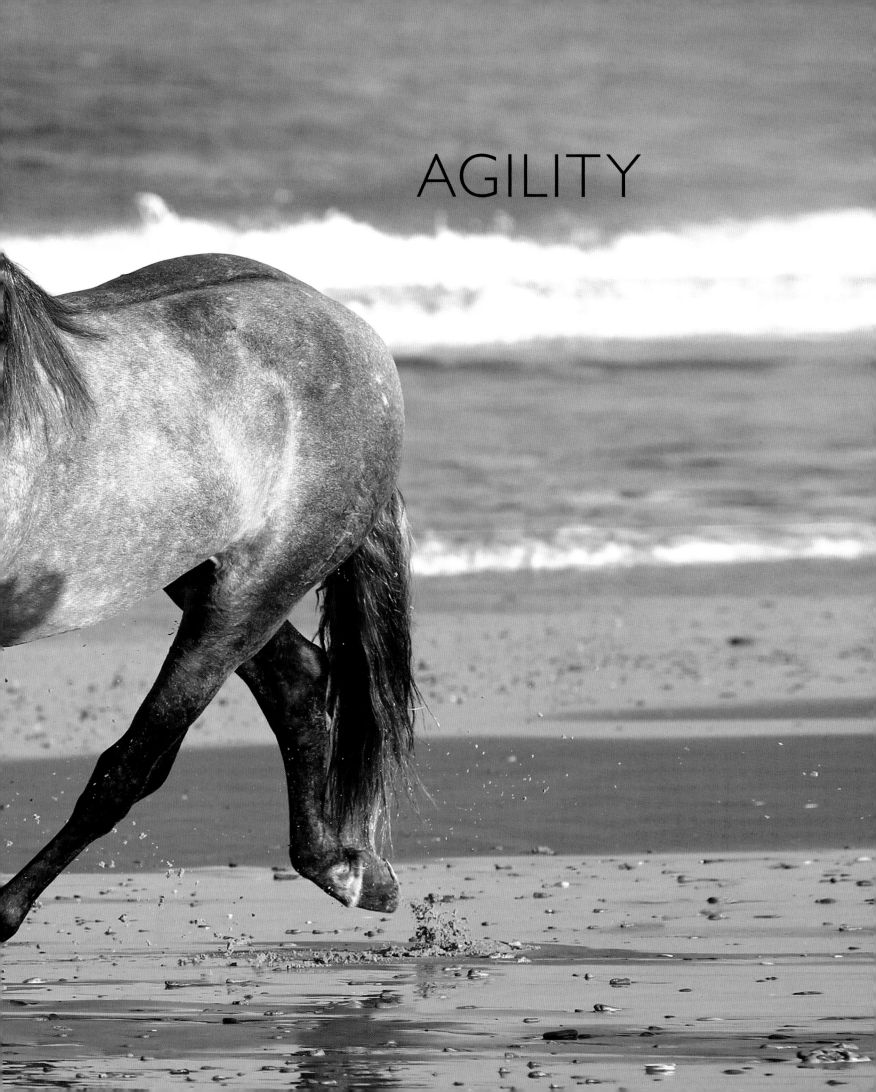

AGILITY

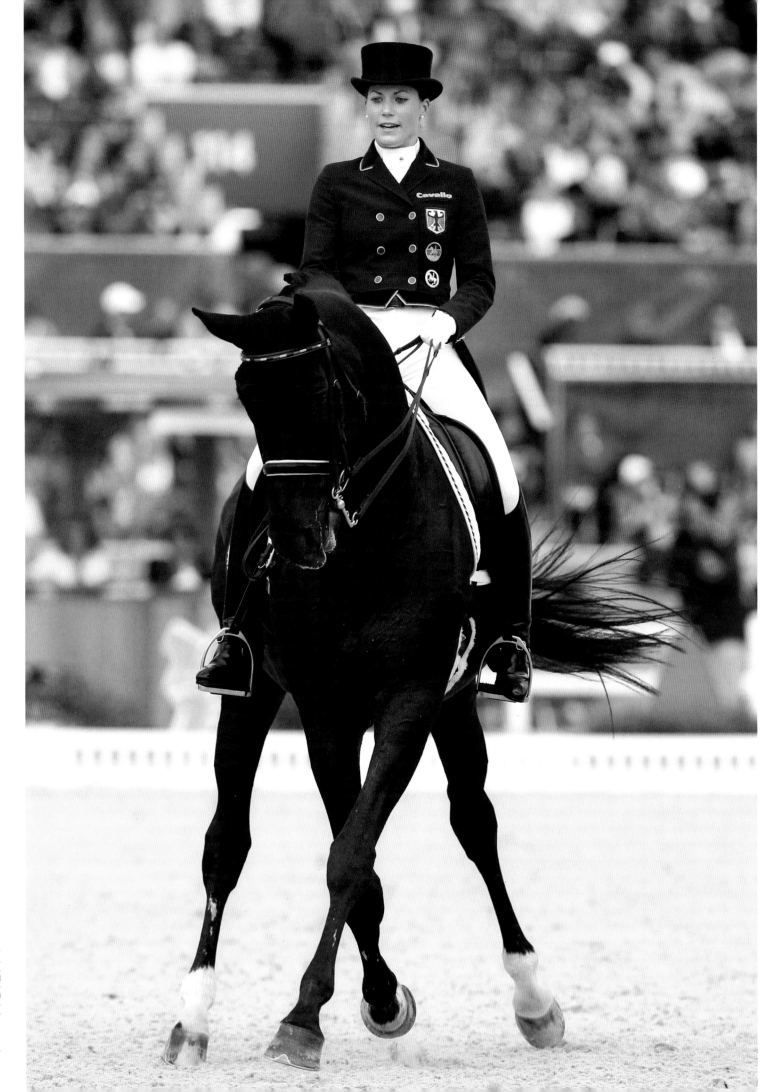

# POISE AND CONTROL

In the popular dressage event at the 2012 Olympic Games in London, new audiences became enchanted by the 'dancing horse'. But the dressage horse is as much an athlete as a ballet dancer, and agility is a vital element of that ability to dance.

Many of the spectators in London already loved horses and admired their beauty, but knew little about the intricacies of dressage itself. But as they moved confidently in time to the music, the talented horses and their brilliant riders introduced their enthusiastic, but inexpert, audience to this most elegant of equine sports.

Dressage in its purest form is indeed a dance, and part of its glory is that the horse becomes our willing dance partner. No dressage rider would be able to ride a 'test' – a set performance of different precise movements at specific intervals – without the absolute cooperation of their horse. Of course there is a very high level of training involved in this discipline, and the dressage horses that are at the top of their game are worth fortunes, but when you consider the horse's strength compared with that of the puny human rider, you can see that there must be a deep relationship involved. Not only does this glorious creature do what we ask of it, but it strives to do so because of a vital part of its makeup – it genuinely wants to please us.

The agility displayed by the dressage horse can be seen in the *haute école* – high school – displays of the Spanish Riding School of Vienna, which celebrated its 450th anniversary in 2015. The *haute école*'s origins lie in ancient Greece, as described by Xenophon, whose treatise *On Horsemanship*, written around 370 BC, is still considered essential reading for any serious rider. Equestrian skills then were needed by the military. In war, a horse might need to spring rapidly from a standstill into gallop, to turn a circle as tightly as possible to retreat or return an injured cavalryman to safety, to form with others a formidable line of cavalry set to charge, or to leap out of the way of a flashing blade.

In *On Horsemanship* Xenophon wrote: 'A horse so prancing is a thing of beauty, a wonder and a marvel; riveting the gaze of all who see him, young alike and greybeards. They will never turn their backs, I venture

to predict, or weary of their gazing so long as he continues to display his splendid action.'

All the high school movements – generally known as 'airs above the ground' – mimic the horse's natural actions when defending itself from a predator or fighting for dominance over another horse; it is, after all, a 'fight or flight' prey animal. Those actions were further developed in military equine training to build strength, agility, balance, concentration and a focus on the rider's demands.

The Spanish Riding School's best-known airs above the ground include the *pesade*, in which the horse's forelegs are raised and flexed so they are at a 45° angle to the ground; *levade*, with the hindlegs flexed until the hock is almost resting on the ground, with the forelegs bent at the knee joint; the *courbette*, in which, when in *levade*, the horse jumps forward several times; and the *capriole*, in which the horse leaps into the air then, with its body parallel to the ground, kicks out behind.

In top-class dressage, movements include *piaffe*, in which the horse appears to trot slowly on the spot; *passage*, as it moves forward from *piaffe* while maintaining the movement; canter pirouette; flying changes in which it changes its lead leg in midair; as well as collected and extended trot and canter. This discipline is about strength as well as beauty, and for a horse to perform the more advanced movements in the dressage arena, it must be strong, flexible and athletic, as well as trainable. Indeed, the word 'dressage' means 'training'.

As Arthur Kottas-Heldenberg, former First Chief Rider at the Spanish Riding School in Vienna, said: 'The key to success in dressage is to make it look easy and beautiful. The goal for my colleagues at the Spanish Riding School is not to be able to do the difficult exercises. Rather, they aim for harmony between horse and rider. They want to appear as if they were born on a horse, so the movements must look easy.

'The goal of all riders should be harmony, which doesn't mean you have to be a Grand Prix rider or even a competitive rider. When the riding looks easy, it's well done. When it looks difficult, then there is strengthening and correct riding to be done.'

While strength and beauty define dressage, there is a third vital component: collection. There are many thoughts on how we describe 'collection'. Certainly, the *levade* – one of the airs above the ground – requires the ultimate level of collection, as the horse's hindlegs are beneath its body and it carries 100 per cent of its weight in its hindquarters. This is broadly what collection means; the horse steps underneath its body, giving it strength and elevation, allowing it to work 'uphill', which is desirable in the dressage arena as it means the horse is working from its back.

**LEFT** A vital part of the horse's nature is that it is willing to work and genuinely wants to please us.

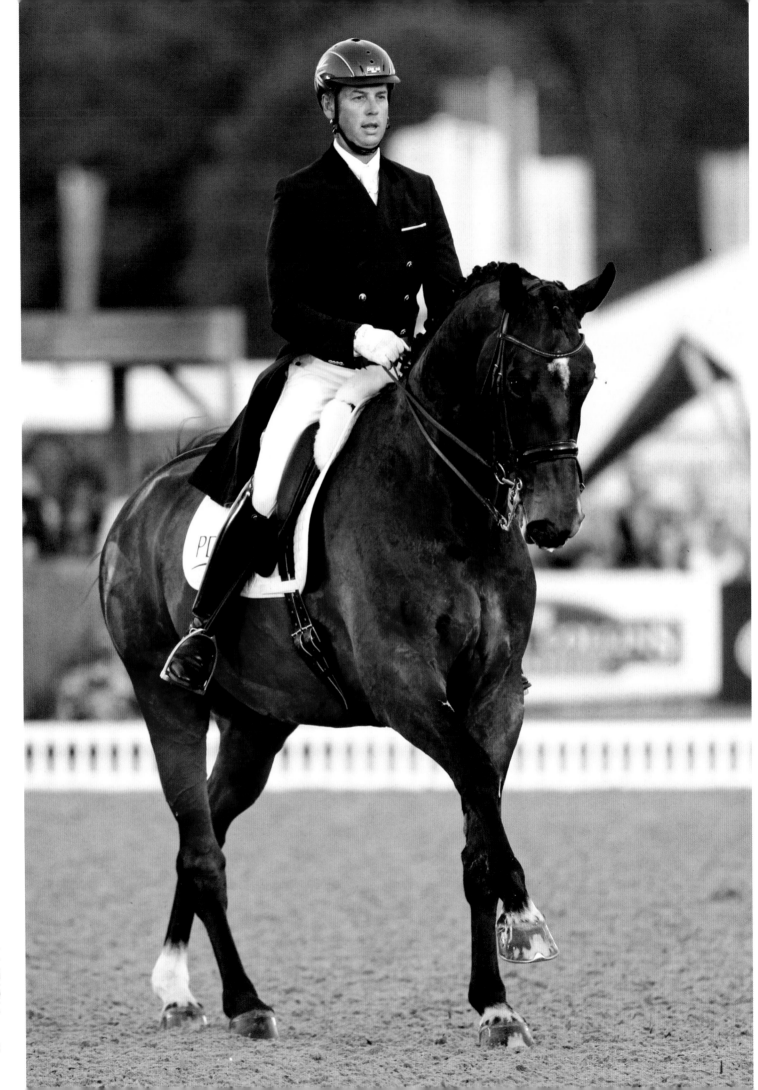

At the very top level, pure dressage is a joy to watch, as much about the partnership between horse and rider as the dressage movements themselves. And this is what we must never forget – whatever equestrian sport we choose to practise, we couldn't do it without the compliance and cooperation of our partner, the horse.

There can be a downside to this acquiescence, however. The horse has evolved so that it is able to move its body to compensate for any discomfort. Even though it may be in considerable pain, it doesn't show it. This ability keeps it alive in the wild, where predators look for abnormal movement that signifies weakness, but it also means that our horses cannot tell us when they are suffering and we may not notice from their movement, unless they are obviously lame. So it is our responsibility to ensure that we know our horses and how they move intimately.

To perform dressage properly, the horse must use the correct muscles, and the rider must build up those muscles, in much the same way that a personal trainer helps us to use our muscles correctly. The muscles must be strengthened gradually – building muscle in horses takes time. If the training is too intensive, discomfort and injury can result.

We should also remember that the horse really is an athlete, and probably revels in its ability just as a human athlete does. Even the most staid of equines, once turned out in a field, will kick up their heels and gallop off, enjoying the chance to stretch their muscles and show off to each other. Why should we imagine that what we ask them to do is entirely work, when it may just as easily be play?

There are few truly wild horses left in the world now, but the herd mentality – as well as the fight or flight mechanism – still plays out. If you watch a field full of young horses, for example, they will play-fight with one another, showing off their superior strength and agility. It is this agility that we can harness – literally – in the dressage arena.

An adult horse can weigh up to a tonne. It is an impressive creature forged of muscle and bone. That this mass can 'dance' so lightly and with such supreme elegance depends on the way its skeleton can move. While the horse's spine allows for little movement, the lumbosacral junction, which joins the pelvis to the spine, acts as a giant hinge that allows the horse to bring its hindlegs underneath its body – to achieve that all-important 'collection'. If you watch a horse in *piaffe*, you will see that its hindlegs are well underneath its hindquarters; this also is important for propulsion as it moves forward into *passage*. The enormous power in the hindquarters gives the horse that vital spring as it comes off the floor in the movement, making it look light and easy rather than plodding hard work. The same power that makes dressage look effortless would, in the wild, have been used by the horse to spring forward in a fight with an opponent, or wheel round and flee if under threat from a predator.

All the movements in the dressage arena must be fluid and easy, with the transitions smooth and the rider's aids – the instructions the rider gives to the horse – almost invisible. In walk, the horse must appear loose and relaxed, stepping well out and covering the ground. In collected trot

**OPPOSITE** Top-level dressage is a joy to watch. It is often described as the highest expression of horse training, as demonstrated here by Carl Hester, riding Nip Tuck at the Royal Windsor Horse Show in 2014.

it should look springy and elastic, while the extended trot should be full of energy and expression. Canter must show cadence and elegance with plenty of spring and flying changes smooth and beautifully balanced. In the one-time (or *tempi*) changes, seen in the very top levels of dressage where it changes legs with every stride, the horse appears to skip, light as air.

The canter pirouette illustrates not only the horse's agility but also its suppleness. The exercise – in which the horse's hindlegs stay in one place and it moves in a full circle through from the shoulder, bending its body equally from head to tail – is one of the more advanced. The horse should be light and on the bit – that is, accepting the contact with the bit down the reins to the rider – while it draws a circle around the hindquarters. Its outside hindleg turns around the inside leg, which should continue to leave the ground and land on the same spot, maintaining the three-beat gait of the canter through the entire pirouette. The rhythm is slow and absolutely even and the horse's posture remains unchanged. Although pirouette can be done at walk or in *piaffe*, the most difficult is in canter. It shows a high level of training and an excellent partnership between horse and rider.

Ideally, the rider will be able to lower the reins; if he has to use his hands to balance during the pirouette, the horse will appear to rock its neck and head. If the rider uses the aids too much, the pirouette will appear choppy and ungraceful. The aids must be given smoothly and accurately and the horse should appear supple and relaxed. And when it comes out of pirouette, the transition must be seamless.

The pirouette again has its origins in mounted warfare. During one-on-one combat, if the horse could turn on the spot, the rider might avoid being attacked from behind as he fought face-to-face with his opponent. The horse's ability to pirouette was essential for its rider to survive in battle. All of these movements are based on the behaviours of horses in the wild. Although every breed – from the stocky Highland pony to the elegant Thoroughbred – is capable of performing a dressage test, the mechanics of the horse means some are better suited than others.

Just as the Lipizzaner horse is bred for the Spanish Riding School of Vienna, the Continental warmblood horse is bred for the dressage arena – some of the most revered dressage horses are warmbloods, including the record-breaking Valegro, who won gold medals at both the London 2012 and Rio 2016 Olympic Games. Valegro is a Dutch Warmblood, sometimes referred to as KWPN (reflecting the abbreviation of the Dutch registry of the breed). Totilas, who enthralled and enchanted dressage audiences with his rider Edward Gal, is also a Dutch Warmblood. He broke records at the European Dressage Championships in 2009 and won three gold medals (freestyle, individual, team) at the World Championships in Lexington. In 2010 the stallion was sold for a reported 10 million Euros – becoming the world's most expensive dressage horse ever.

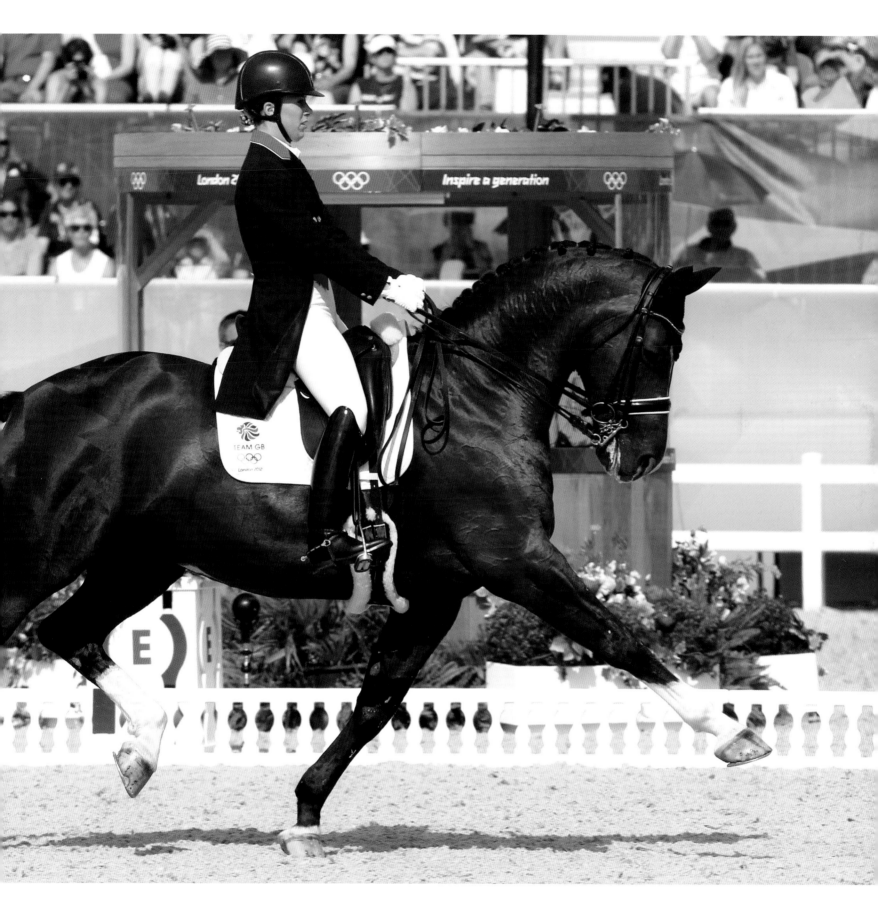

**ABOVE** Great Britain's Charlotte Dujardin and Valegro show off their glorious extended trot at the 2012 London Olympic Games.

It is perhaps only in the past one hundred years or so that the warmblood has risen to the top as the dressage virtuoso. Through selective breeding, these horses combine strength, agility and suppleness with sufficient intelligence to understand what their riders want of them. It helps that warmbloods tend to have bigger, more expressive paces than some other breeds that give them the 'wow factor'.

The Trakehner is prized for its trainability and magnificent movement, as well as its beauty. At the 1936 Olympic Games in Berlin, Trakehners won every medal for the German Olympic team. But less than ten years later, the breed was almost lost. At the end of World War II, East Prussians were forced to flee the advancing Soviet Army. They packed their belongings into wagons pulled by Trakehners – the Trakehner stud was in East Prussia – and escaped across the frozen Vistula lagoon towards the west. The ice cracked beneath their feet and many perished – less than ten per cent of the Trakehner horses from East Prussia reached the safety of west Germany. The fact that the owners were desperate to save their horses is a revealing example of the unbreakable partnership between riders and their horses.

With no sense of irony, the Trakehner is sometimes called the 'Thoroughbred' of the warmbloods, as it has more Thoroughbred blood, as well as Anglo Arab and Arabian lines, than some of the other types. It has been used to improve other breeds, among them the Hanoverian, Germany's equine success story, which takes its name from the old kingdom of Hanover in northern Germany. This handsome creature was bred from 1735 as a carriage horse, so it had to be good-looking, good-moving and athletic. Hanoverians were later used by the German cavalry and artillery, so they needed strength and agility too. Those same characteristics proved valuable in dressage. One of the dressage sensations of the twenty-first century, the stunning chestnut mare Woodlander Farouche, is pure Hanoverian.

Every European country has its own warmblood, but their talents are not restricted to the dressage arena. Their strength, trainability and agility are highly valued in the specialist discipline of horse-driving trials, where up to four horses – known as 'four in hand' – are harnessed to a carriage and compete in three phases. The competitive sport was effectively invented by HRH The Duke of Edinburgh in 1968, as he drew up the rules that are still followed today.

Prince Philip competed internationally with a four-in-hand of Fell ponies, one of the native ponies of the United Kingdom, but driving trials can be for singles, pairs and tandems as well as fours. The sport encompasses three different phases, based on the ridden three-day event: a triathlon that tests strength, stamina, athleticism, agility, obedience and skill.

The competition starts with a dressage test on the first day. If you imagine the partnership of horse and rider, and the dedication and training it takes for them to perform as one in the dressage arena, imagine how much more skill it takes to drive four horses to perform the prescribed actions. These include circles, half-circles and serpentines, driven at various speeds from walk to extended trot. The combinations are also required to perform circles driven one-handed, halts and rein-backs, in which the horses step

**OPPOSITE** Performing the movements with agility and grace, Dolcevendy O is completely attuned to Laura Tomlinson's aids during a competition at West Palm Beach, Florida in 2016.

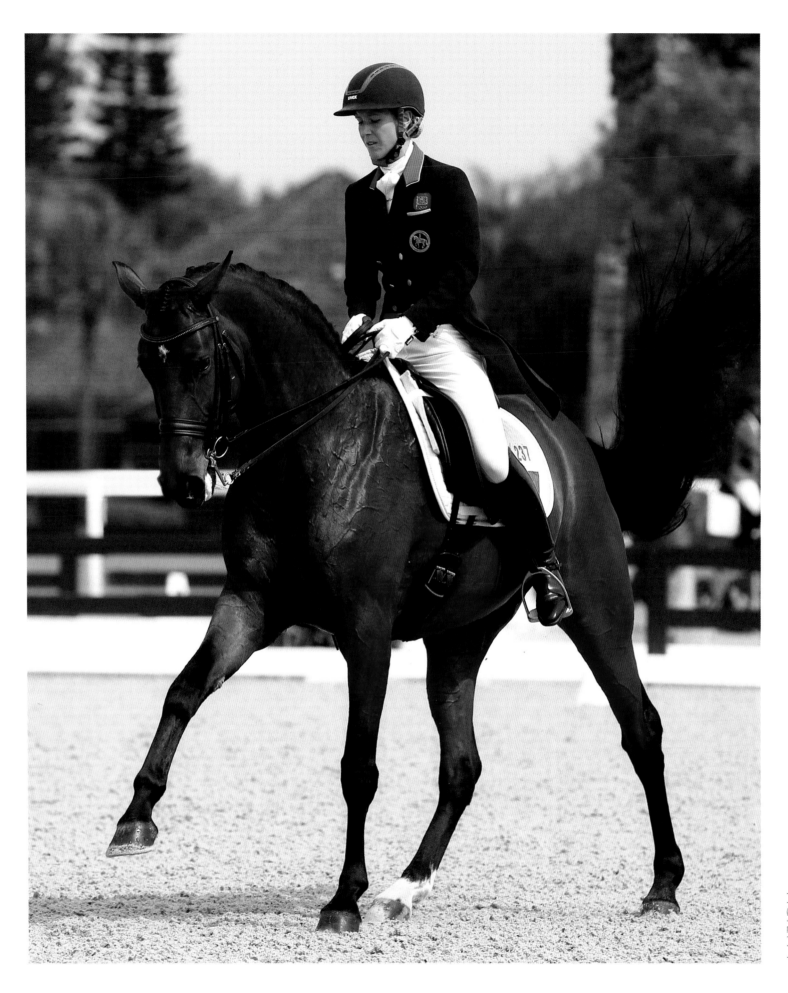

backwards. As well as the driver, the carriage must carry a groom (two for teams), who must remain seated throughout the test and is not permitted to speak or communicate with the driver.

Each of the movements is marked out of ten, and penalties are added for taking the wrong course or if the groom or grooms dismount. This phase is a test of the driver's accuracy as well as the horses' paces and agility.

The second phase of the three-day trial is the marathon, which itself is divided into three parts, with halts in between each section. The marathon course contains several gates through which the team must be driven and each section is timed, with penalties given if the competitors exceed the time allowed. At each halt, the horses or ponies are checked by a veterinary surgeon – who will measure their temperature, respiration and pulse – to ensure that they are fit to continue. In the final phase, the driver has to negotiate up to eight obstacles – sometimes referred to as hazards – which are based on natural features such as watercourses and banks. They test both the driver's accuracy and his horses' agility as they manoeuvre through gates and tight turns. Again, the section is timed and the obstacles must be negotiated in the correct order. The groom or grooms must not dismount.

This doesn't mean that the groom is mere 'ballast'. For the dressage phase, the groom is there simply for emergencies, such as broken tack, but during the marathon stage, the groom has a vital role to play, helping the driver stay on course, guiding him through the obstacles, as well as balancing the vehicle on tight turns and uneven ground by shifting his weight.

Enthralling to watch, driving trials are a supreme test of skill and partnership; the quicker the team can get through the obstacles the higher its placing will be, so teams must be fast as well as accurate. Some of the best competitors are so in tune with their horses that they appear to think as one seamless unit.

The final phase of the trial, the cones section, is another test of speed and accuracy. The team must drive a course of up to twenty 'gates' – a pair of cones with balls on top – in the allotted time. The course can be up to 800m (875yd) long, the cones are numbered and must be negotiated in sequence. Penalties are given for exceeding the time allowed, dislodging any of the balls, course errors and groom dismount. The width between the cones is a mere 20cm (8in) greater than the track width of the vehicle. The driver has to drive his horses through tight corners at speed, which requires a huge amount of trust between driver and horse.

**LEFT** The cones section is a part of the driving trial that requires great accuracy from both the driver and the horses.

It is, essentially, a test of mathematics, agility, courage and memory. The maths takes the form of geometry as the driver must decide which side to turn in for a smoother arc; most horses and ponies can turn in one direction better than the other. Even riding in a horse-drawn carriage at a fairly sedate pace such as trot feels incredibly fast, so negotiating streams and banks at a spanking canter is terrifying and exhilarating in equal measure.

In a team of four horses, the front pair are called leaders, the back pair wheelers. Unsurprisingly, the most experienced horses tend to be in the lead, the two behind may still be learning their job. But all four horses must work together. Again, the horse's development as a herd animal means that all equines, left to their own devices, will find a pecking order, and it's rare that any serious aggression develops. This helps when four – or more – are driven as a team. They have to learn to turn together, following the instructions of the driver, often at great speed.

As with dressage, a lot of training goes into the end product. The drivers who are at the top of their game never forget that horses must be allowed to be horses. Boyd Exell, an Australian four-in-hand driver who has been World Champion four times, readily admits that he has in the past made the mistake of treating any exercise with his teams as a 'mini marathon'. 'This tends to make the horses more and more excited at events. If they have any spirit, it is usually better to have faster stages but also do some slower collected work with plenty of impulsion but not speed.'

He notes that most animals will appreciate an occasional hack out, perhaps with a good canter or gallop to 'open their pipes' and blow away the cobwebs. During training Boyd does spells of driven canter work with pull-ups to a halt, followed by another spell of canter. This helps to give the horses rapid response to commands to change their pace, while keeping them calm and unexcited by the canter parts. He also acknowledges that a great part of his success is because he forms such a close bond with his horses.

'You have a connection with horses – grooms who work with the animal have a connection when they're handling them and I have a connection when I'm training with them,' he said. 'I can feel a trust with my horses – I can feel down the rein if they're feeling stiff, or if they're expressive and wanting to show off.'

Boyd drives a team of primarily warmbloods, a combination of Russian Orlov, Holsteiner and Cleveland Bay crossed with Thoroughbred. These certainly shine in the dressage section but they also have the necessary power and speed for the gruelling marathon phase and the brain and agility for the cones section.

**RIGHT** Four-times World Champion four-in-hand driver Australia's Boyd Exell, pictured in action at Aachen in 2014.

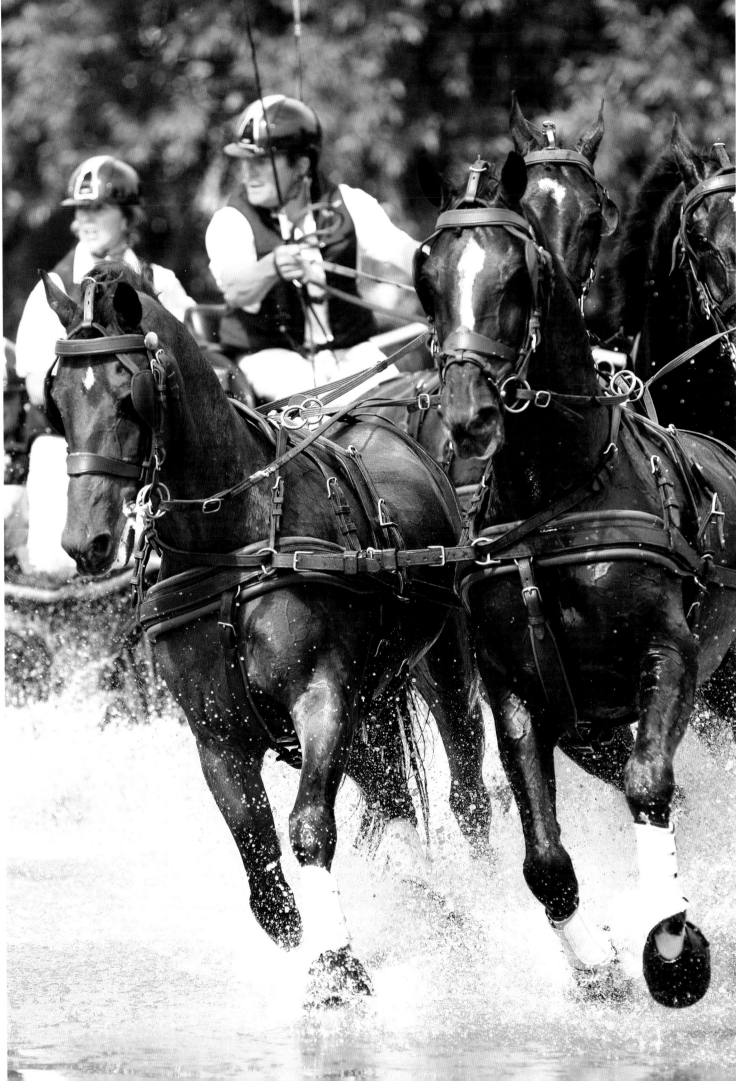

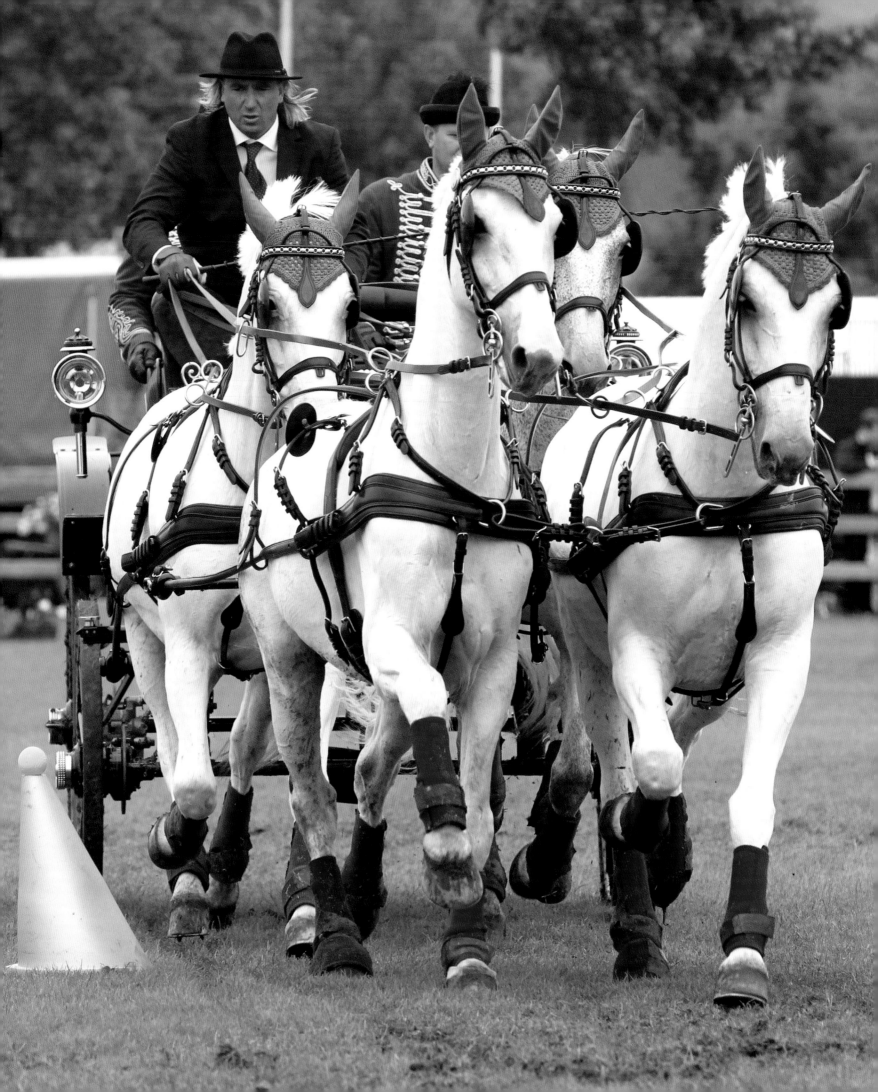

As in dressage, physical conformation is vital in the driven horse. Many pony breeds – including the Welsh Section A, American Spotted, Connemara and Haflinger, to mention just a few – have the agility and speed to flash through the testing obstacles with barely a pause. The warmblood horses, with their supreme build and athleticism, have the desired sloping shoulder. A horse with an upright shoulder will have shorter muscular attachments that have less ability to contract and lengthen; this shortens the stride length, so the horse must take more steps to cover the ground. It also increases the risk of injury to the front legs and hastens muscular fatigue.

In horses used for driving, the more sloping the shoulder, the better. The first horses that were driven in harness, the heavy draught breeds, were bred to hold the collar of the harness. A good draught horse would need a lot of head and neck out of the front of the collar because all the strength comes from the shoulder where the collar lies. The wider the area you can put against the collar, the more force you are going to get.

A more upright shoulder is seen in the Quarter Horse and some of the 'gaited' American breeds that are used for the skill of Western riding. This sport originated with the Spanish conquistadores who set up ranches across the Americas, starting in Mexico and California then spreading throughout the American Old West – hence the term 'Western' riding.

The demands of this sport, particularly reining and barrel racing, require an agile equine that can turn on the proverbial sixpence and is capable of bursts of speed from a standstill. The Quarter Horse has this ability, with plenty of stamina and muscle. Despite popular belief, the breed is not so-called because it is a quarter Thoroughbred; the name came from the practice of racing the animals over a quarter of a mile through North America's townships.

As with dressage, Western riding should look effortless, and it requires the same bond, and the same trust, between horse and rider. The best Western riders sit loose in the saddle, with their hands low but maintaining contact with the horse through the bit and their feet light in the stirrups.

Western riding comes in many forms, but the most demanding in terms of agility are reining and barrel racing. The former is sometimes described as the American form of dressage, because reining horses are required to perform precise movements, including stops and spins, and so need agility, suppleness, balance and responsiveness. The movements that a reiner must execute, however, derive from cattle work, rather than the aesthetic dance of dressage.

Cowboys and ranchers needed horses that could move fast, respond to subtle commands, stop immediately and change direction in a flash. Horses had to be sturdy, quick, responsive and agile to be able to herd and move cattle and other livestock across the range. As an added complication, the cowboys would often use their hands to rope cattle so would drop their reins. Their trust in their mounts needed to be absolute.

In a reining competition, the riders show off the skill and athletic ability necessary in a working ranch horse but within the confines of an arena, known as the show pen. This means that the movements have become

**OPPOSITE** Zoltán Lázár drives his handsome team of Lipizzaners round an obstacle at Aachen in 2013. The Lipizzaner is best known from the Spanish Riding School of Vienna, but its trainability makes it suitable for almost any discipline.

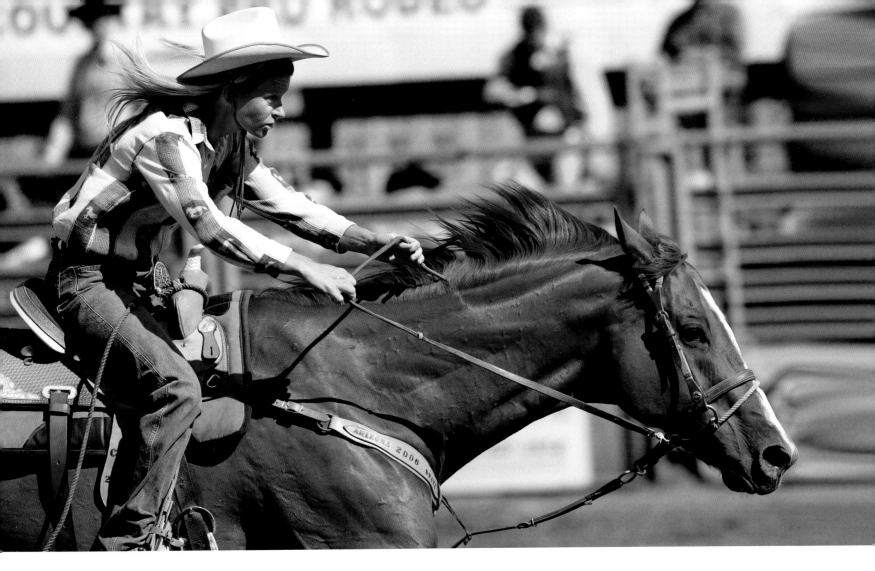

**ABOVE** A partnership in every sense of the word; this rider and horse both look determined to shine in the Western riding arena. Horses need to be fast, agile and able to stop or turn in an instant to excel in this discipline.

precise and highly refined. There are a total of thirteen official reining patterns and the horses and riders must perform individual compulsory movements. These include small slow circles, large fast circles, flying changes – as in dressage – roll-backs, quick 360° spins and the breathtaking sliding stops that have become the signature of the reining horse.

As the name suggests, the horse gallops then, at a command from its rider, it 'sits' on its hocks and slides to a stop. The manoeuvre is defined as 'the act of slowing a horse from a lope to a stop position by bringing the hindlegs under [its body] in a locked position, sliding on the hind feet. The horse should enter the stop position by bending the back, bringing the hindlegs under the body while maintaining forward motion and ground contact and cadence with front legs. Throughout the stop the horse should continue in a straight line while maintaining contact with the hind feet.'

In the show pen, stops that are not straight are penalized, as are inaction in the front feet and 'skipping' in the tracks. A correct stop is when the horse goes to the ground and stays in the ground – body straight and front legs trotting. In the spin, another hallmark manoeuvre also known as the turnaround, the animal should 'spin a hole in the ground', planting a hind foot and sweeping the forehand in a series of circles – the best reining horses will crouch so they pivot in place.

The horse has to be super-fit for these movements. It has to be able to go fast, and to go slow, and to work in anaerobic (sprinting) and aerobic (sustaining

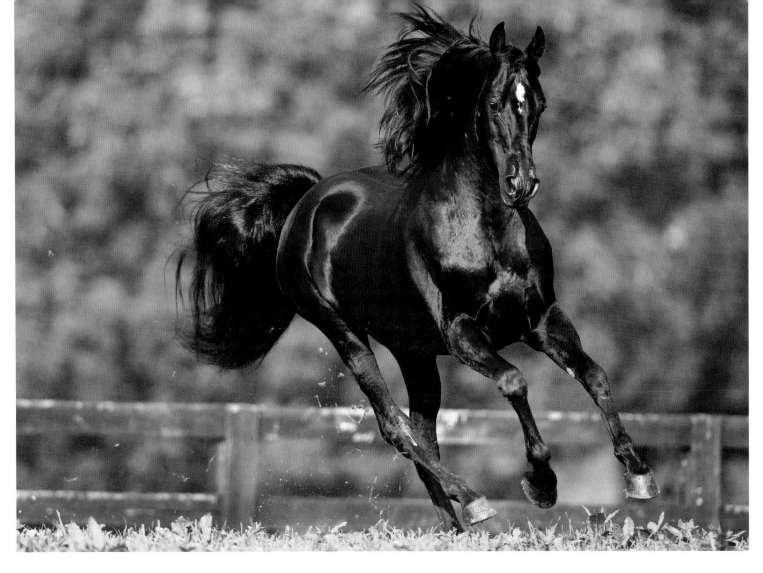

speed for a period of time) disciplines, with the mental aptitude to do both. In this sport, perhaps more than any other, that mental attitude – known as 'the try' – must be there at the start. The ideal horse will be honest and sane, sound in wind and limb with large joints. It should be balanced with withers higher than its croup, a strong back and loin, and its angles of the foot and shoulder, and hock and rear feet should all correspond. It must have a free-moving front, so that it can lift its legs, shoulders, neck and head when it sits in the sliding stop, and it must – unsurprisingly – have strong hocks.

Smaller horses tend to be best suited to reining, such as the Quarter Horse. This breed was developed by early American settlers for racing over short distances, so is fast enough to chase after cattle. It is also muscular and compact. Other American breeds, such as the Morgan, are also capable. The Morgan, developed from a stallion called Figure, is fast, strong and enduring, so can take the training and is intelligent enough to understand what is required. It has an excellent temperament and will form a close bond with its rider.

The Appaloosa, the iconic spotted horse seen in so many Western movies, also makes a good reining animal. The Nez Percé tribe is credited with creating this agile, strong and sure-footed little creature; it is widely acknowledged as being the first to be selectively bred. The result is a tough and attractive animal – the Nez Percé only bred from the best – with a neat and compact conformation that allows a great range of movement.

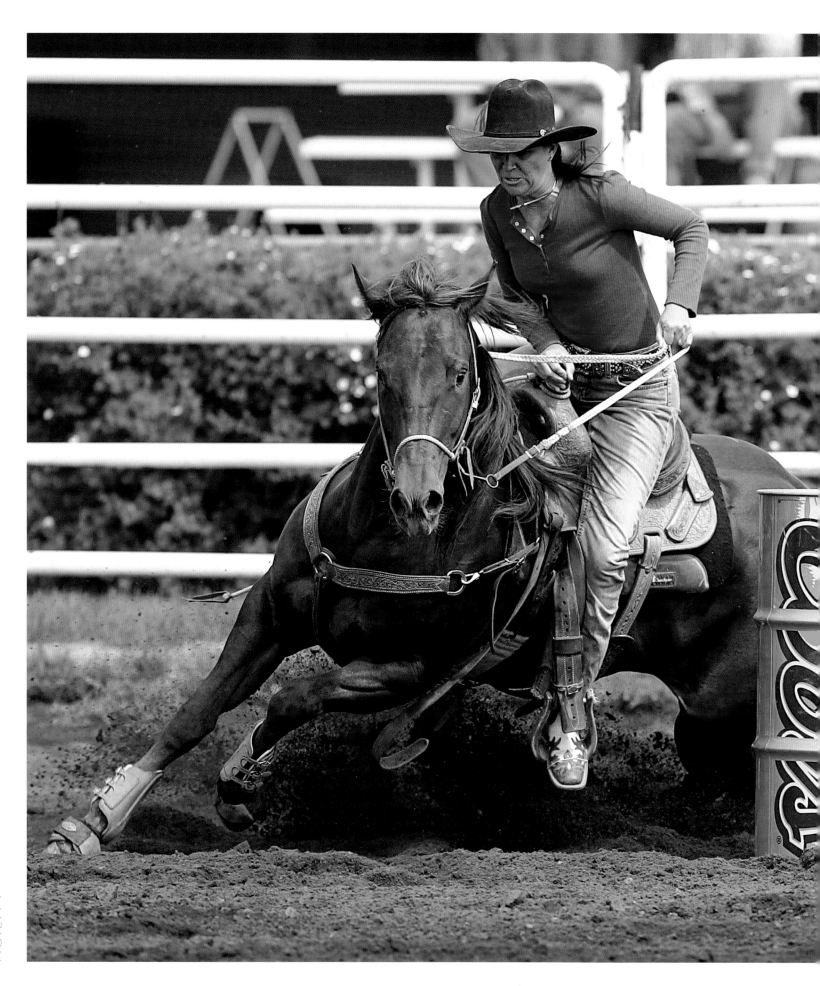

The Arabian horse also excels at reining because it is naturally hardy and is light enough to move at speed. It too is intelligent, but can be wilful. A good rider, however, will be able to get the most out of an Arab. And, of course, there is Arabian influence in almost every breed, including the Morgan and Quarter Horse.

American breeds also shine in the sport of barrel racing, a fast and furious rodeo event that was originally invented for women – or cowgirls – in the 1930s, while the cowboys would compete in sports such as roping, bull and bucking bronco riding. In the early days of barrel racing, speed was less of a factor as the rider's outfit and horsemanship were also taken into account in the competition.

Modern barrel racing is open to anyone of any age. A team of riders must complete a course of barrels, placed in a triangle in the middle of an arena, in a clover-leaf pattern, at great speed; the winner may be decided by mere thousandths of a second. The time for each round begins as soon as the rider gallops through the start. Once they complete the course, they race for the finish line, shaving off as much time as possible. The team that records the fastest time with tight turns, explosiveness, communication and – crucially – no overturned barrels wins.

Many of the requirements for a reining horse also apply to the barrel racer, with emphasis on soundness and trainability. Smaller horses are generally preferred, as they have a lower centre of gravity, with a short, straight back, long underline and matching hip and shoulder angles. They must be able to reach under with their hindlegs for extra propulsion and speed. The Quarter Horse is the premier breed in this sport, as its strong legs and hindquarters enable it to gets its legs well underneath its body. It also has the right attitude and will relish the challenge. But other American breeds can excel, including the Paint, which is based on the Quarter Horse and has an even temperament. Smaller Thoroughbreds also make good barrel racers with their bursts of speed and agility to turn sharply, and an Appendix horse – a relatively new type, which is a cross between a Thoroughbred and a Quarter Horse – is becoming more popular for barrel racing.

As with reining, it seems fitting that an American sport that was developed in the Wild West should use the compact and agile American breeds. But the most important secret of success is the relationship between each horse and rider, as the sports test the horse's agility and the rider's horsemanship to the limit.

**OPPOSITE** The expression of commitment and drive on the rider's face is echoed on that of the horse as they speed through a barrel race with agility and determination.

# DRESSAGE

If dressage is an art form, the horse is our canvas and we are the paint and brushes. Neither is much use without the other, but in combination the horse's supreme agility allows it to perform intricate movements in a dressage test with outstanding elegance and ease.

Though many of those movements can trace their origins to battleground manoeuvres, today our horses can be considered to dance: those pirouettes, *piaffes* and flying changes are even set to music especially scored for them.

This art was developed some 400 years ago by the Spanish Riding School of Vienna, whose noble Lipizzaners are renowned worldwide as 'the dancing white horses'. However, many of the horses that dazzle audiences and judges in international dressage arenas today are warmbloods, a type that combines the elegance and grace of the Thoroughbred 'hotblood' with the power and beauty of heavier 'coldblooded' types.

Practically every country that competes in Olympic equestrian sports has developed its own warmblood breed, with arguably the most successful being the Hanoverian, Dutch Warmblood and Selle Français. But almost any breed can perform dressage, from the Gypsy Vanner to America Quarter Horses and even the sturdy Highland pony. All they need is the right training to develop their natural agility and a patient partner who can make those first brush strokes on that blank canvas.

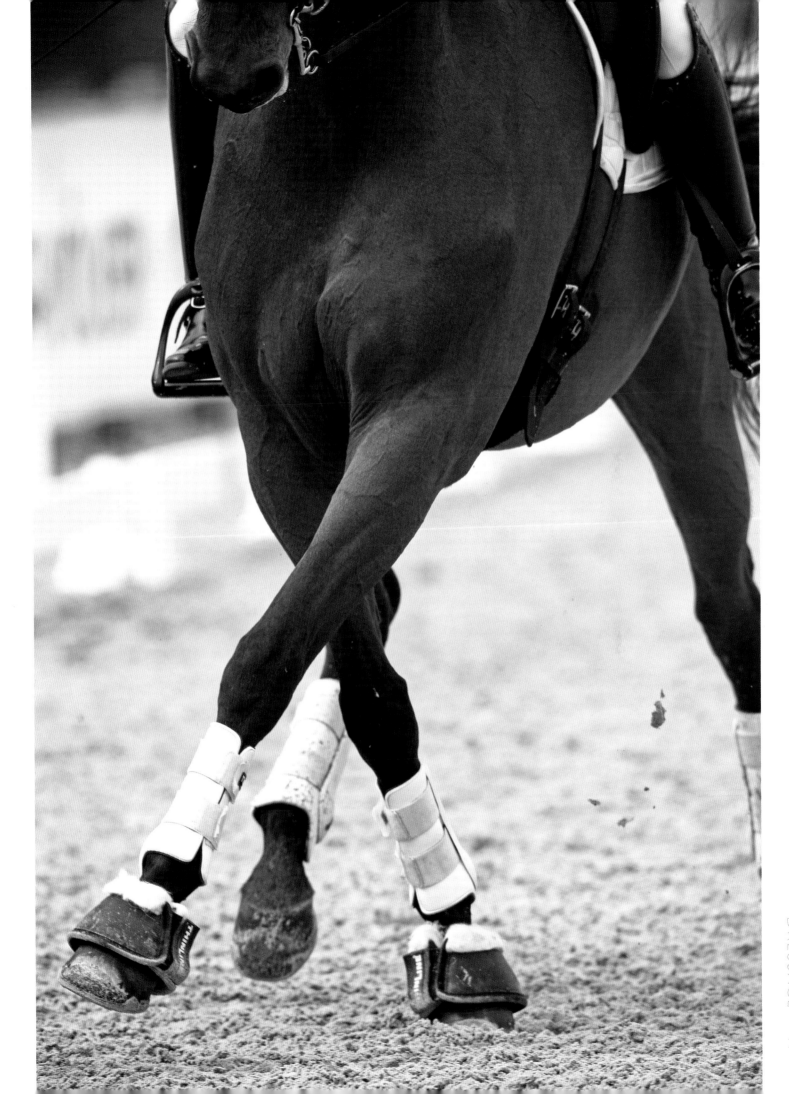

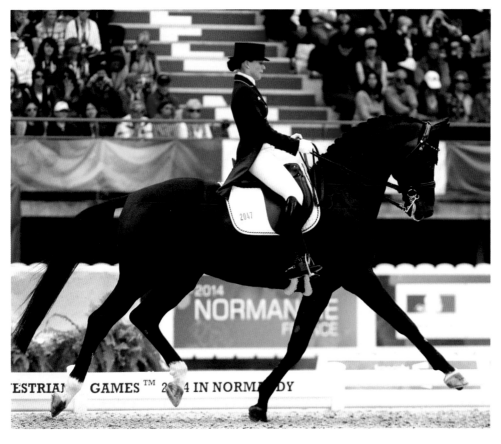

**ABOVE** Germany's Kristina Bröring-Sprehe shows off Desperados FRH's supreme extended trot in the Grand Prix special at the World Equestrian Games in Normandy, France, in 2014.

**RIGHT** In the flying changes, Laura Bechtolsheimer's Mistral Højris appears to skip, changing the lead leg every three, two or even every other stride at the London Olympics in 2012.

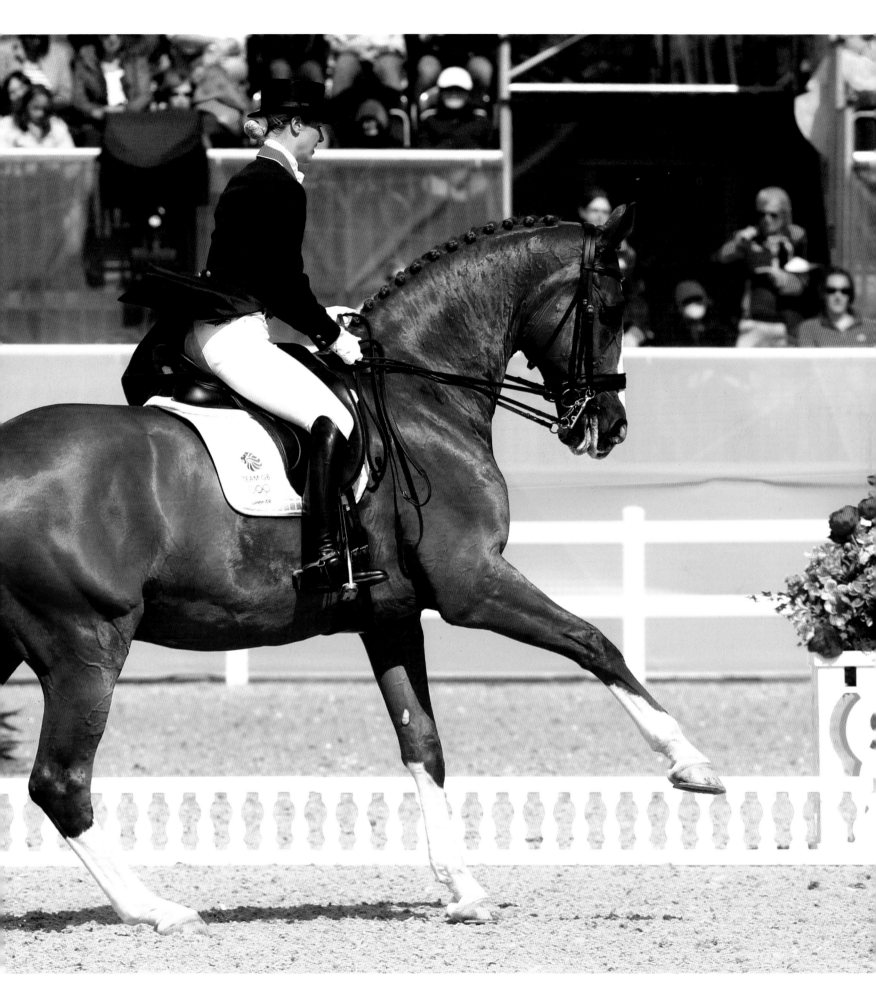

**RIGHT** Training the dressage horse for competition takes a great deal of commitment, from both the rider and the horse. Note the bandages; these are not allowed in the competition arena.

**OPPOSITE** A picture of harmony: American rider Tina Konyot has a loose contact with Diamantino at West Palm Beach in 2017. The horse has its ears back to listen to her voice commands.

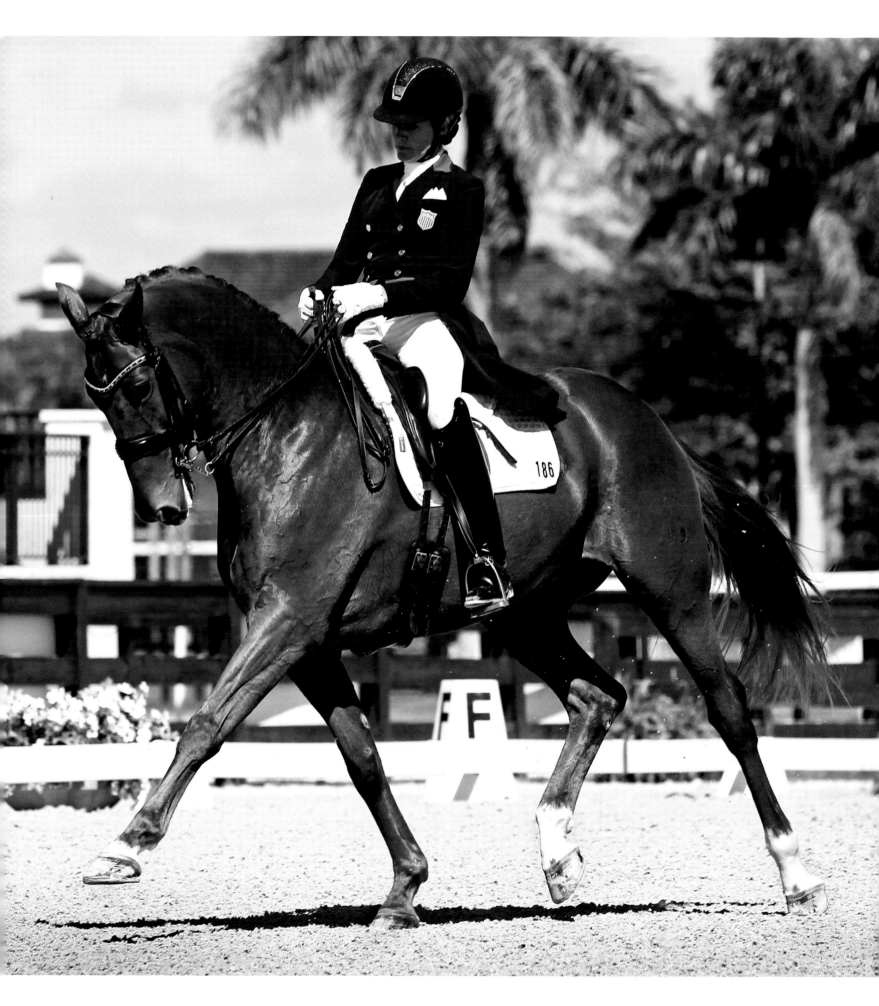

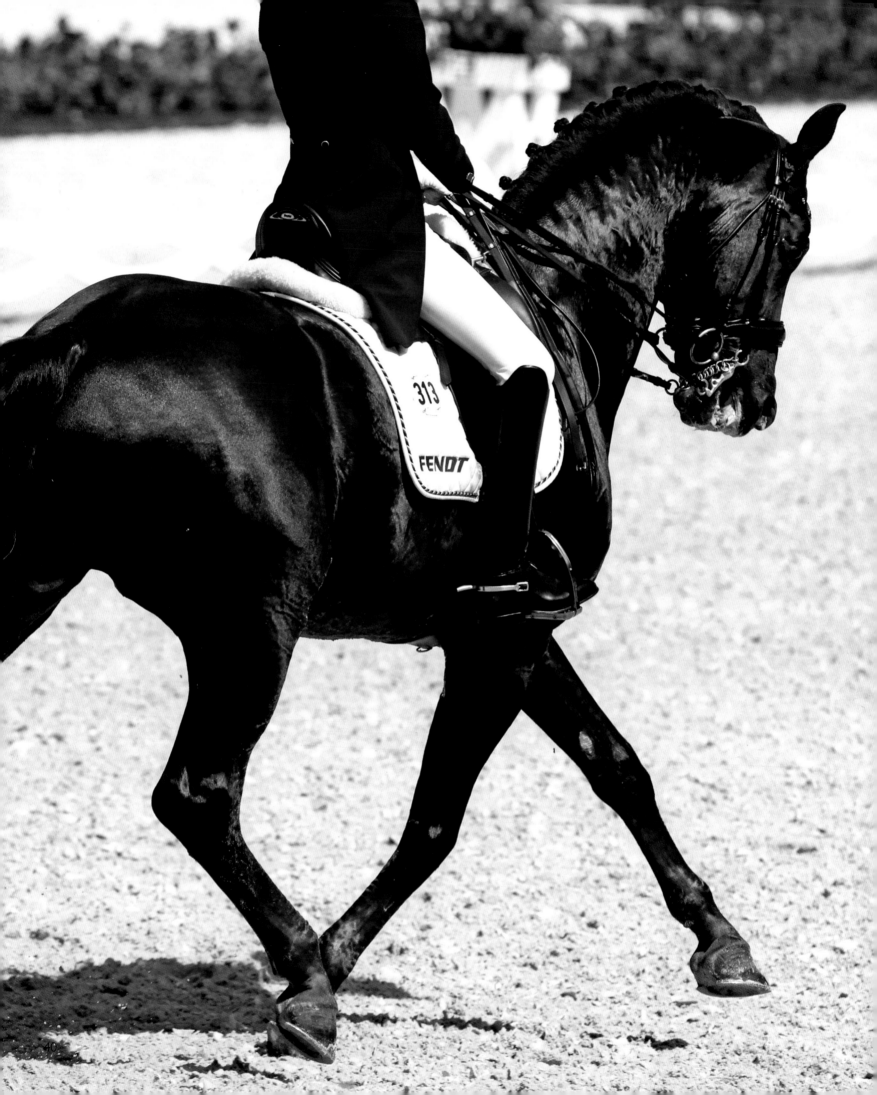

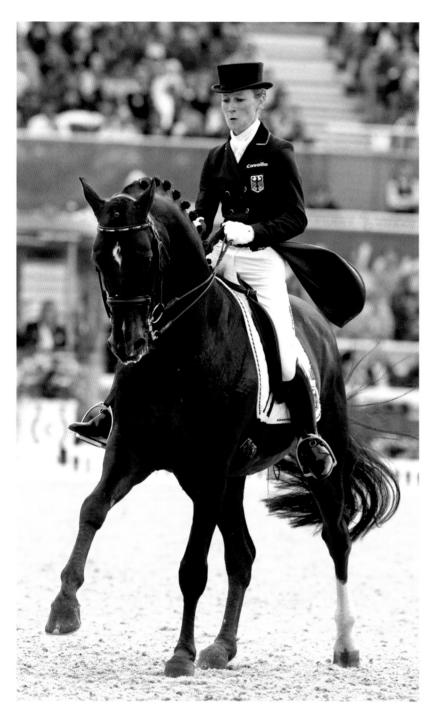

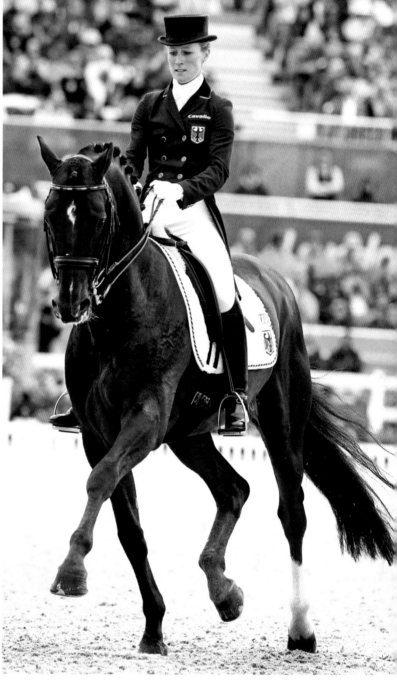

**ABOVE** Germany's Helen Langehanenberg competing with the stallion Damon Hill NRW at the London Olympics in 2012, where they took a team silver medal just two years into their partnership.

**OPPOSITE** The same combination two years later – Helen sits quietly while competing the stallion on home turf at Aachen in 2014.

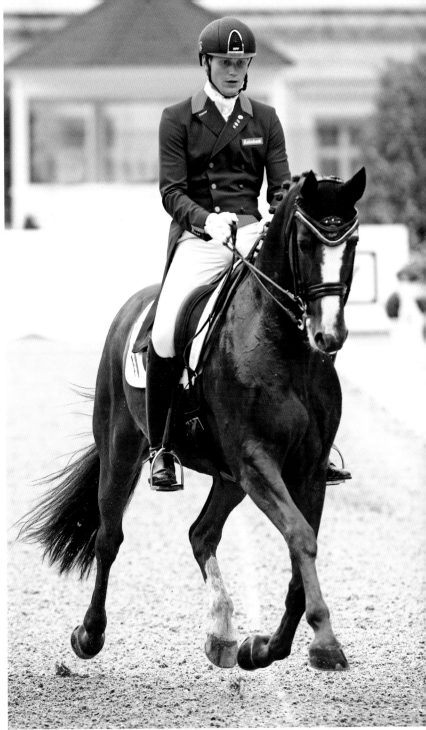

**ABOVE AND OPPOSITE** The intense concentration can clearly been seen on the faces of these dressage horses as they strain every sinew to produce their best performance for their human partners.

**ABOVE RIGHT** Diederik van Silfhout of The Netherlands and Vorst D – a Dutch Warmblood – leave the ground completely during an expressive and uphill trot.

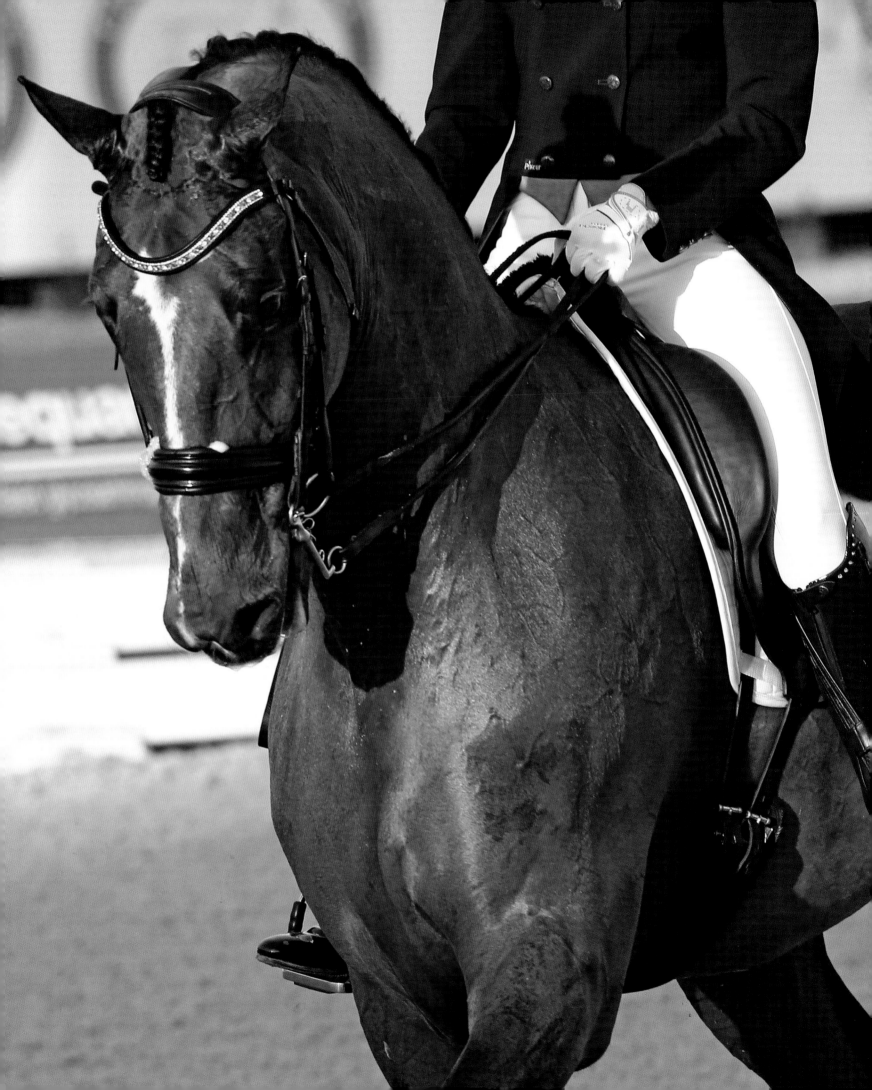

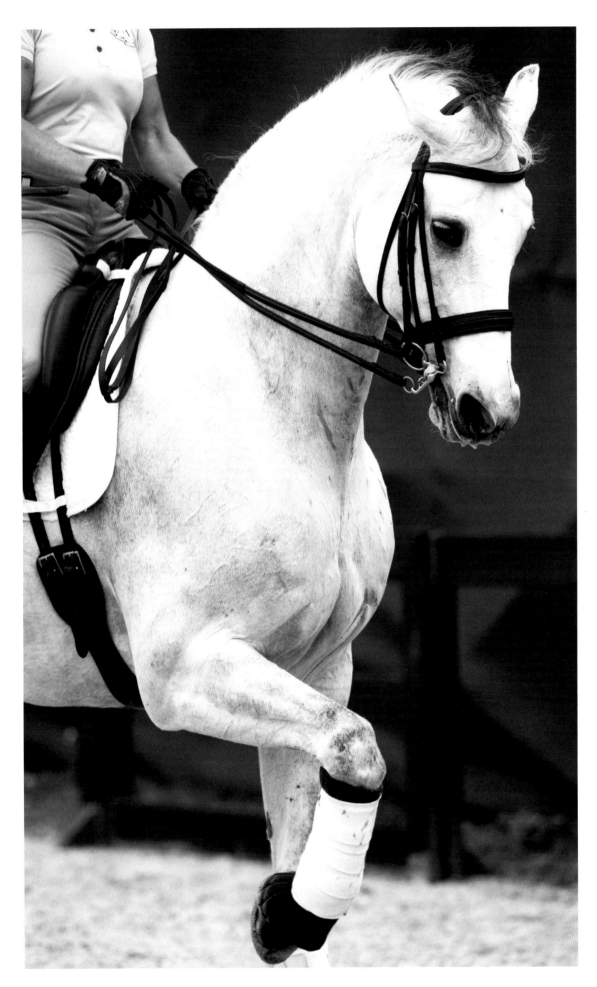

**LEFT** Working with precision, this horse is in self-carriage, concentrating carefully on the aids being given by the rider.

**OPPOSITE** Pierre Volla and Sir Piko, a warmblood breed from Germany called Mecklenburger, were part of the winning French dressage team at the Hickstead Nations Cup in 2017.

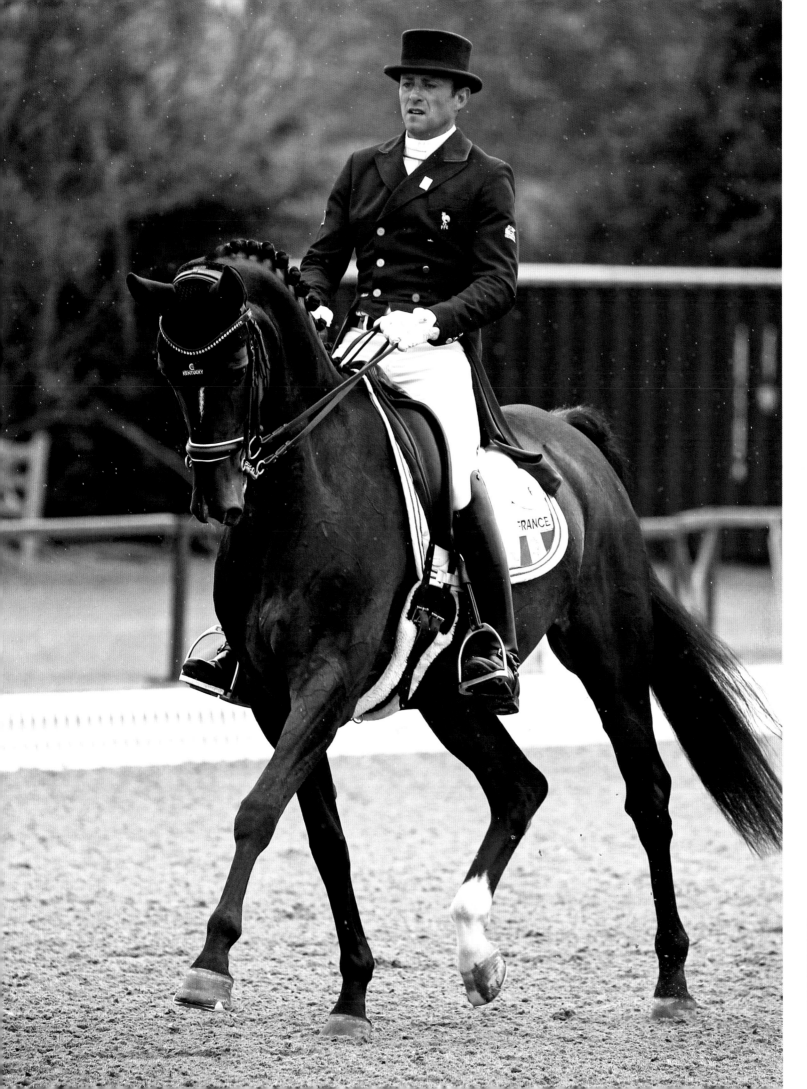

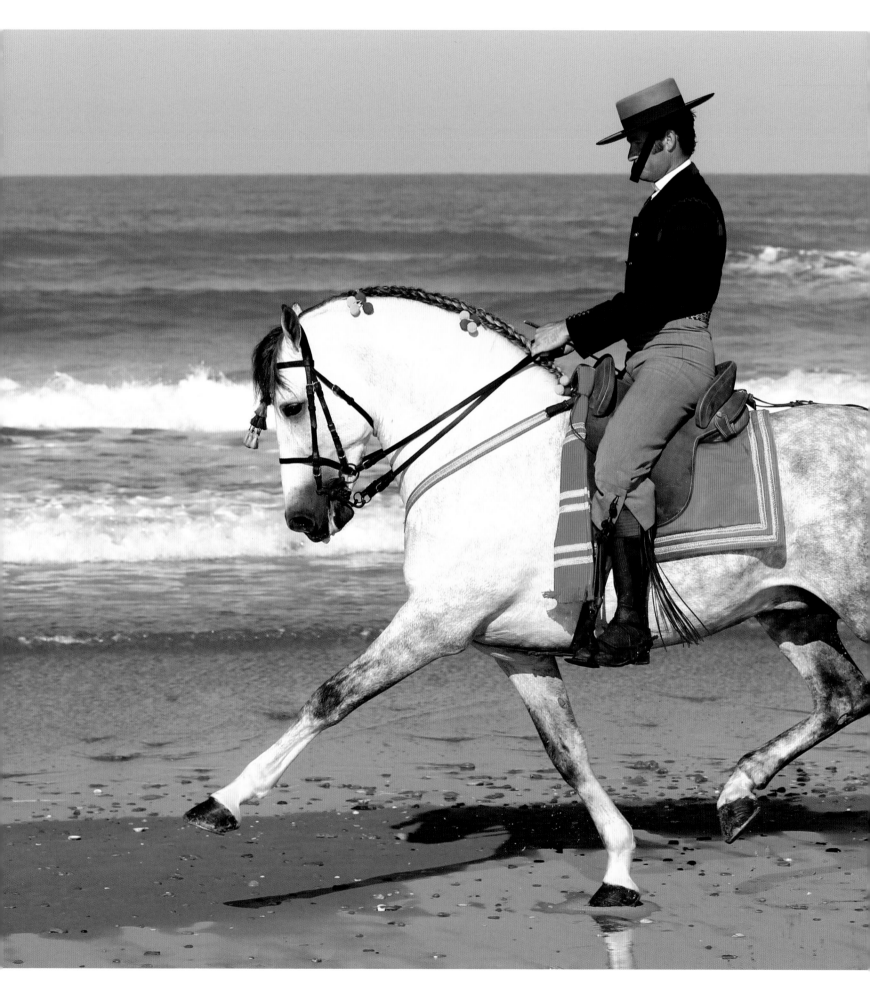

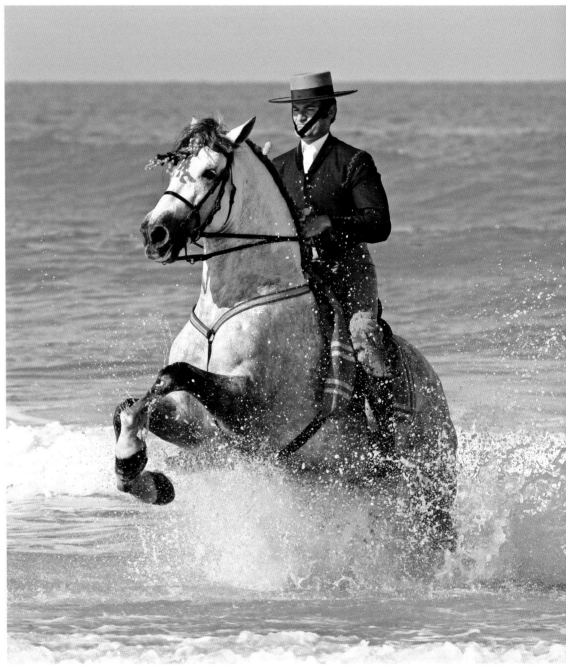

**LEFT AND ABOVE** Exercise on sand and in seawater is good for a horse as it strengthens its muscles, which helps it to perform the intricate movements required for dressage. Here, a rider in traditional costume on the Andalusian stallion Estrella CLXV from the Tomás Osborne stable performs a magnificent extended trot on a Spanish beach (*left*), demonstrating the classical riding style that is still revered today – an equal partnership of horse and rider.

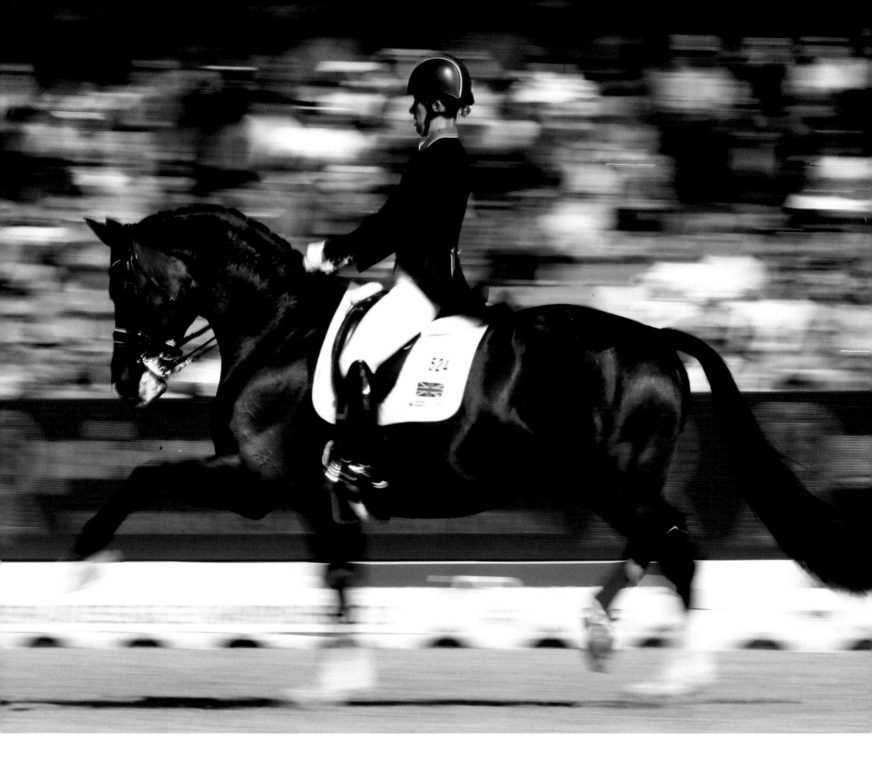

**ABOVE** Charlotte Dujardin and her acclaimed equine partner Valegro put British dressage firmly on the map at the London 2012 Olympic Games where they claimed team and individual gold medals.

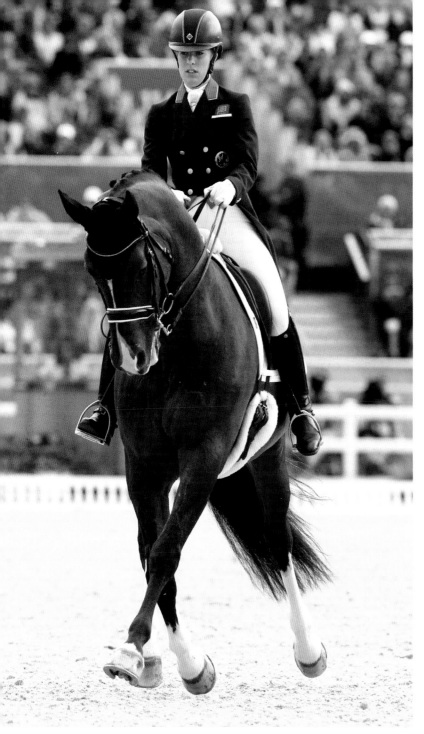

**ABOVE** The agile Valegro momentarily leaves the ground (*above*), shows off his uphill canter (*above right*) and inquisitively accepts the accolades with his proud partner (*right*).

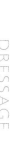

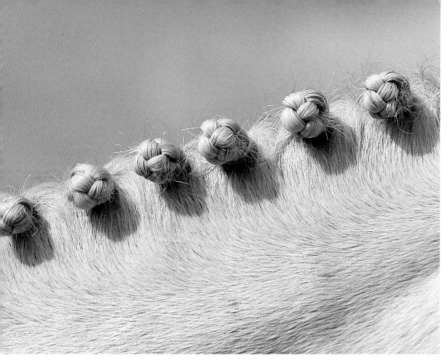

**ABOVE** The overall attractive 'picture' is considered very important in the dressage arena, so the horses are always well groomed and beautifully turned out with neatly plaited manes.

**RIGHT** The Andalusian stallion Abolengo, in Costa Rica, shows the natural agility of the horse that enables it to dance.

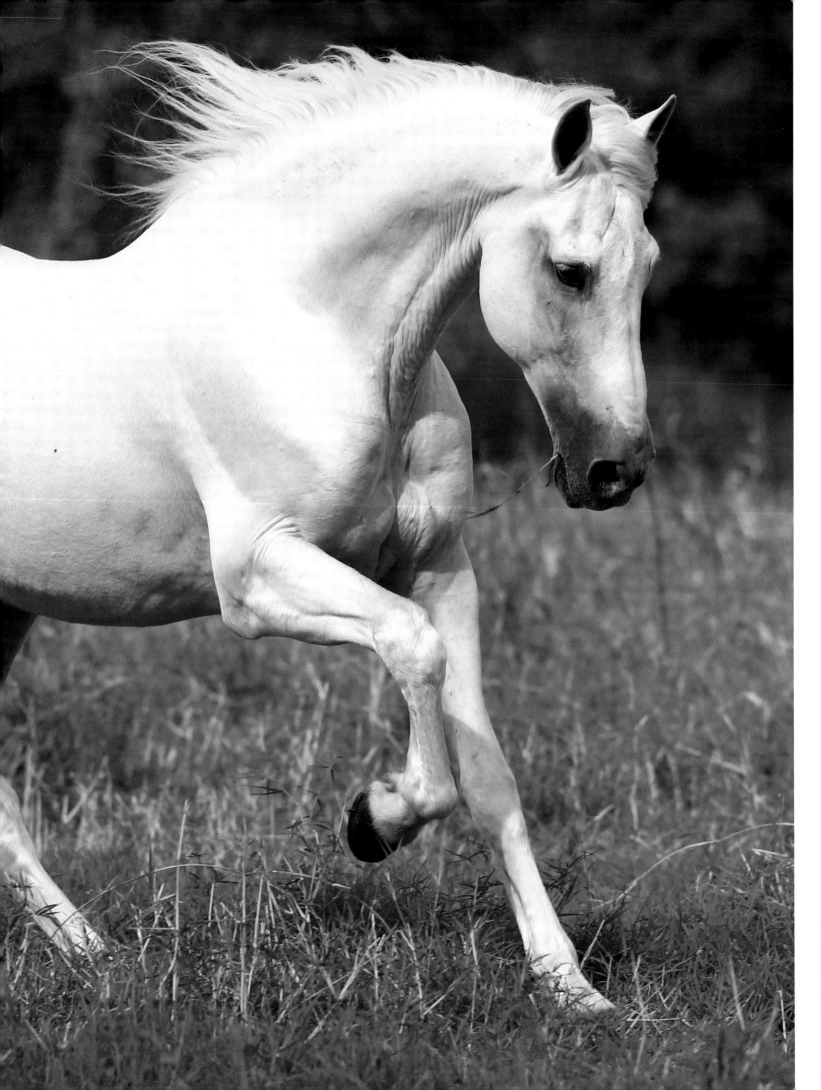

# DRIVING

If you are under the impression that driving a horse – or horses – is a considerably more sedate sport than riding, just try it! Sitting in a cart behind a cantering, or even trotting, horse feels very fast indeed. Now imagine tackling it at a gallop, with four horses to control and with aptly named 'hazards' to negotiate.

Driving trials can involve a single pony or horse, a pair, a tandem – one in front of the other – or a four-in-hand, two pairs one in front of the other. A single is challenging enough, four of them is hair-raising. It involves a huge amount of mutual trust: for the driver to guide the horses safely through the obstacles and for the horses to do his bidding.

It wasn't so long ago that horses were the only mode of transport, and the nobility loved to display their wealth by using handsome matching fours to pull their smart carriages. The royal courts of Europe opened stud farms purely to breed these striking status symbols. The Dutch Gelderlander, for example, was bred to be a stylish carriage horse, but today it is driven with aplomb through those challenging obstacles where a horse's agility and speed of reaction are put to the ultimate test.

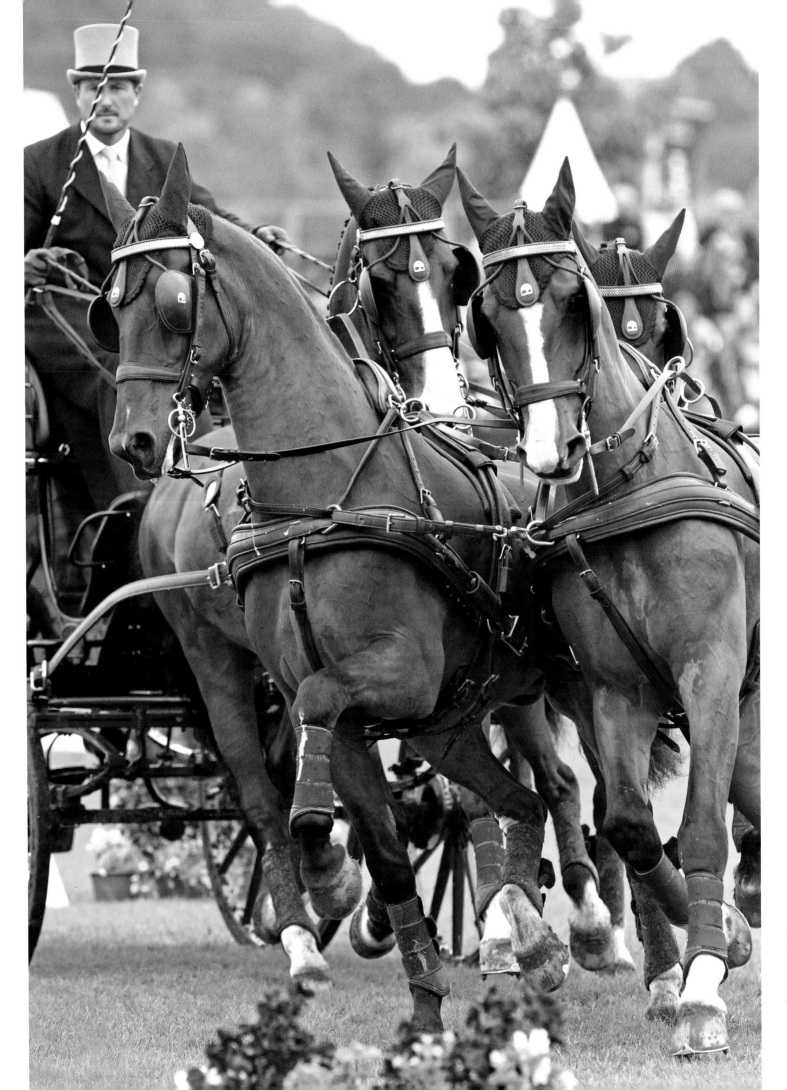

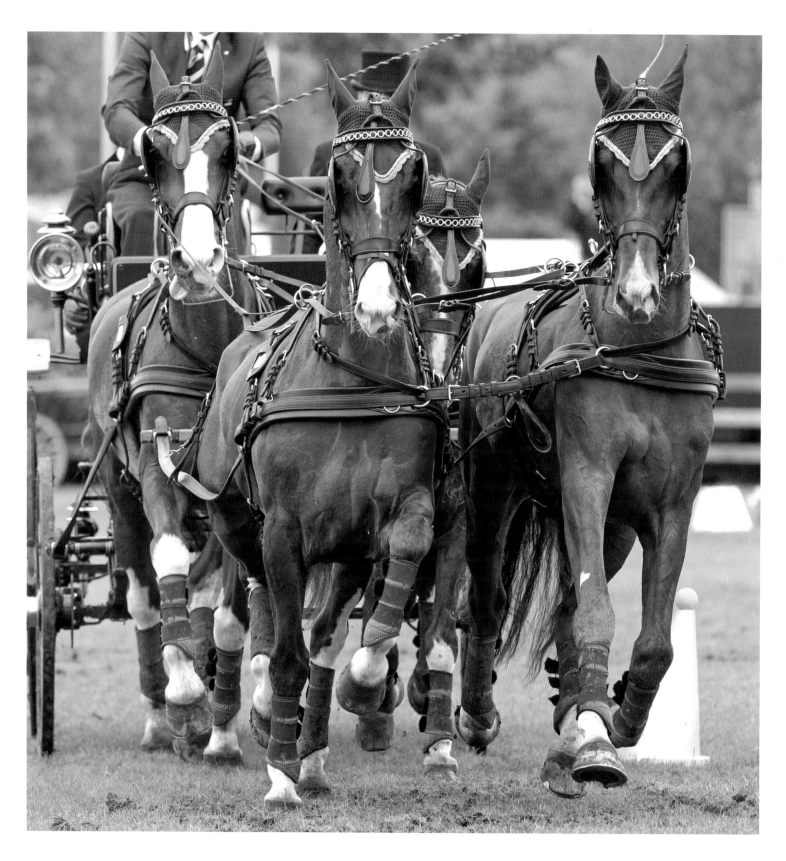

**ABOVE** Showing the high level of training and teamwork that goes into carriage driving, these two front horses, known as the 'leaders' and which are generally more experienced, work as a team with the pair behind them that are known as the 'wheelers'.

**OPPOSITE** In driving trials, the horses face challenging obstacles, usually including at least one water hazard. It is a measure of the trust that they have in their driver that they are willing to go forward at speed into unknown territory.

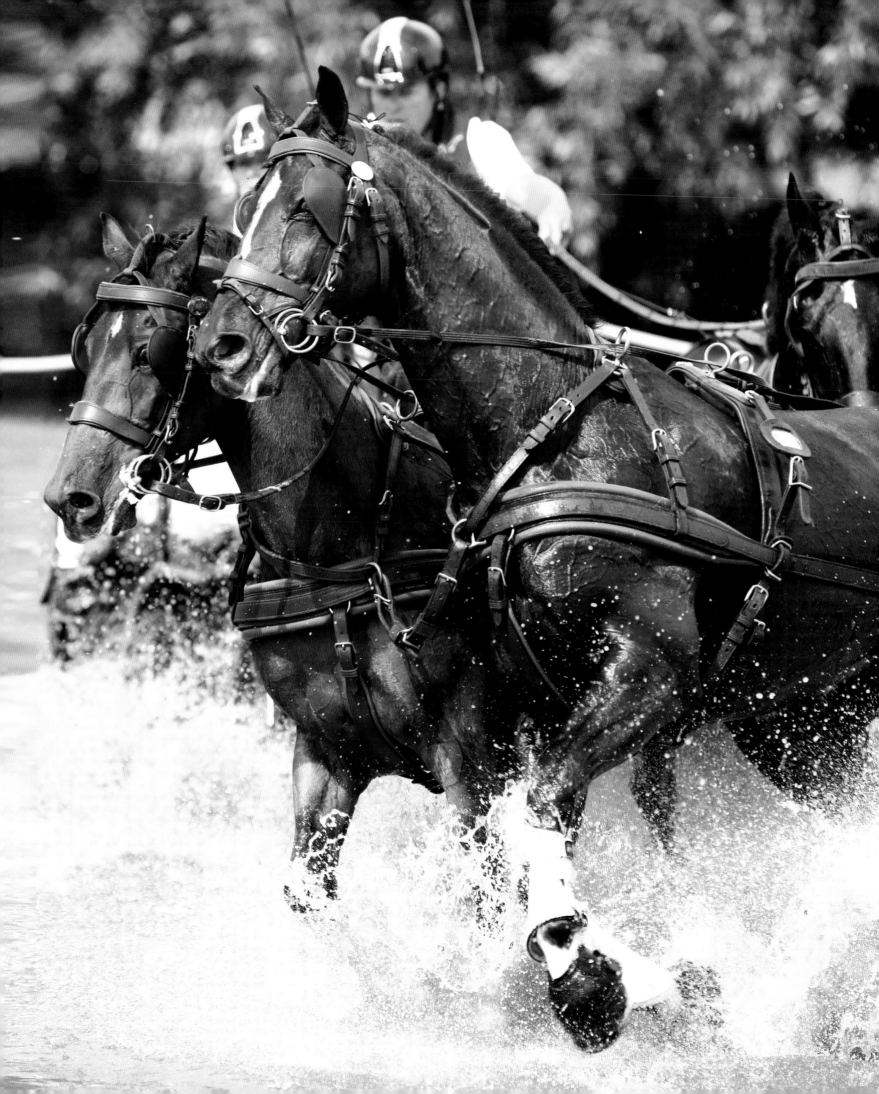

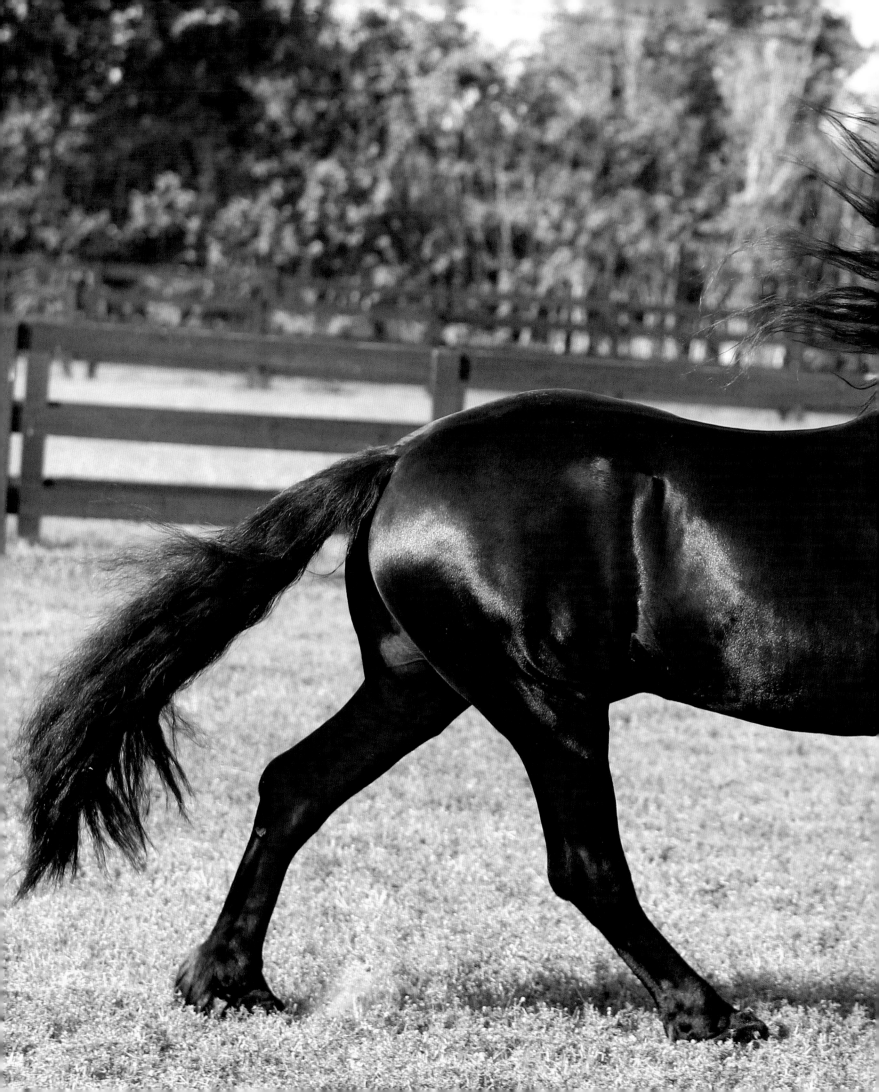

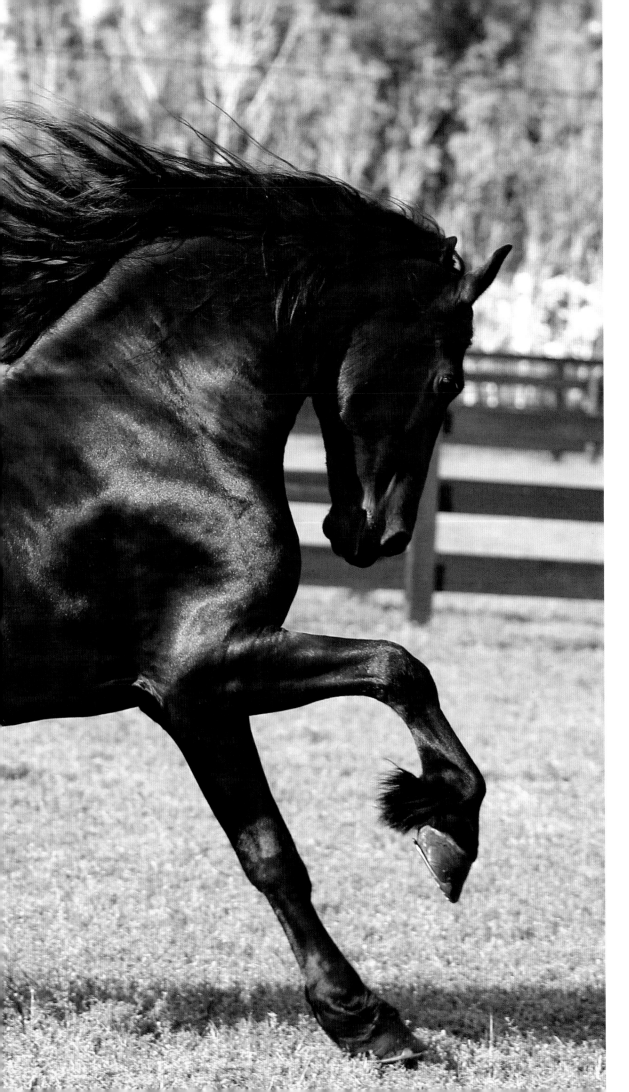

**LEFT** The handsome Friesian is one of the most beautiful carriage breeds. Originally bred as a warhorse, the lighter modern version was developed to pull a carriage – to which its striking good looks and extravagant movement is ideally suited.

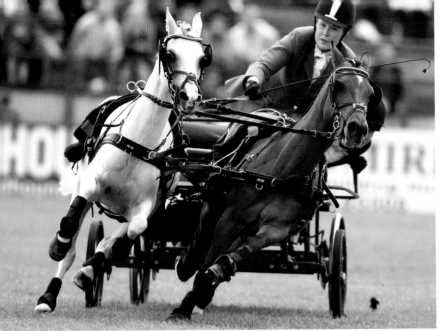

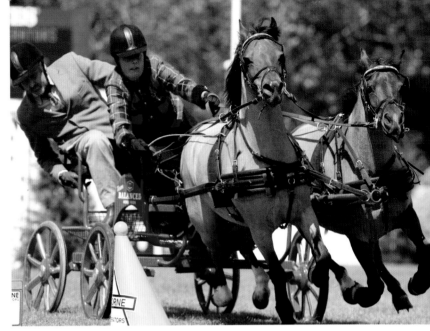

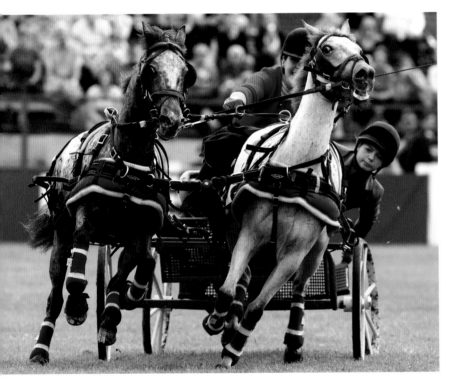

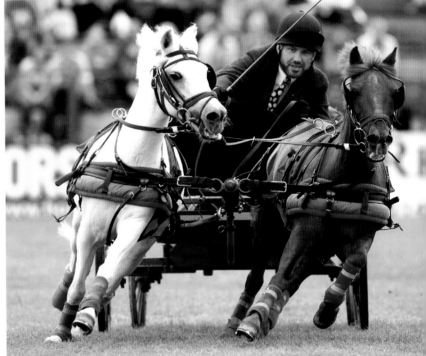

**ABOVE** These fast, agile little ponies are taking part in a scurry, which demands accuracy as they have to complete a course at speed without dislodging the balls balanced on top of the cones.

**OPPOSITE** Carriage horses are usually driven in blinkers so that they can concentrate fully on what is ahead, rather than being spooked by spectators or other distractions on the course.

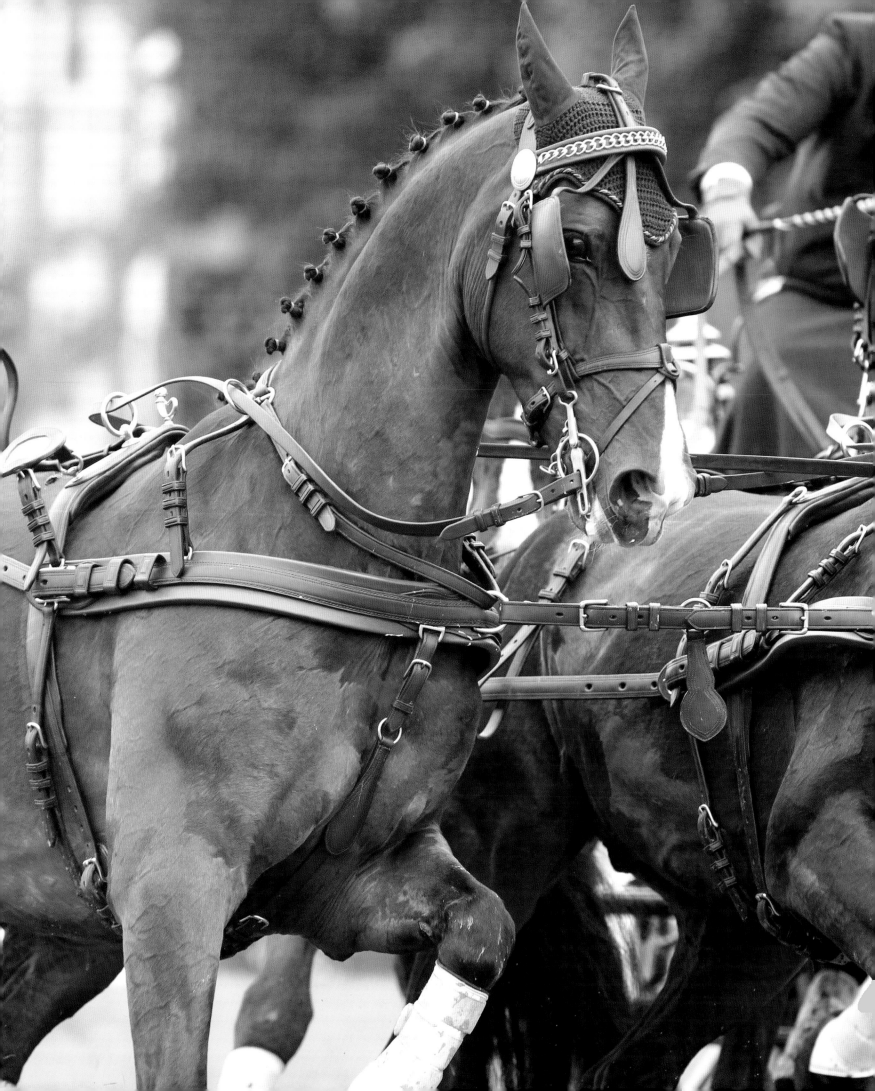

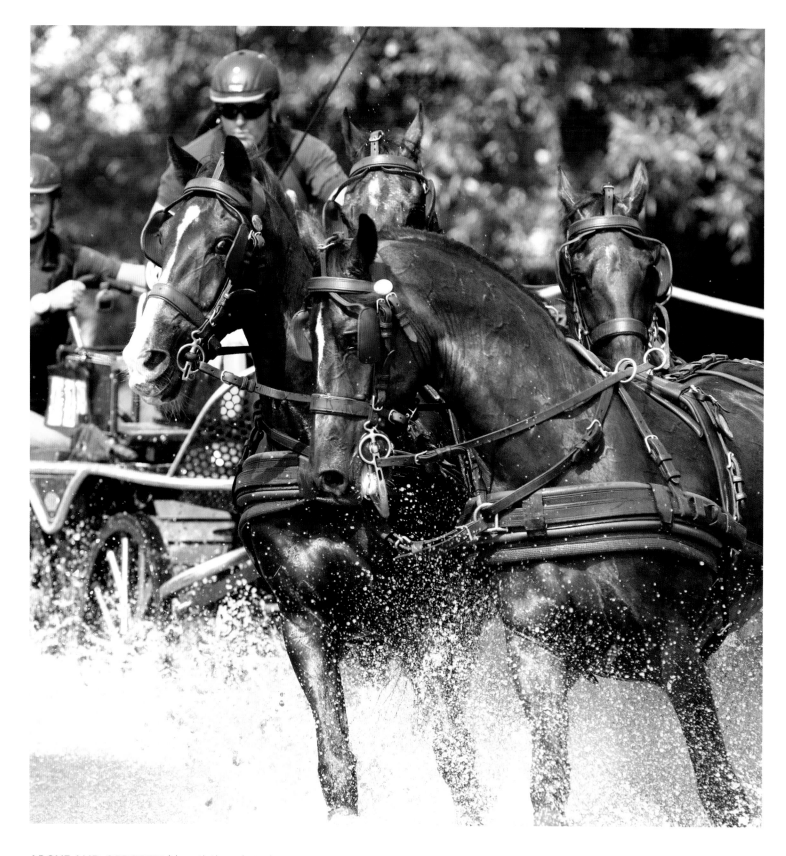

**ABOVE AND OPPOSITE** Negotiating obstacles at speed takes considerable skill from the driver and agility from the horses, which often have to perform right-angled turns in tight hazards.

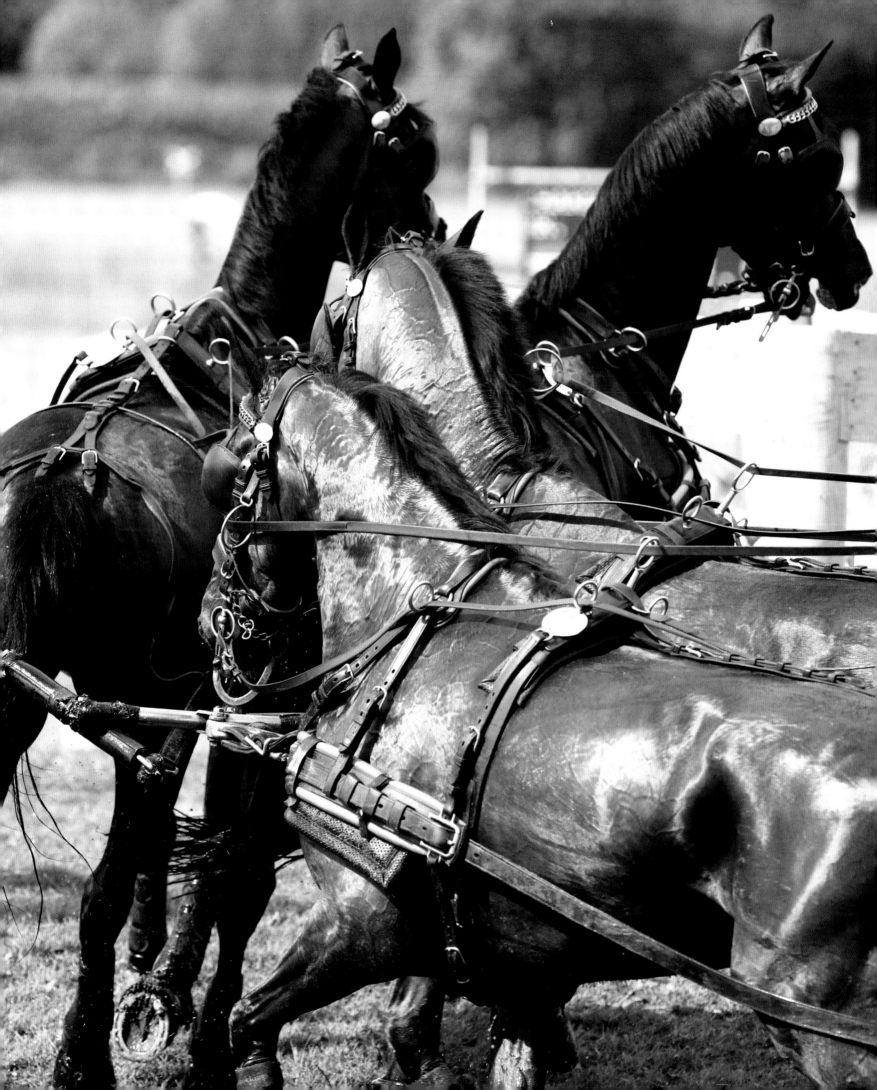

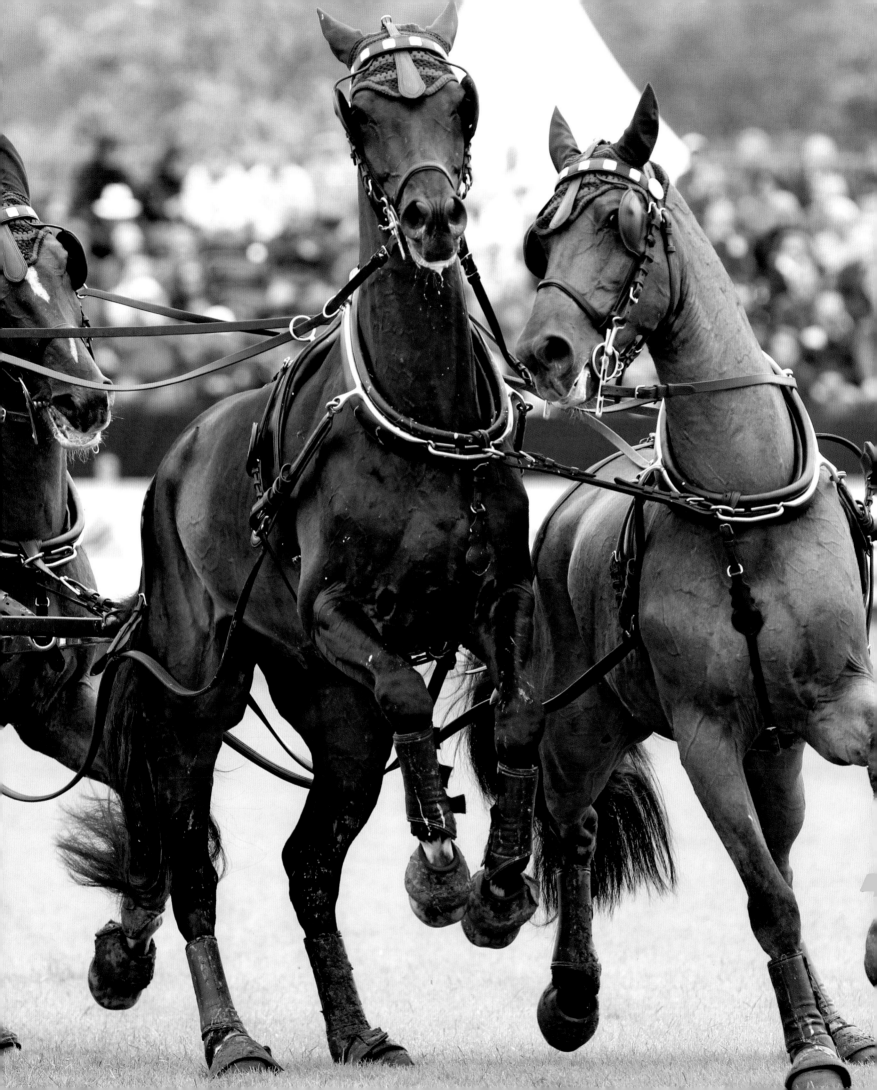

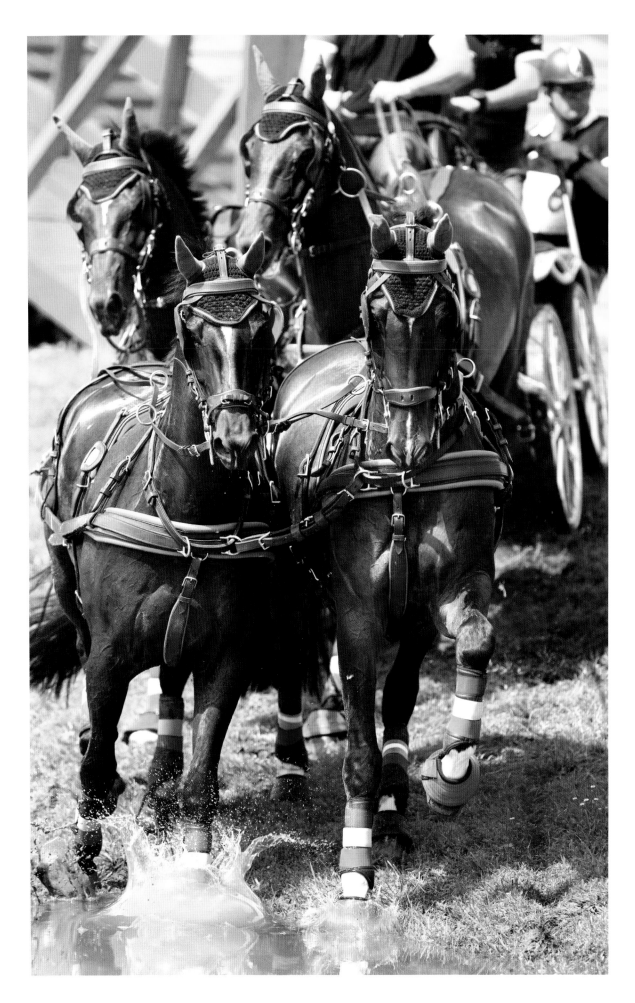

**LEFT** Lakes, ponds, bridges and ramps feature in most of the top driving trials.

**OPPOSITE** The two front horses in a team of four are rightly called leaders because the driver must be able to trust this pair to forge ahead and confidently lead the back two in the team.

# WESTERN SPORTS

You can imagine the boredom: long days riding the vast ranges, longer nights spent waiting for the dawn. The cowboys who herded cattle across the sprawling American West had to find some way to pass the time and it is easy to picture them boasting to one another about the prowess of their horses.

Those cowboys were highly skilled horsemen. They had to be multi-talented: able to ride, shoot, lasso, wrangle, round up, herd, cross rivers, 'turn' or head off stampedes by the huge herds, scout, keep watch for and drive off rustlers – all at the same time. This is probably how reining – the art of Western riding – began. These were competitions between cowboys to show how skilful their horses were, demonstrating the manoeuvres used in the 'day job'.

Those horses were developed from the small and agile Spanish animals brought to the Americas by the conquistadors – there were no horses in either American continent before that time. What they needed above all was 'cow sense', an innate ability to read and react to cattle almost before their rider could do so. The Quarter Horse was supreme at this, but others – including the American Paint, Appaloosa and beguilingly named Florida Cracker – also made great 'cow ponies'. Their speed of foot and swiftness of turn allow them to become the supreme competitors that we marvel at today.

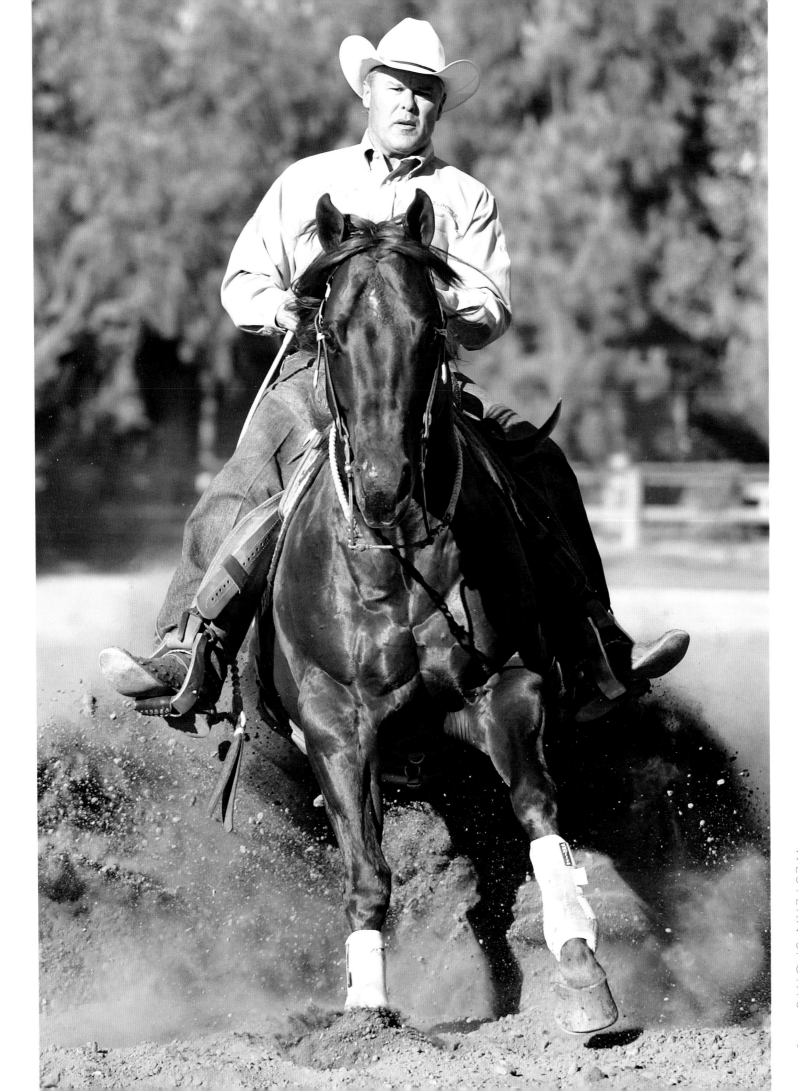

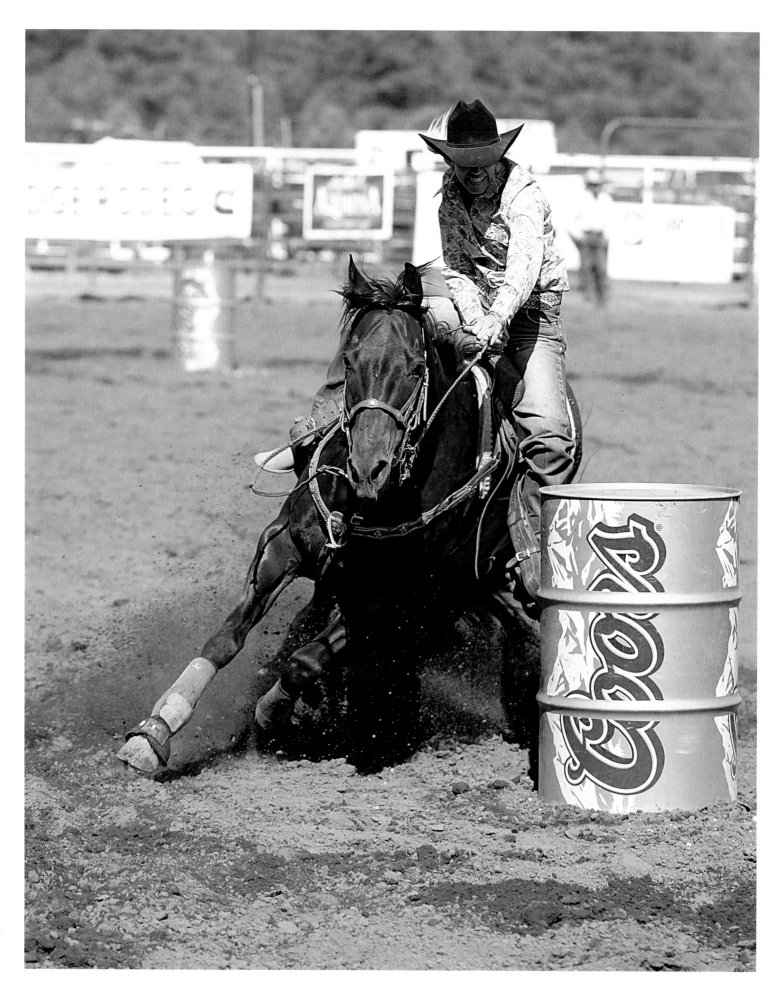

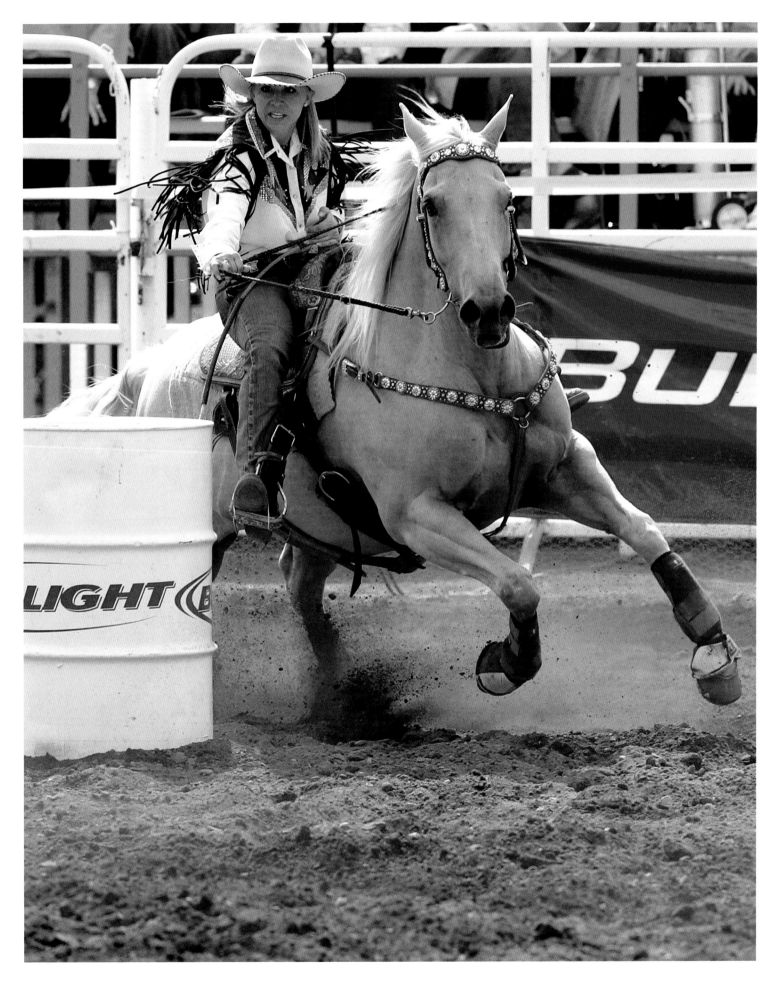

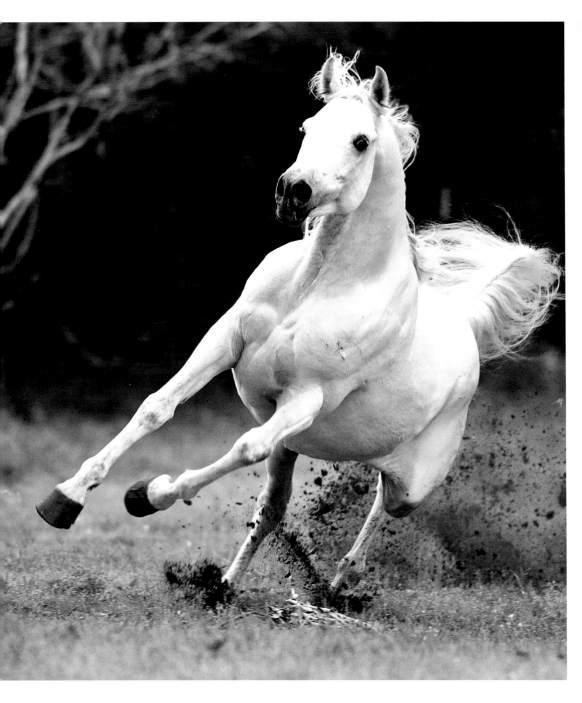

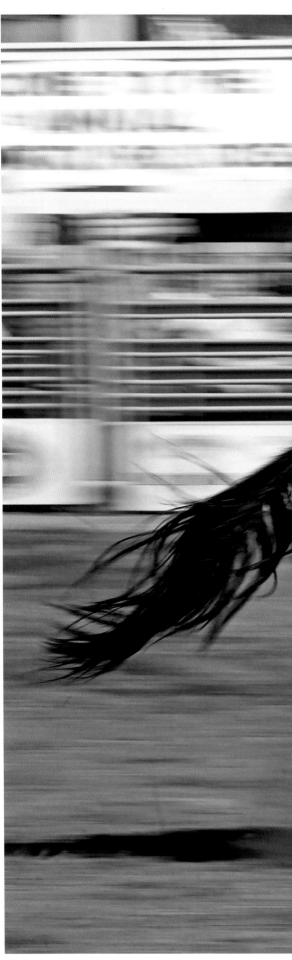

**ABOVE** This expressive Arab shows how movements seen in Western sports, such as reining and barrel racing, make the most of the horse's natural agility and responsiveness.

**RIGHT** Western riding is a fast and exciting spectacle and a great display of the implicit trust and close communication that horse and rider share.

**PAGES 66 AND 67** Barrel racing competitors at the annual Flagstaff Rodeo, Arizona (*left*), and the Sisters Rodeo, Oregon (*right*), skilfully guide their agile horses around the course with precision and at great speed.

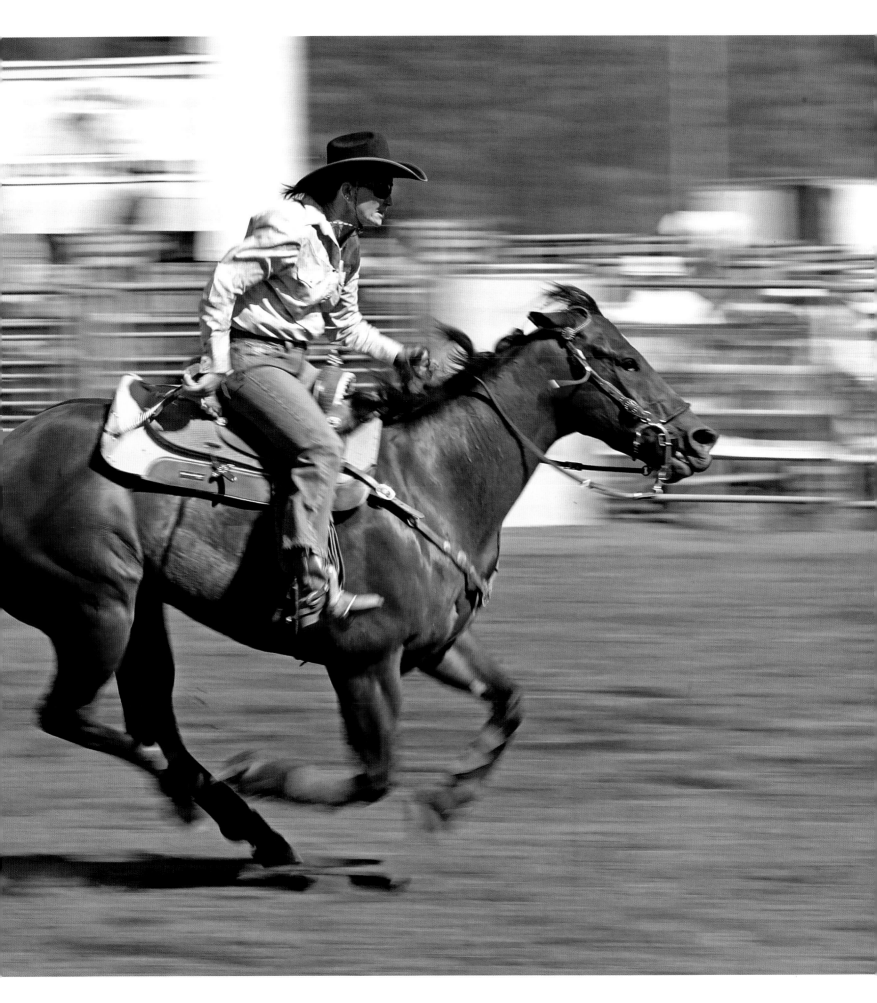

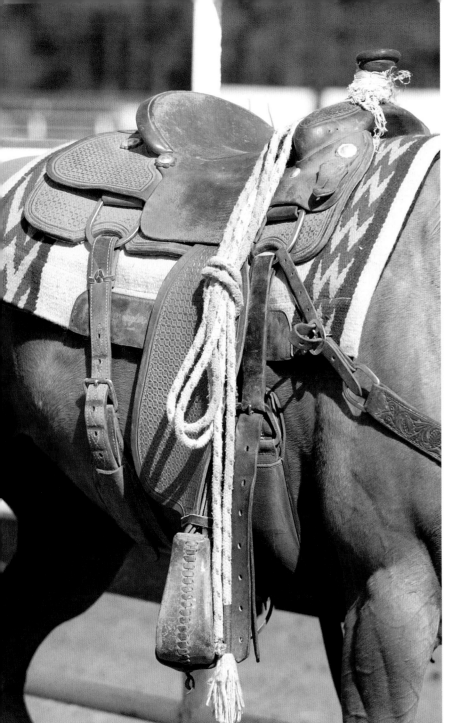

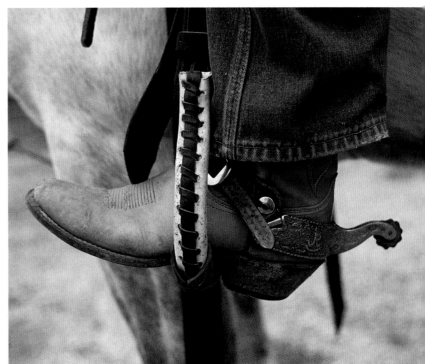

**ABOVE** The Western saddle has a deeper seat than an English one, which means the rider feels more secure. The lasso, seen here looped over the horn above the pommel, is a recognized part of cowboy equipment and the rowel spurs hark back to traditional rodeo riding.

**ABOVE** World Champion rider and trainer, Bob Avila, demonstrates the art of the sliding stop, in which the horse 'sits' back on its hocks – a signature manoeuvre in Western reining competitions where the responsiveness of the horse is highly prized.

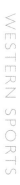

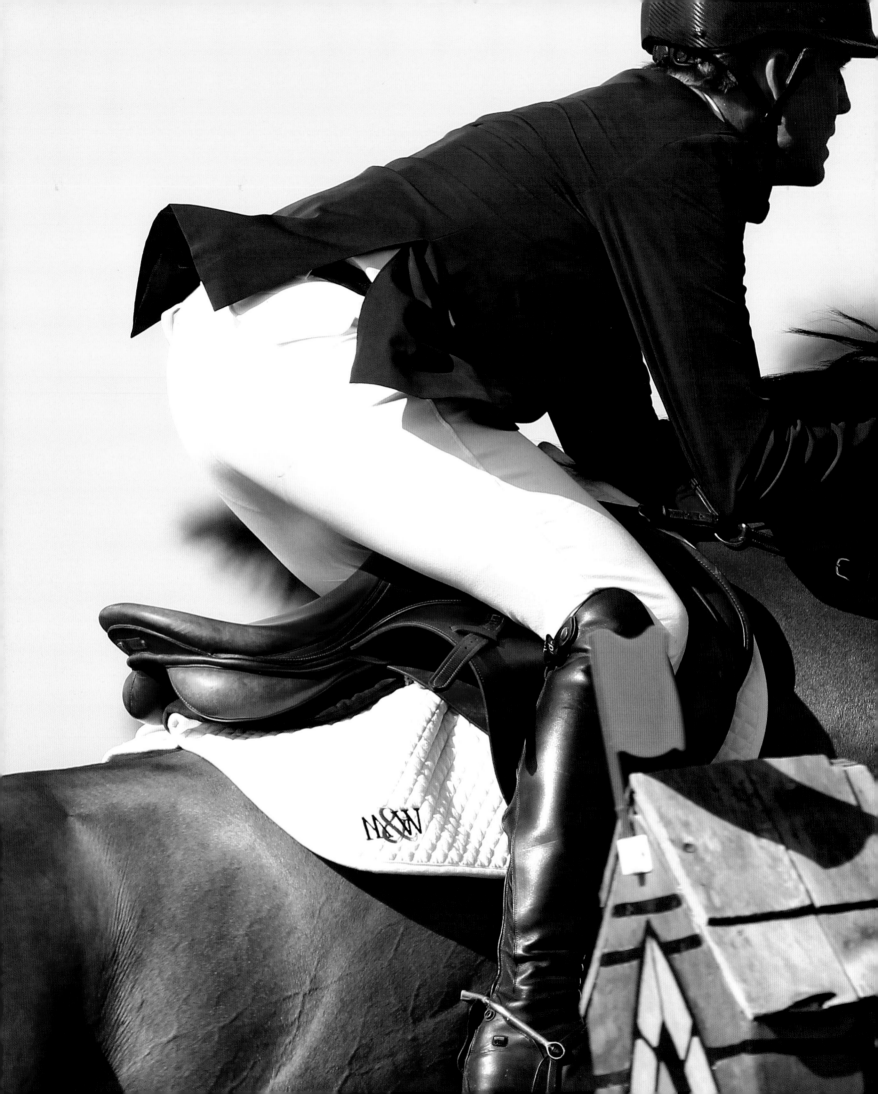

ATHLETICISM

# ENERGY AND IMPULSION

In 1978 a twenty-one-year-old showjumper called Nick Skelton set a British record for the highest jump in an indoor arena. At Olympia in London he and his horse, Lastic, cleared 2.32m (7ft 7 5/16 in) – a record that still stands.

It took Nick three attempts to clear the sloping rails and brush fence. After the first attempt he was not sure he wanted to go on. 'It was quite scary as the high jump was wider and I think more difficult and daunting than the [puissance] wall and he was not a big horse,' he said. 'After Lastic smashed through it the first time I was ready to leave the arena, but I was told to go back in. In those days I did as I was told.'

One of the most popular and entertaining showjumping classes is the puissance, in which riders have to clear the notorious 'big red wall', which requires supreme athleticism from the horse and a nerves of steel from the rider. The leading professional showjumpers even keep a particular horse – and it takes a certain kind of horse – specifically for the puissance.

Remarkably, Nick and Lastic do not hold the world record for jumping the puissance wall. This is held by Germany's Franke Sloothaak, who cleared 2.40m (7ft 10½in) at Chaudfontaine in Belgium in June 1991 on Optiebeurs Golo. At the time, he was smashing his own record of 2.35m (7ft 8½in) that he set with his horse Leonardo two years previously.

Both Franke and Nick – who went on to be one of Britain's most successful riders, winning an historic individual gold at the 2016 Olympic Games in Rio, having taken team gold four years earlier in London – were at the top of their game when they set their respective records. And the puissance remains a massive test of the bond between horse and rider, as are all showjumping competitions, which require supreme athleticism from both.

The sport of showjumping has its roots in the British Inclosures Acts of the eighteenth century. Before the Acts, extraordinary as may seem to us now, there were few fences in the British countryside. Farming was based on open fields, in which individual yeomen or tenant farmers cultivated scattered strips of land and any enclosure of land was made through informal agreement. During the seventeenth century however, the practice developed

**OPPOSITE** Brazil's Eduardo Menezez on Balou's Captain, making a lovely shape over a fence at West Palm Beach in 2018.

of obtaining authorization for enclosures by an Act of Parliament. Initiatives to enclose came either from landowners hoping to maximize rental from their estates, or from tenant farmers anxious to improve their farms.

From then on, in order to cross land behind huntsman and hounds, hunt followers had to jump obstacles and the 'hunting seat' – where the riders would lean back and pull the reins while jumping a fence – was developed, as it was believed that it relieved pressure on the horse's front end as it landed.

The first recorded showjumping competition was held in Paris in 1866. Horses and riders paraded in front of an audience, then went to jump a series of obstacles across country out of view of the spectators. Later, jumping events were moved to indoor arenas, where the audience could see the action. The first international showjumping competition – though then it was called 'leaping' – was held in 1902. Ten years later it was added to Olympic programme.

Observing that the hunting seat prevented the horse from rounding its body over the jump and caused it a lot of discomfort on landing, Federico Caprilli, an Italian cavalry officer, developed the 'forward seat', with the rider leaning forward as the horse jumps, with little pressure on the reins. The technique proved to be kinder to horses which in turn became more willing and easier to train. The revolutionary style quickly spread worldwide and Captain Caprilli, dubbed 'the Flying Knight', is widely regarded as the 'father of modern riding'. An engraving on his tombstone reads simply 'Master of horseman'.

The technique was widely adopted and the sport of showjumping grew from then on. Over the next few decades it was dominated by military horsemen who competed in teams, but as the army became increasingly mechanized, civilians became more prevalent. The sport wasn't without its hiccups, however. In 1932 at the Los Angeles Olympics, the course was so difficult that no team completed it, so no medals were awarded in the team event.

The decline of the military teams also paved the way for women, who first competed in the Olympic Games in Stockholm in 1956. Equestrianism remains the only Olympic sport in which men and women compete at the same level in the same competition.

As the sport has evolved, so have the horses. No doubt the earlier showjumpers were substantial cavalry horses or hunters as few people then kept animals purely for leisure. They would have had the necessary scope – the ability, courage and, crucially, desire to jump considerable heights and distances – as well as speed, though perhaps not be as athletic as today's great jumpers. Just as the cavalryman needs a bond with his horse, so does the showjumping rider. It requires absolute trust and absolute commitment on both sides.

The top showjumping horses today are specialists, but when the sport was still in its infancy all and any type would do. One of the most unlikely jumpers was a little Chilean horse called Huaso. He had been seen to clear a 2m (6ft 6in) wall and was trained by Chilean Captain Alberto Larraguibel

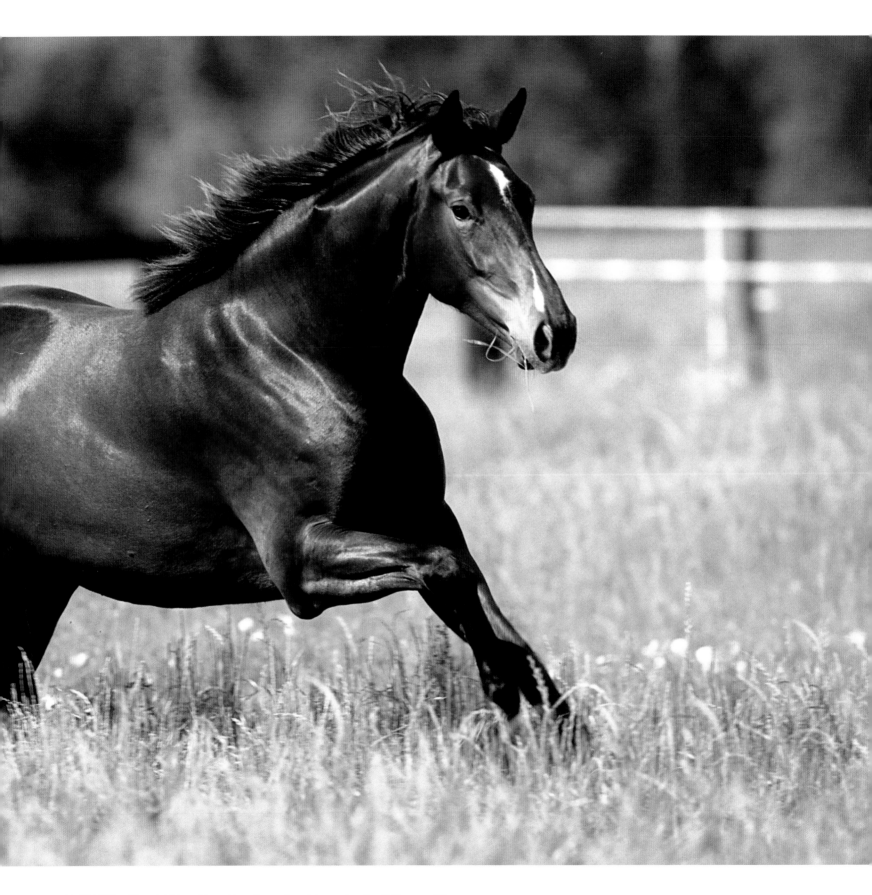

**ABOVE** The Dutch Warmblood has been bred to embody all the qualities desired in a modern sports horse. In competitive equestrian disciplines the natural attributes of the horse – its athleticism, strength, agility and courage – combine perfectly with its willingness to please us.

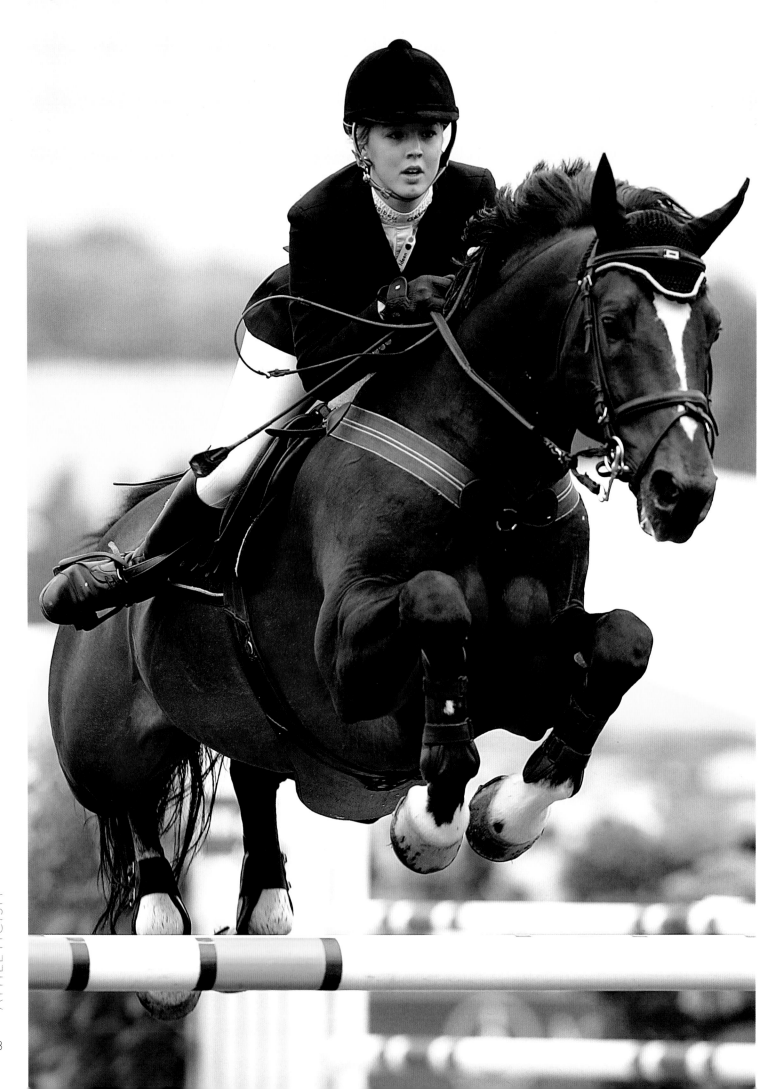

Morales to high jump. In 1949 the pair attempted an obstacle that stood at 2.47m (more than 8ft 1in) tall. On their first attempt, Huaso was on the wrong stride and refused, on the second he rubbed the top rail, but on the third he soared over it and into showjumping history. Huaso's world record still stands today.

In the 1960s a horse called Snowman gained celebrity status in the United States. He had been a simple plough horse and was on his way to the slaughterhouse at the age of eight, when he was spotted in 1956 at an auction by a rider called Harry de Leyer who paid eighty dollars for him – the equivalent of around 700 dollars today. De Leyer, who was Dutch but moved to the States after World War II, taught at a private girls' school and was looking for a substantial but quiet horse to carry heavier riders.

Following a short time as a riding school horse, Snowman was sold to a local man who wanted a quiet mount for trail riding, but one day de Layer got a surprise. 'Clip, clop, clip, clop, he [Snowman] come right in and stood there in my ring where I taught him. I called the owner to come pick him up. He told me that he jumped the fence. I told him to raise it.'

It soon became apparent that it didn't matter how high the fence was raised, Snowman could jump out. Not long after, Snowman arrived in de Leyer's ring dragging a log and a three-foot halter. De Leyer promptly bought him back – and vowed never to sell Snowman again, no matter how big the offer. Capable of clearing 2.18m (7ft 2in), Snowman was the first horse to become Horse of the Year in the Professional Horsemen's Association and in the American Horse Shows Association in 1958 and 1959. After a long retirement, Snowman died in 1974 at the age of twenty-six. It is a lovely story of second chances and an illustration of what some people believe – we don't choose our horses; they choose us.

During the golden years of showjumping, many horses became national and even international heroes. One of the most famous is a British horse called Foxhunter who was bought by Colonel Harry Llewellyn as a six-year-old novice. Astonishingly, just one year later, the pair took the bronze medal at the 1948 London Olympics. Four years on, in Helsinki, Finland, they won team gold – the only gold medal for Great Britain at those Games. During their career, Col Llewellyn and Foxhunter won an astonishing seventy-eight international competitions.

Another British team star with a huge following was not even a horse; Stroller, at 14.2hh (147.3cm), was technically a pony. He was ridden by Marion Coakes, who at the age of sixteen won junior European team gold with him in 1963. When she moved into the senior ranks, such was their bond that she refused to part with the pony and competed him internationally against much bigger horses. Her faith was repaid. In 1965 Marion was showjumping's Ladies' World Champion, and in 1968 at the Mexico Olympics they claimed individual silver. Marion was the first female equestrian to win individual silver at an Olympics and Stroller was the first – and only – pony to compete in the Games.

More recently, the sport has feted horses such as Milton – the first showjumper to win more than £1 million – and Ryan's Son (both ridden

**OPPOSITE** The Holsteiner stallion Locarno must trust his rider Ellen Whitaker implicitly. When a horse soars athletically over the coloured poles, it is effectively jumping blind because it cannot clearly see the jump at the point of take-off.

by John Whitaker); Touch of Class, who won two gold medals at the 1984 Los Angeles Olympics with Joe Fargis; Big Ben, a Canadian national hero ridden by Ian Millar; and later Gem Twist, who took team and individual silver for North America at the 1988 Seoul Olympics with Greg Best. Gem Twist also gained the 'world's best horse' title at the 1990 World Equestrian Games in Stockholm. That is not all he is famous for, however: in 2008 a clone of this gelding – who died the same year – was created, the first from a showjumper.

These great horses – and there are, of course, many more – were not just superb athletes. That alone is not enough for success in showjumping; the horse must also possess that all-important scope, as well as stamina, heart, agility and courage. This last is vital – because when a horse jumps a fence, it is essentially jumping blind. As a prey animal the horse has its eyes on the side of its face to allow a wide field of view; we humans, being predators, have eyes in the centre of our face. This means the horse has a much wider peripheral vision than we do. In terms of sight, perfect vision in humans is measured as 20/20; the horse's is between 20/30 to 20/40. The fraction 20/20 means that a human can see an object clearly that is twenty feet away. The horse's 20/30 means that it has to be twenty feet away from the object to see the same details that the person can discern from thirty feet – the higher the second number, the less acute is the vision. However, as a prey animal, the horse's night vision is better than ours.

Where the horse is significantly better off is in its panoramic field of view. With one eye a horse can see about 190° horizontally and around 178° vertically, and it has very few blind spots. This means that in the wild it is difficult for a predator to ambush a horse; its field of view around its body is virtually a 350° arc. It also has 'binocular' vision directly ahead of between 55 to 65°; for comparison, we have 120° binocular vision. This figure applies if the horse is carrying its head normally; if a ridden horse is forced to carry its head so its face is vertical, its binocular vision is directed down the nose and it is confined to looking at the ground.

Horses are also able to see close up and can focus on objects as near as 25cm (10in). And they are not colour blind, as some people believe. They have fewer 'cones', or light receptors, in their eyes than we do; two compared with our three. In scientific terms, horses are dichromatic; we are trichromatic. Studies suggest that they can see the difference between blue and grey, between yellow and grey and between green and grey. When two colours are combined, the horse is able to see the object more clearly; this is why showjumping poles are generally painted two or more different colours.

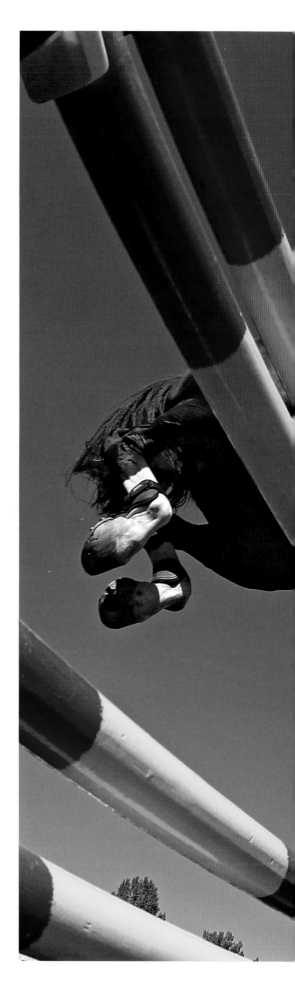

**RIGHT** At the point when it is in the air over a jump, the athletic horse stretches every sinew and brings its hind legs up underneath its body.

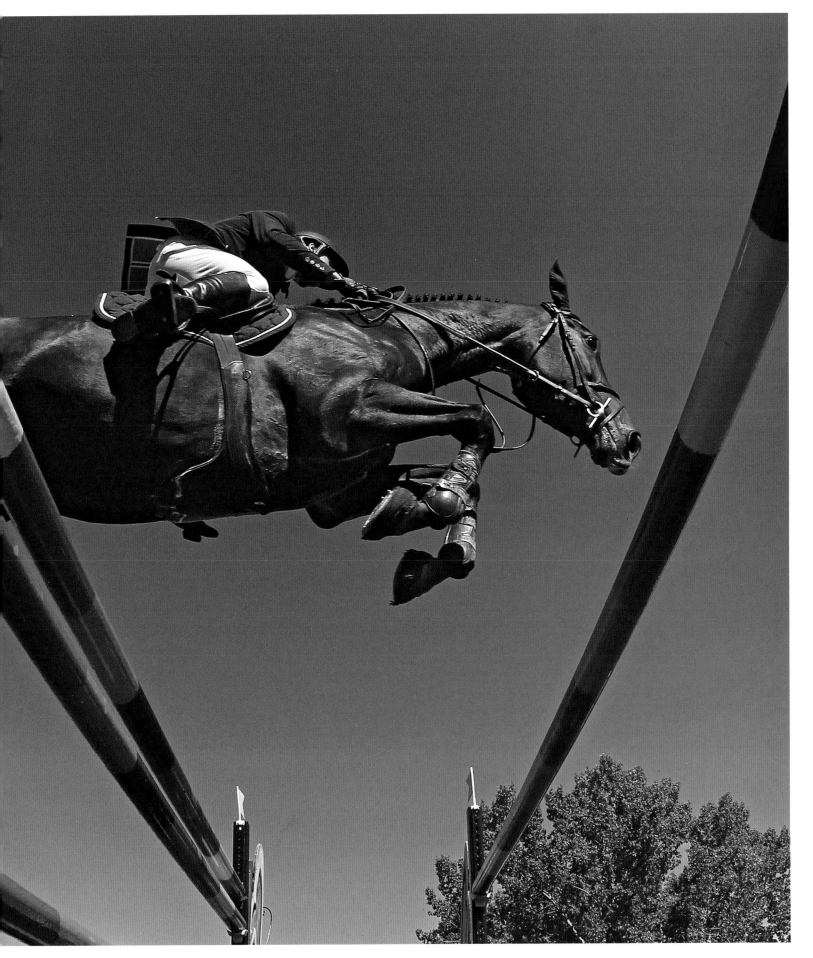

When it comes to jumping those coloured poles, the horse is literally taking a leap of faith. It can see the fence from a distance but as it approaches, the fence becomes blurred. As the horse reaches its take-off point, it cannot see the obstacle at all; it is in one of those blind spots, which is cone-shaped and extends about 1.2m (4ft) in front of its face. This is why you often see showjumping horses raise their heads as they approach a jump; they are taking another look to gauge what they need to do. Otherwise, the horse has to trust its rider to get it on the right stride and guide it safely over.

This makes the achievements of Adventure de Kannan (known as Addy) all the more impressive, as the Belgium Warmblood lost his right eye in 2013 due to an eye condition. There were fears that Addy, partner of Ireland's Trevor Breen, would be unable to resume his showjumping career but the thirteen-year-old never got the memo. He came back to international competition just months after the surgery and finished an impressive second in the immensely challenging British Jumping Derby at Hickstead in Sussex. The following year he went one better, triumphing after a nail-biting jump-off against the previous year's victors, Phillip Miller and Caritiar Z. The 'one-eyed wonder' retired at Hickstead in 2017. Addy will go into the history books as he is the only horse to win the Speed Derby, the Eventing Grand Prix, the All England Grand Prix, the Queen Elizabeth II Cup and the British Jumping Derby.

Addy trusted his rider absolutely and, for his part, Breen has acknowledged their incredible partnership. He commented on the decision to retire him: 'I probably owe a lot of my career to Addy. He was my best horse for the majority of my professional career. He won classes for me week in, week out, year in, year out. He was the horse I could pull out and go to any show in the world. He's won so much for me. I want to retire him at the top.'

The partnership between horse and rider is always a two-way street. The obstacles in the Hickstead Derby are formidable, including a 4.5m- (15ft-) high bank that the horses have to come down almost perpendicularly. The legs of a showjumper – many of them warmbloods – must withstand considerable stress, both front and back. As a horse approaches a fence, it rounds its back to bring its hindlegs underneath its body. This concentrates the impulsion, rather like coiling a spring, to give the animal maximum power at the take-off point. It shortens its stride as it gets closer, flexing its fetlocks and lowering its withers, and plants its front feet on the ground in much the way a vaulter plants his pole. This is when the horse also raises its head to get a last-minute view of the obstacle.

As the horse begins to jump, its non-leading foreleg will absorb most of the force, pushing off from the ground first. It shifts its weight backwards by raising its head, shortening the neck and lifting its shoulders. At this point the rider must be careful not to sit too far forward. As it shortens its neck, the horse prevents the forward movement of its canter on approach. The consummate athlete, it lifts and rotates its shoulders and as it rises, tucks its front legs tightly into its body while its hindlegs lift off the ground. All its hind joints will ideally be flexed equally and its pelvis will rotate due to the flexion of its sacral and iliac junction. The hindlegs reach maximum

**OPPOSITE** Ireland's Trevor Breen and Adventure de Kannan competing in the Nations Cup in Canada in 2010. The Belgian Warmblood's right eye was removed in 2013 due to an infection.

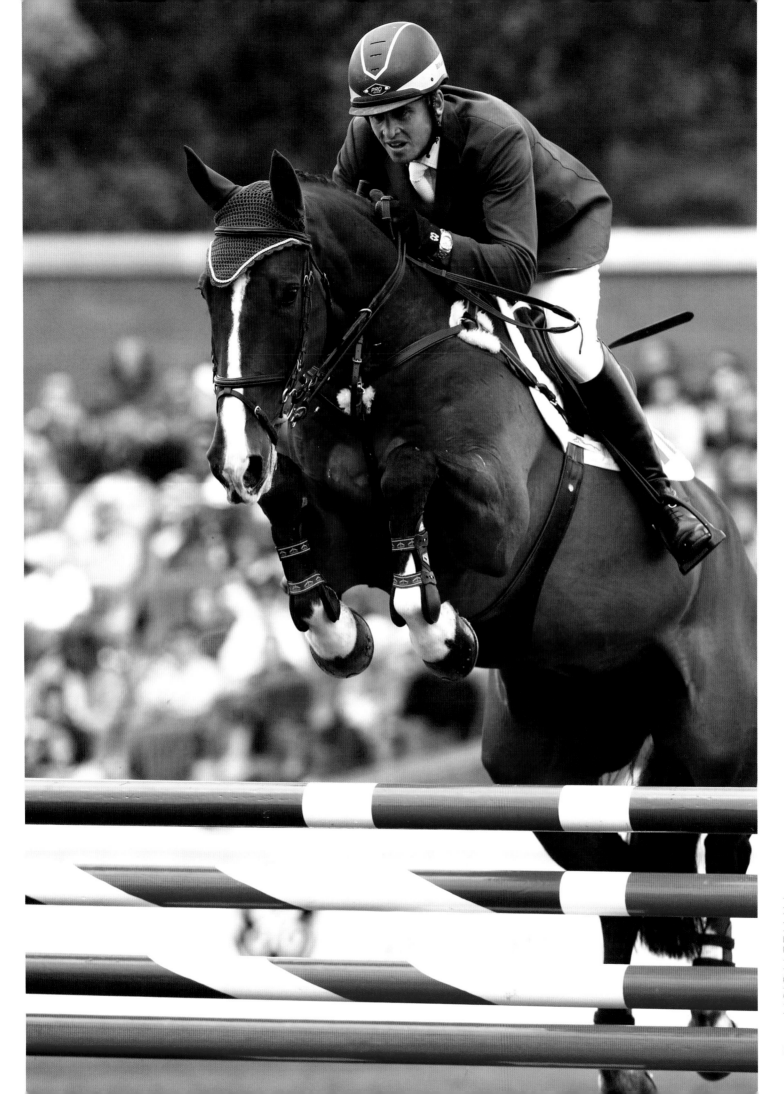

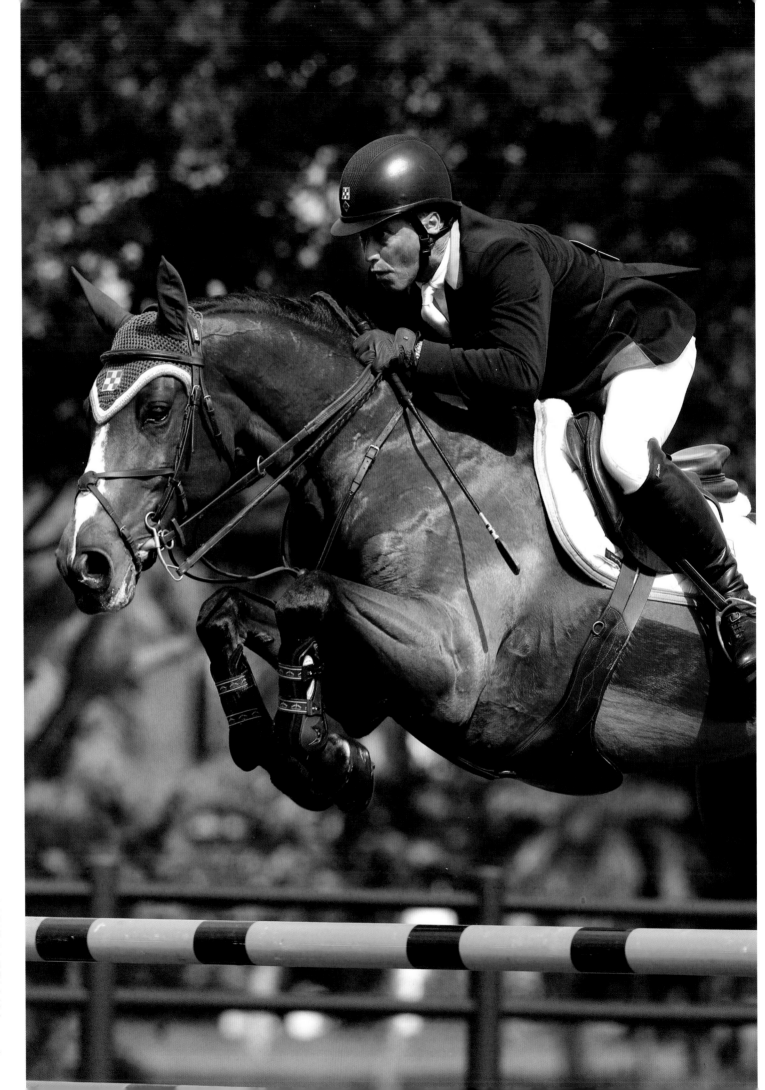

stretch after they leave the ground. The horse begins to extend its neck further forward and brings its hindlegs forward beneath its body. The top showjumpers, which are careful and brave in equal measure, will twist their pelvis to lift their hindlegs even higher – a feat of athleticism that is invaluable in the hunting field.

Most horses learn that picking up their knees – and their knees are capable of considerable flexion – means that they don't have to lift their torso so high, which conserves energy and power. As they reach forward with their forelegs to land, they lift their head and neck to slow the impulsion. The non-leading foreleg lands first, absorbing 20 per cent more force than the leading leg. As their front feet hit the ground, both forelegs push against it in an upward and backward direction. Meanwhile, the hindquarters rotate underneath the body, reaching the ground as the forehand moves forward and out of the way. The rounded shape a horse's body makes when it curves its neck and back over a jump is called the 'bascule'.

Throughout all of this, the rider is more than simply a passenger. He or she must keep their weight in the right place at all times. If they lean too far forward on take-off, they will be putting too much weight on the horse's forehand as it is trying to leave the ground. But as the horse lifts, then the rider leans forward to keep the impulsion and to streamline their own body with that of the horse. The leading riders are often said to appear to 'carry their horse' over the fence.

Once the horse is in midair, the rider has little influence and should avoid pulling on the reins or shifting their balance, though if they are jumping a very wide fence or water jump, for example, they may help slightly by leaning a little further forward. On landing, the rider's lower leg should be underneath their body, rather than behind it, so they don't get thrown forward on the horse's neck – they will be ready to gather themselves and the horse to get to the next fence.

As in dressage, many of the top showjumpers nowadays are warmbloods. Nick Skelton's gold medal-winning partner in Rio was a thirteen-year-old Dutch Warmblood called Big Star. Individual silver went to Sweden's Peder Fredricson, riding All In, a Belgian Warmblood, and Canadian Eric Lamaze, who took bronze, rode Fine Lady 5, a Hanoverian. Indeed, the Hanoverian is possibly the most impressive success story of modern breeding.

This breed takes its name from the State Stud at Celle in Lower Saxony – the former kingdom of Saxony – which was established in 1735. The stud's early remit was to produce handsome and athletic horses to pull carriages and, later, for the cavalry and artillery. Following World War II, the Hanoverian was used increasingly for recreational riding and proved itself a superlative competition horse, excelling in showjumping, dressage and three-day eventing.

Germany has other warmblood breeds including the Oldenburg, developed by Herzog Anton Günther von Oldenburg, from whom it took its name, in the seventeenth century. Oldenburg's initial aim was to develop an excellent carriage horse using mares of the Friesian breed as well as selected stallions from Spain and Italy. Later, as the demand grew for an all-

**OPPOSITE** Front legs tucked up, eyes and ears alert, Quality Girl knows her job and is clearly in tune with her determined rider, Todd Minikus, who is in perfect balance at Wellington, West Palm Beach, Florida in 2018.

**ABOVE** The Dutch Warmblood has achieved great success in the showjumping ring where its athleticism, strength and power combine with its trainable nature.

**OPPOSITE** Eric Lamaze and his horse Hickstead demonstrate the athleticism necessary to showjump at the very highest level of competition.

round sport horse, more Thoroughbred blood was added. Notable Oldenburg showjumpers include Franke Sloothaak's Weihaiwej – who won gold at the 1994 World Equestrian Games – and Markus Beerbaum's Lady Weingard. Germany also has the Holsteiner, which dates back to the thirteenth century and was originally bred by monks, to whom the Count of Holstein and Storman, Gerhard I, granted grazing rights.

A much newer – and arguably equally successful – warmblood is the French version, the Selle Français – or saddle horse – which was developed in Normandy by using Thoroughbreds and trotters imported from England on native mares. Like virtually all warmbloods, the Selle Français is exceptionally good-looking, with a neat, attractive head, sloping shoulder, deep chest and muscular body. It is little wonder, then, that this breed has become so popular. At the World Equestrian Games at Jerez in 2002, the gold medal-winning French showjumping team were all mounted on Selle Français horses.

Many countries have their own warmblood breed. The American and Canadian Warmbloods are still seen as a 'type', though registries set up for both aim to improve and promote those horses. Eric Lamaze's horse Hickstead, who won individual gold and team silver for Canada at the 2008 Beijing Olympic Games, was a Dutch Warmblood stallion. Ranked number one showjumping horse in the world until his death in 2011, he was approved

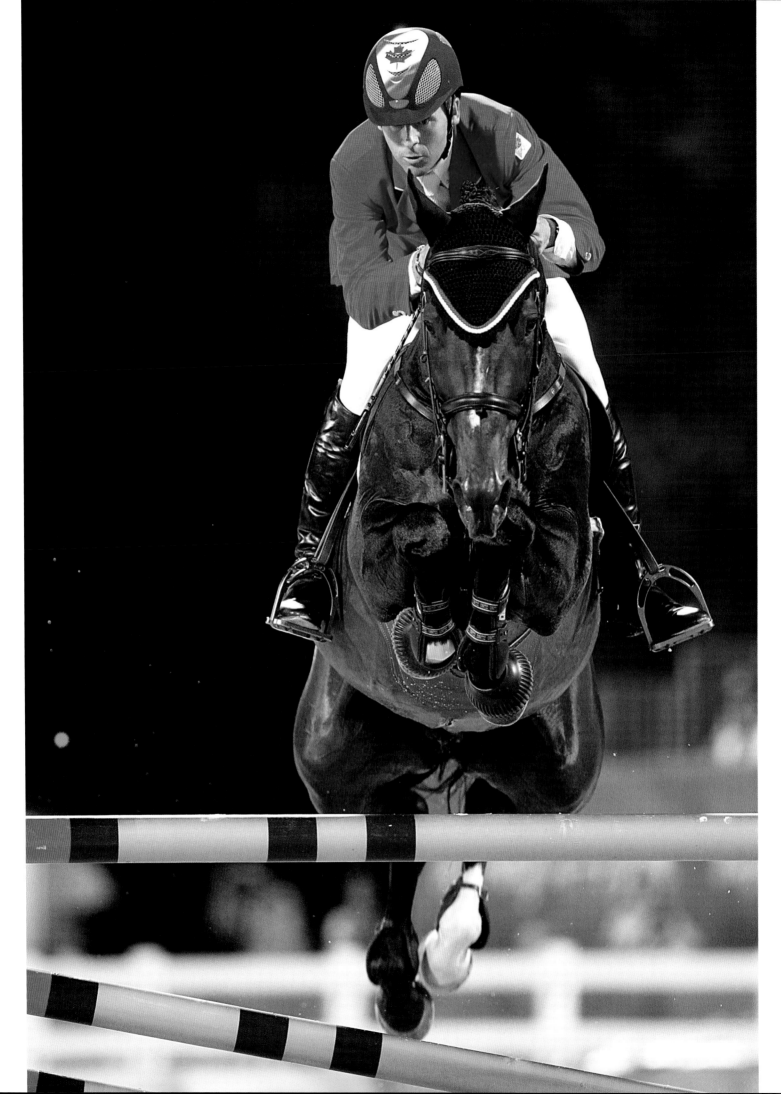

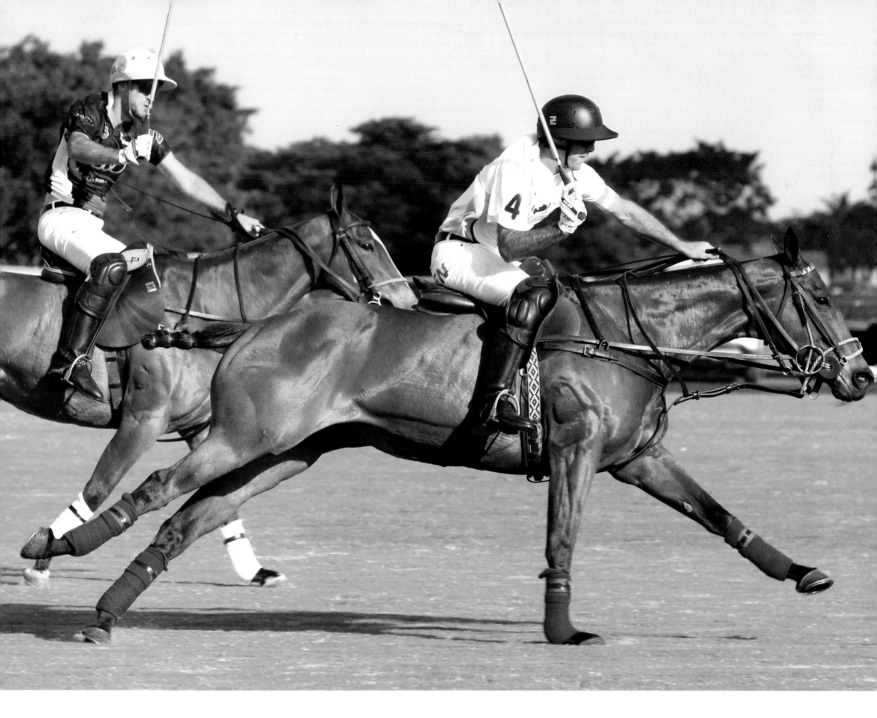

**ABOVE** At full gallop this polo 'pony' – though most mounts are at least 15.2hh (157.5cm) – speeds with its rider towards the goal with an opponent in hot pursuit.

by the Canadian Warmblood Horse Breeders Association and many other warmblood associations in Europe and North America.

Akaash Maharaj, chief executive of the Canadian team, said movingly: 'Every horseman knows the proverb: for every rider there's one horse, and for every horse there's one rider. [Hickstead and Eric] were that sort of partnership. Hickstead wasn't simply his partner in sport, he was his partner in his life's hopes and ambitions. It's a bit like falling in love. You can hope for it, you can plan for it, but you can't make it happen.'

The horses gifted by the Royal Canadian Mounted Police in a reciprocal arrangement to Her Majesty Queen Elizabeth II, including the great Burmese – the Monarch's favourite – were in essence warmbloods from Canada. They are generally Hanoverian crossed with Thoroughbred blood, which provides the warmblood types with athleticism, speed and stamina. That is why the small, agile and super-fast equines found between the boards on a polo ground are Thoroughbreds.

Polo is a fast game – the little horses reach speeds of 50kph (30mph) – and its players, human and equine, must have quick reflexes. Dubbed 'hockey on horseback' the game is every bit as balletic, in its way, as dressage, requiring also the lightning-fast spins and turns of a barrel-racer, as well as the agility and athleticism of a showjumper.

The polo player needs a horse that is fast, agile, manoeuvrable and controllable. Although most of the horses used in the game stand around 15–16hh (152.4–162.5cm), they are always referred to as polo ponies. This is because when the modern sport was developed in India in the nineteenth century, the maximum height for the equines was 14hh (142.2cm), though the height limit was abandoned in 1919.

The sport's origins date back more than 2,000 years to a time when mounted nomads played a type of polo – part game, part training for war – with up to one hundred riders on each side. The nomads took the activity with them to Persia (now Iran) where it became the national sport. It then began to spread around the world and when it reached Manipur, a northeastern state of India, it was taken up by the British military.

An American called James Gordon Bennett, publisher of the *New York Herald*, saw a match during a trip to England and returned to the States with mallets and a copy of the rules as laid down by the Hurlingham Club, the English polo authority. The first match to be played in America was at a city riding school, before moving outdoors to a field in Westchester County: the Westchester Polo Club was formed in 1876. In August 1886 the club challenged the British and put up a silver trophy – now known as the Westchester Cup – still contested every season.

In such a competitive game, it was inevitable that the team that had the best ponies would have the advantage. The Americans crossed Thoroughbreds with Quarter Horses to breed small, athletic equines with the required stamina and acceleration, while the Argentines put Thoroughbreds to their Criollos (a native South American breed much valued for its hardiness and stamina). Ideal polo ponies combine speed, stamina, agility and athleticism. The best are responsive, even intuitive, and have a calm disposition that enables them to focus all of their energy on the game.

And polo is an extremely energetic game; each side has a team of four players, who score points by striking the ball – hit with long-handled mallets – through the goal posts. Traditionally the polo ground is 300yd (274m) long and 160yd (146m) wide if it includes boards, which are 12in (30cm) high and line the perimeter of the ground. If the ground is unboarded, it is 200yd (183m) wide and marked with a white line. The goal posts at each end are 8yd (7m) apart.

The polo match is split into 'chukkas', each lasting seven minutes or until the ball goes out of play. A full polo game will include eight chukkas, but some clubs play only four or six. A bell is rung to signify the end of a chukka, and there is a break of three minutes between each one. The players change ends after each goal scored or at half-time if there is no score. The half-time interval is five minutes long when spectators are invited on to the pitch to tread in the divots.

The players can change ponies between or even during chukkas. At the very peak of the sport, called high-goal polo, players have a string of eight or more ponies. It is certainly not a game for the financially challenged. Even well-heeled players need patrons to fund their string and to pay for their travel – the high-goal season lasts almost a year and the professional players take in a huge global circuit from Florida (January to April) to England and Europe (May to July) and Argentina (September to December). One patron is said to have spent two million pounds on a single season and commented that there are only two reasons a committed polo player would give up the game: bankruptcy or death.

The game is fast and fascinating to watch, with players 'riding-off' each other, barging their ponies and trying to gain control of the ball. They are also allowed to hook another player's mallet to try to stop them scoring a goal – but only if it is safe to do so. Penalties are given for any sort of unsafe play that could result in injury to an animal.

The best polo ponies seem to understand the rules of the game and almost intuit what their rider wants them to do next. In dressage such anticipation of a movement leads to a lower mark, but in polo this talent is highly prized. The pony will position itself at the best distance from the ball for the rider to make his stroke. Watching a player screaming down the pitch at more than 50kph (30mph) brings to mind the myth of the centaur – man and horse as one. Indeed, one of the world's best players, the Argentine Adolfo Cambiaso, acknowledges that it's mostly the ponies that win the match. 'Without good horses, you are nothing,' he says. 'In polo, it's 70 per cent horse, 30 per cent rider.'

The most prized ponies change hands for tens of thousands of pounds, and those at the top of their game have even been cloned. Cambiaso himself, with the backing of his patron, enlisted the services of Alan Meeker, an American genetics expert, to clone his best ponies. At the end of 2016, in a prestigious match in Buenos Aires, he rode six different ponies to help his team win – each one was a clone of the same mare and they are named Cuartetera 01 to 06. 'They are 100 per cent clones of their mother,' says Cambiaso.

Most polo players tend to favour mares over geldings, as they believe they have more 'heart', though if you ask a dozen horsemen what 'heart' means, you will probably get a dozen different answers. It is often said that you can ask a mare to do something, but you have to tell a gelding. Geldings may take longer to grasp what is required of them. Ponies rarely play before they are five years old, when they are taught the movements required – lightning-fast acceleration, stopping on a sixpence, and rollbacks in which the horse stops and turns swiftly in the opposite direction. Then they spend hours 'stick-and-balling' to get them used to the rider on their back swinging a long mallet. They must also become accustomed to noise and excitement on the polo ground, with other ponies and riders shouting and bumping and galloping. Only after this rigorous training will they be introduced to the game, perhaps playing a few slow chukkas to get accustomed to it.

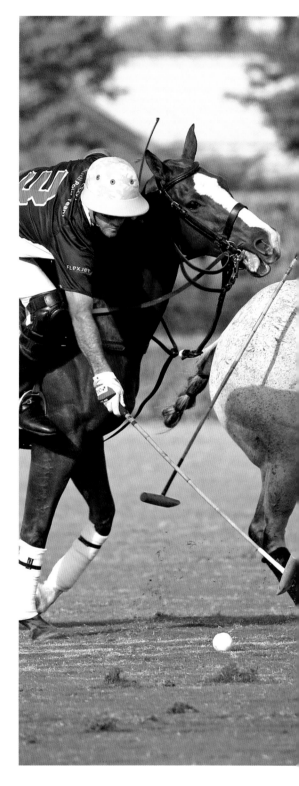

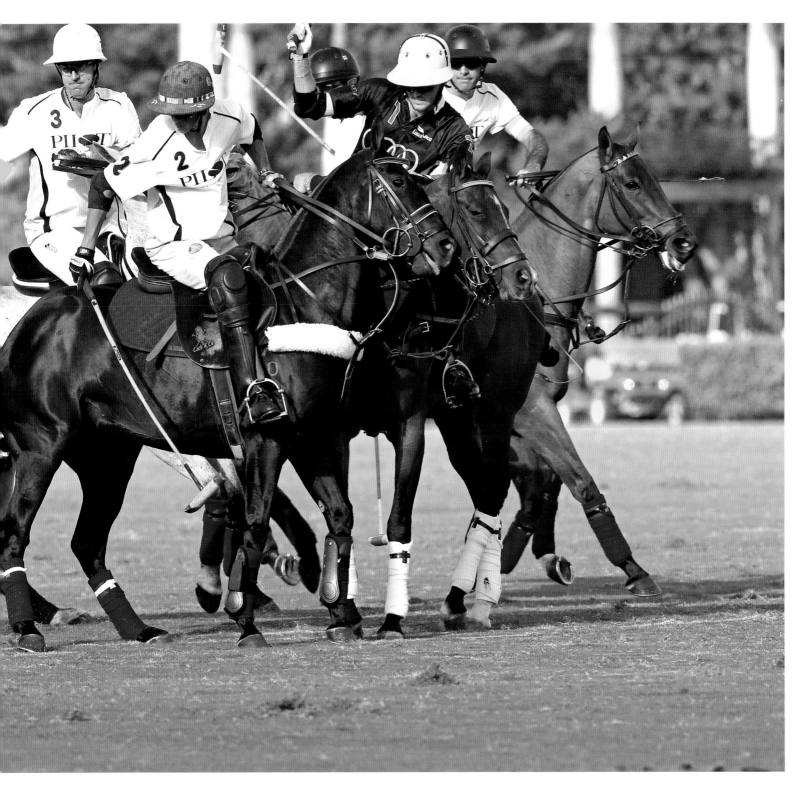

The best polo ponies are naturals at the sport, and combine cleverness and a love for their job – players call this combination a 'mind for the game'. Just as it is impossible to make a Thoroughbred race if it doesn't want to, it is also difficult to teach a pony to play polo. The polo pony must be brave, prepared to attack and ride-off and take its rider into a play, but remain obedient and willing to its player's aids. That perfect polo pony with the right combination of mind and heart may be a once-in-a-lifetime find – unless, of course, it can be cloned.

**ABOVE** In the mêlée of a polo ride-off the horse must be as brave as its rider and prove it has a 'mind for the game'.

# SHOWJUMPING

We ask the horse to jump; the horse asks us how high. The highest recorded jump by a horse is 2.47m (8ft 1in), achieved by a Thoroughbred stallion named Huaso and his Chilean rider Captain Alberto Larraguibel Morales in 1949. This extraordinary achievement stands as eloquent testimony to the innate athleticism of the horse.

The modern version of the high jump is known as a puissance, where competitors face a big red wall that increases in height with each jumping round, until the pair to clear the highest is declared the winner. The word 'puissance' derives from the French for 'great power, influence or prowess', and certainly, the horse needs remarkable power and talent to clear such a formidable obstacle.

But all the fences in showjumping are formidable to a greater or lesser extent. At the highest competitive level, grand prix, the coloured poles can be up to 1.6m (5ft 3in) high and 2m (6ft 7in) in spread width. It is a measure of the horse's faith in its rider and its desire to please that it will take on these mighty fences and throw its heart over them for us.

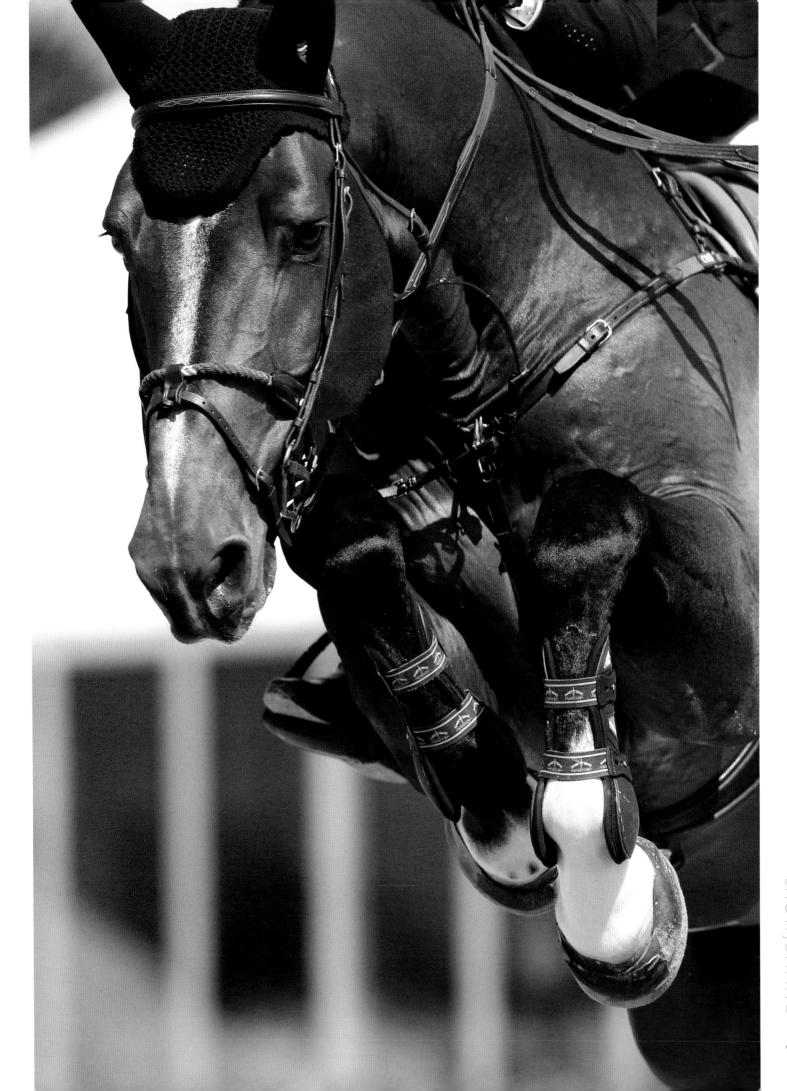

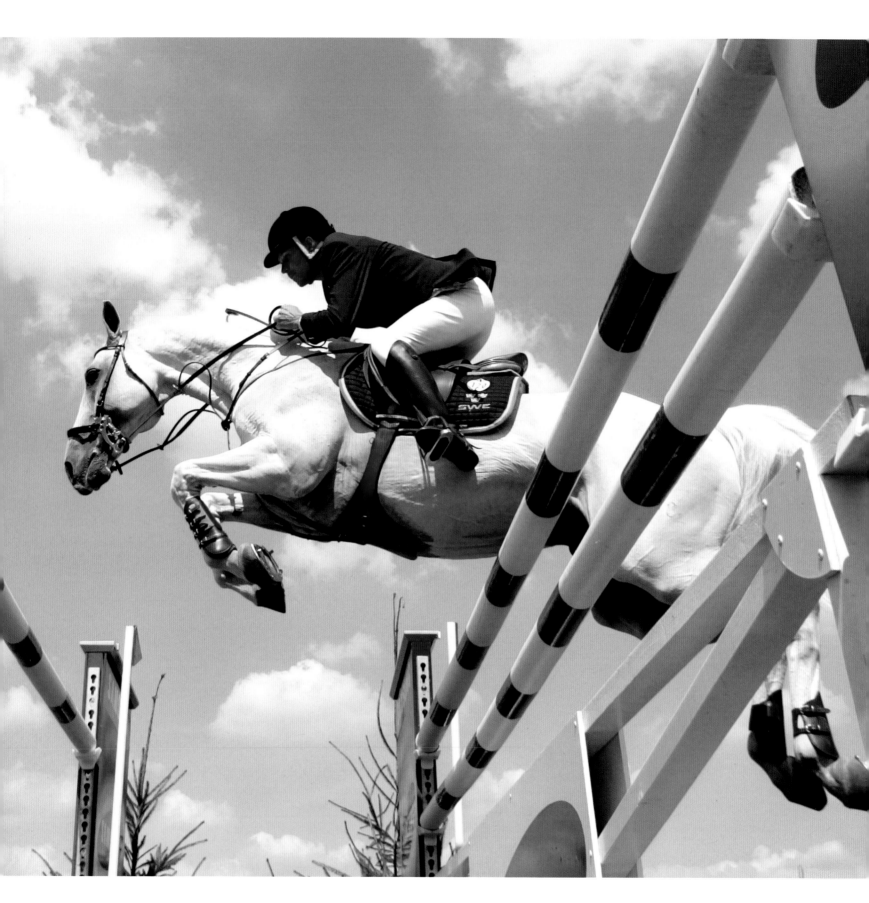

**ABOVE** Peter Eriksson of Sweden jumping the Holsteiner stallion VDL Cardento at Hickstead in 2006.

**OPPOSITE** Great Britain's Robert Smith – son of legendary showjumper Harvey – riding Bavi at Spruce Meadows, Calgary in 2016.

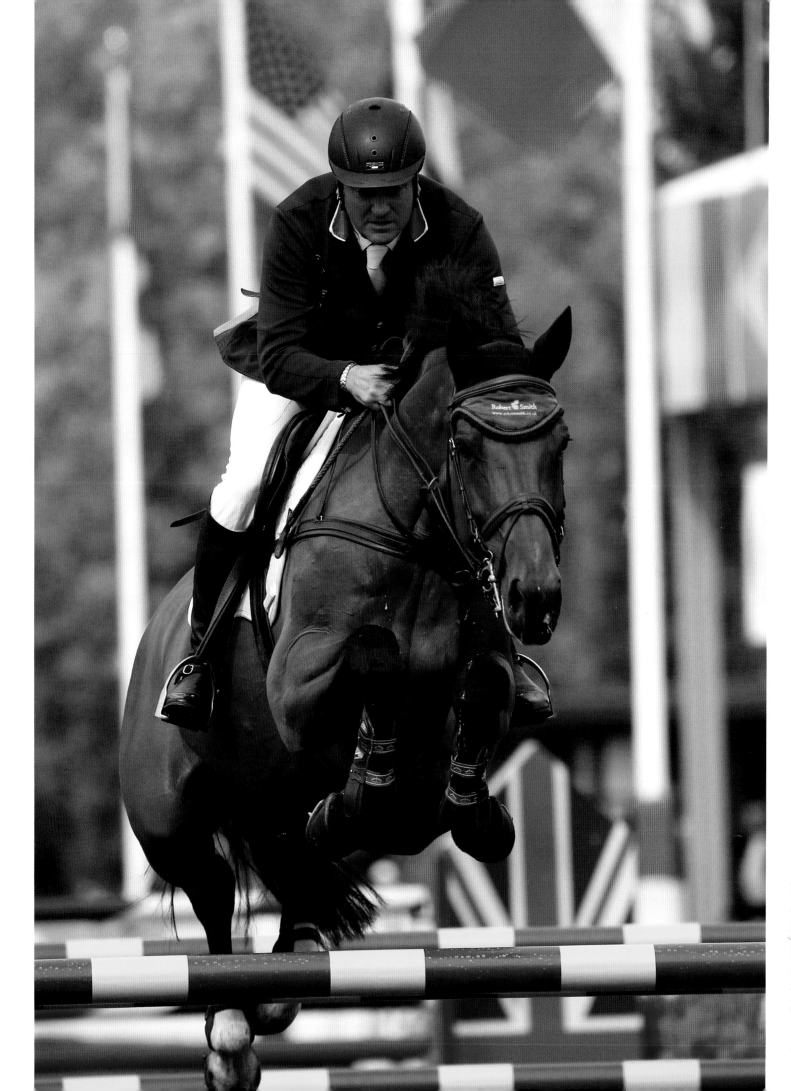

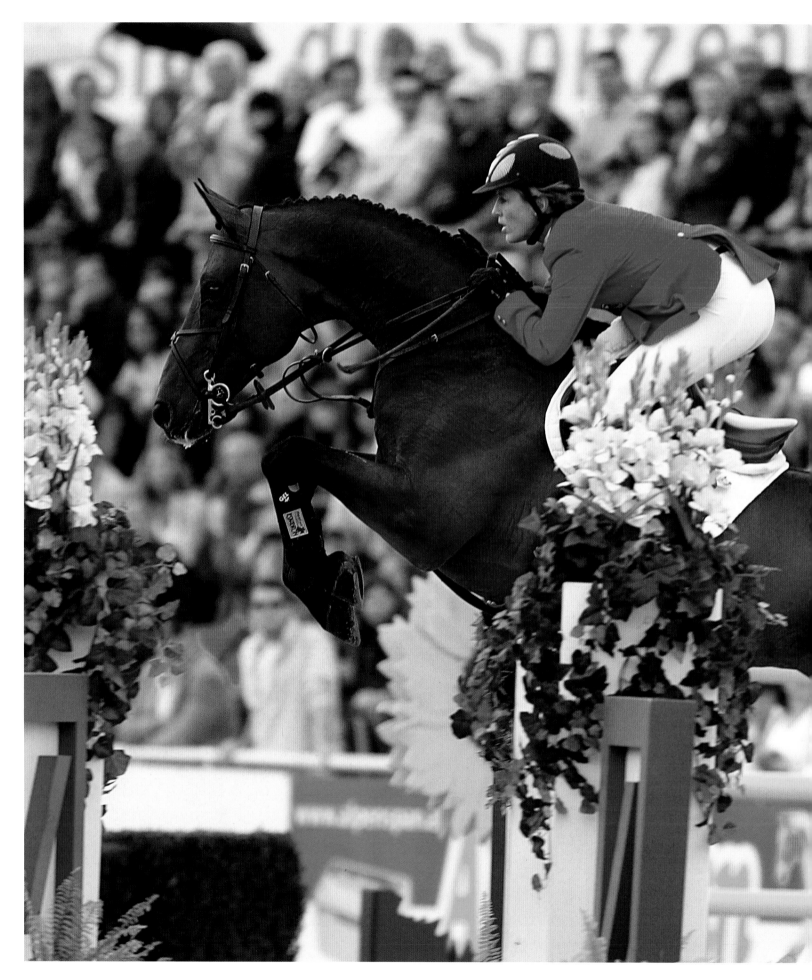

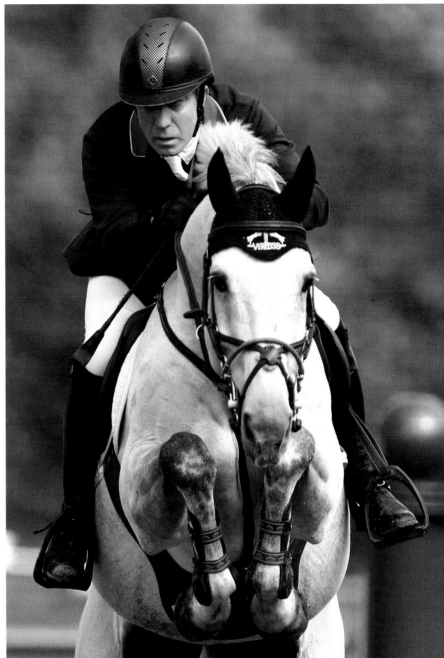

**ABOVE** Ears pricked, looking eagerly for the next jump, Valentin R is athletically picking up his front legs as high as possible to clear the fence for Great Britain's Michael Whitaker.

**LEFT** One of the best showjumpers of the twenty-first century, Meredith Michaels-Beerbaum's Shutterfly makes a beautiful rounded shape – known as a bascule – over an upright fence, stretching his neck forward and with his body in a natural round arc as he reaches the highest point of the jump.

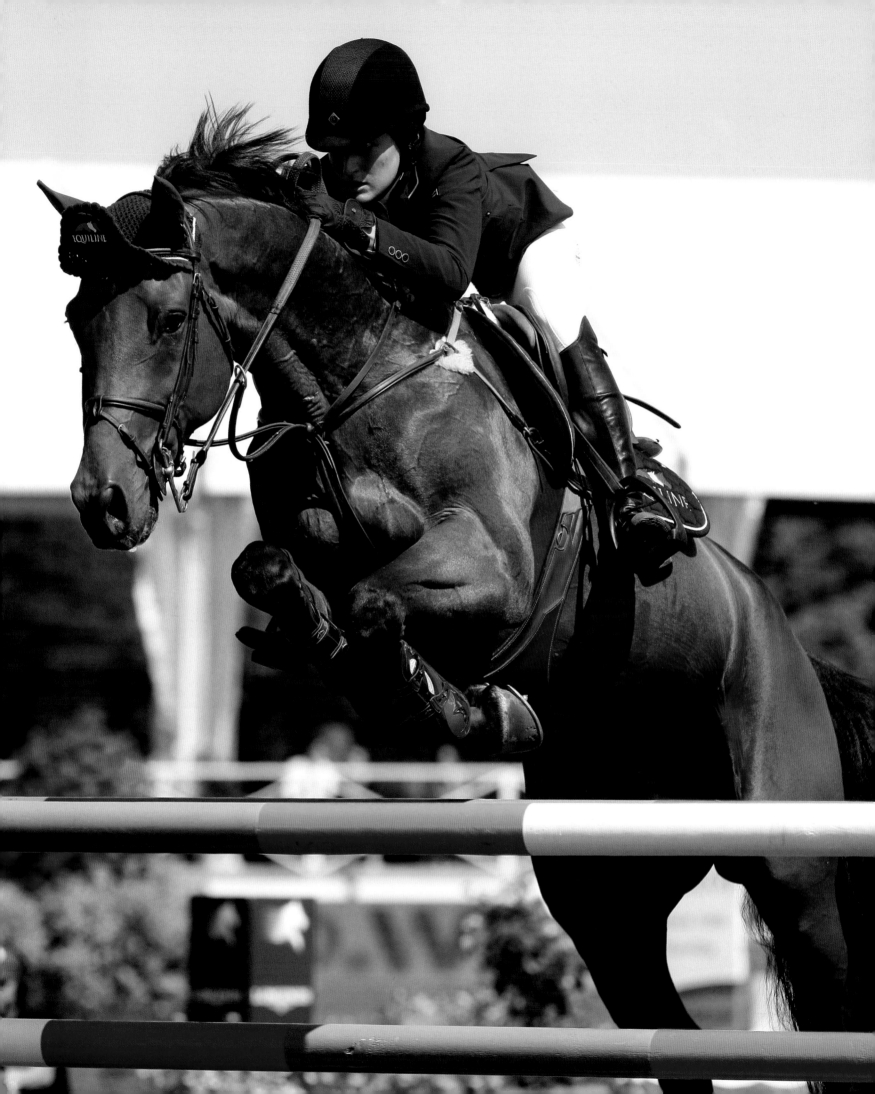

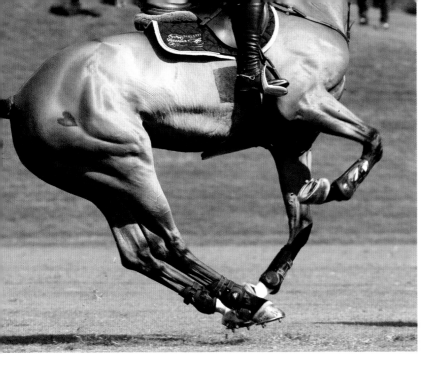

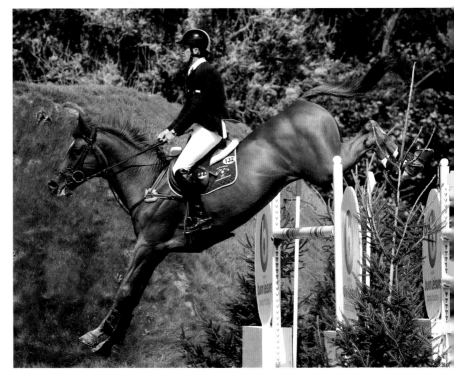

**ABOVE** The showjumper brings its hindlegs underneath as a prelude to using its power to take off in front of the obstacle. Then it lifts its forelegs and tucks them underneath its body – aided by its rider leaning forward over its neck to take the weight off its back – and stretches its forelegs out again for a sound landing while it kicks back with its hindlegs to clear the obstacle.

**OPPOSITE** American young rider Jessica Springsteen and Vindicat competing in the Global Champions Tour of France..

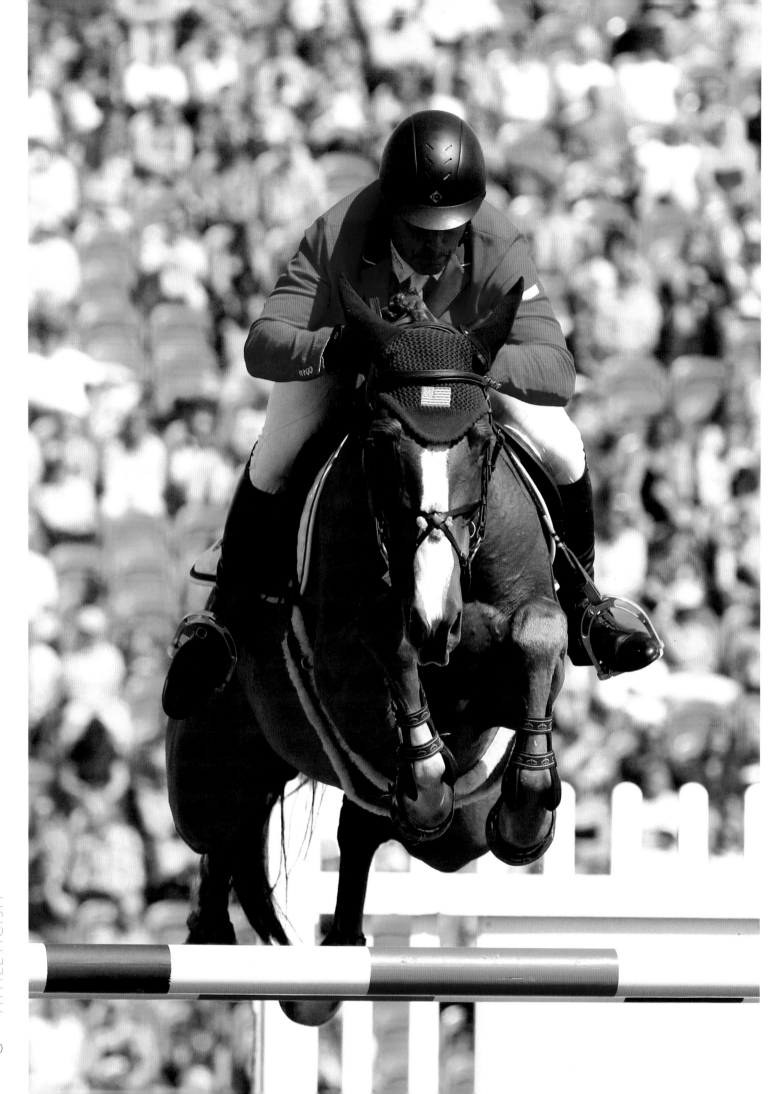

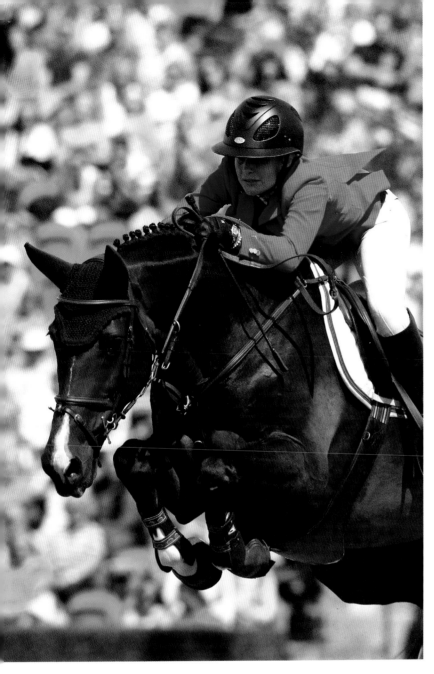

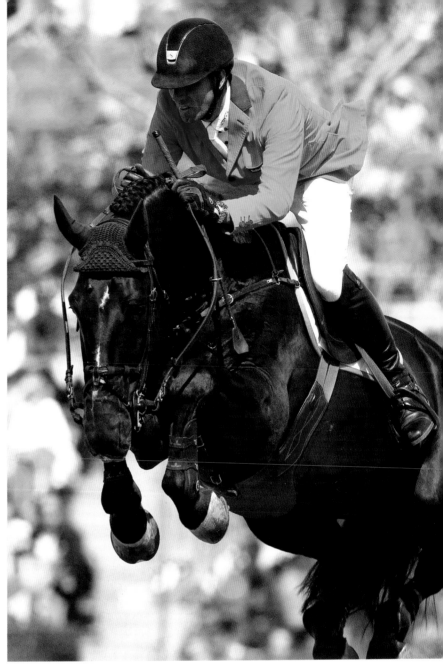

**ABOVE LEFT** The Dutch Warmblood Adare relies upon Paris Sellon of the USA to set him up for the fence; then it's up to him to get from one side to the other while leaving the poles in place.

**ABOVE RIGHT** Jur Vrieling of The Netherlands and the athletic black stallion VDL Glasgow van 't Merelsnest competing in the Nations Cup at Hickstead in 2016.

**OPPOSITE** The USA's Todd Minikus and Babalou 41 demonstrate vividly how showjumping is a close partnership between horse and rider, which is as much about trust as training and fitness.

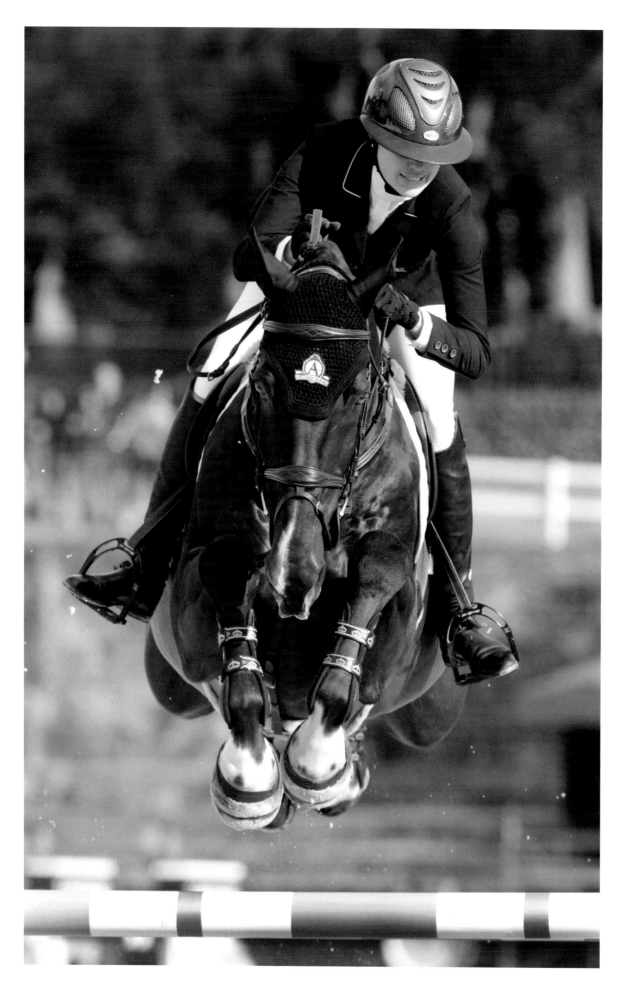

**LEFT** Canada's Tiffany Foster and Tripple X III – who won team gold for Great Britain when ridden by Ben Maher at the 2012 London Olympics – in action in Rome in 2015.

**OPPOSITE** Canadian Eric Lamaze and the Oldenburg gelding Chacco Kid at West Palm Beach. The fly covers on the horse's ears help to mute some of the noise from the crowd, and so help the horse to concentrate.

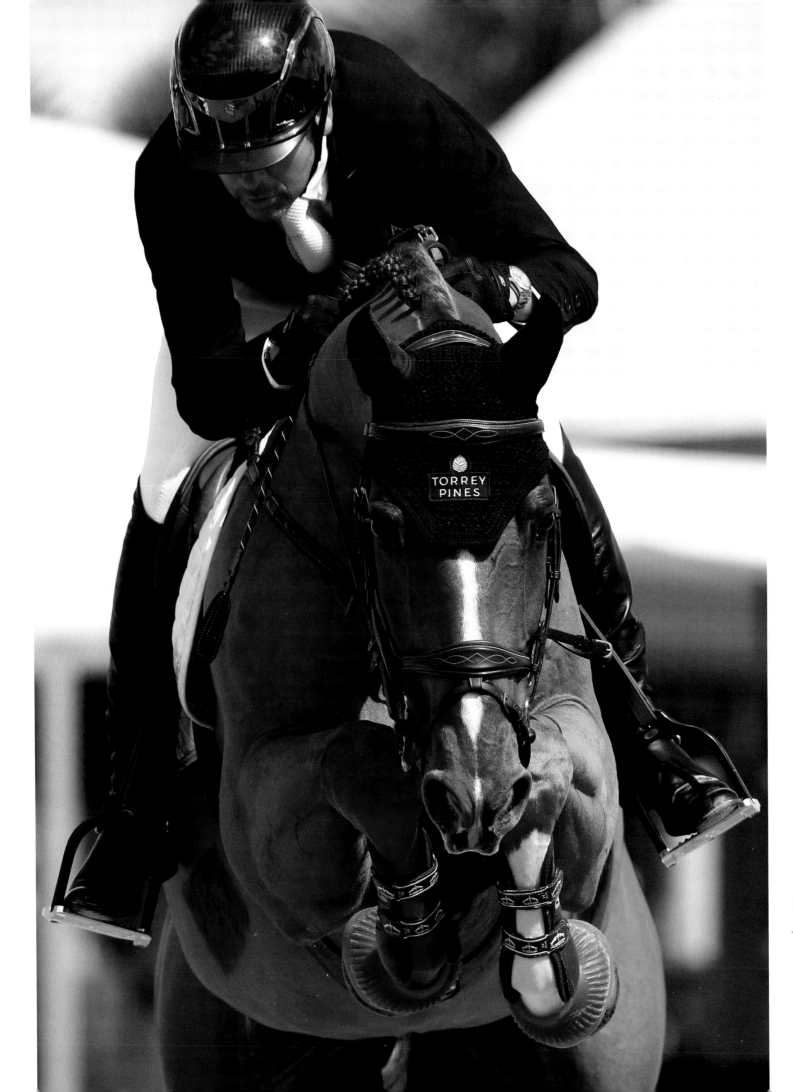

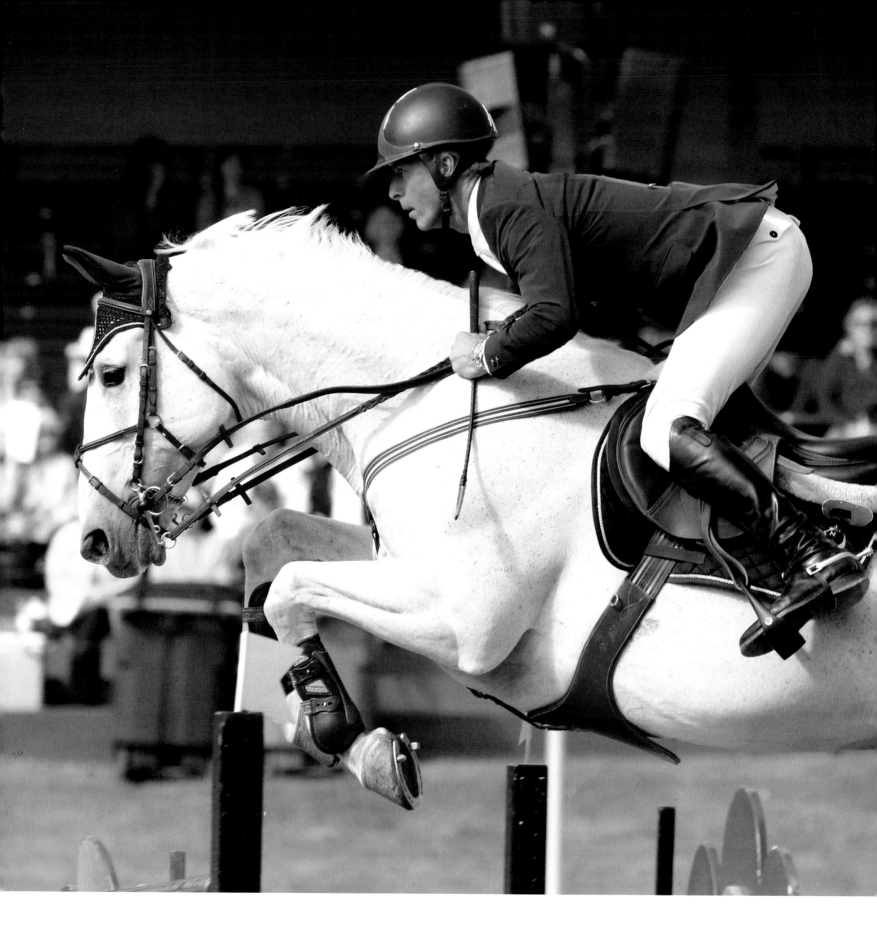

**ABOVE AND OPPOSITE** American Richard Spooner and
Chivas Z jump the challenging course at Spruce Meadows
in Calgary in 2015, and the appreciative rider rewards his
horse for his efforts.

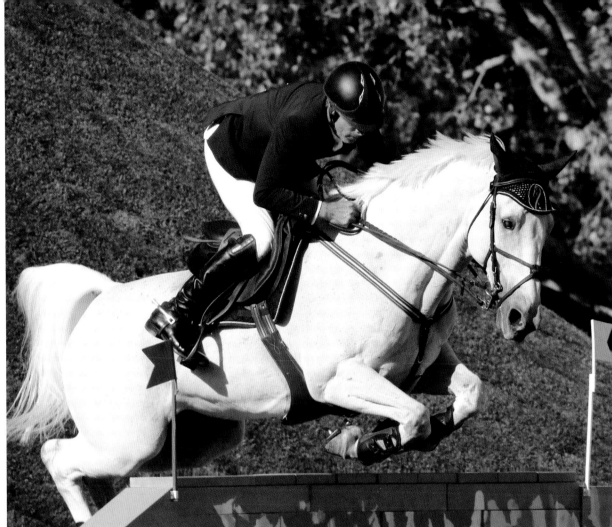

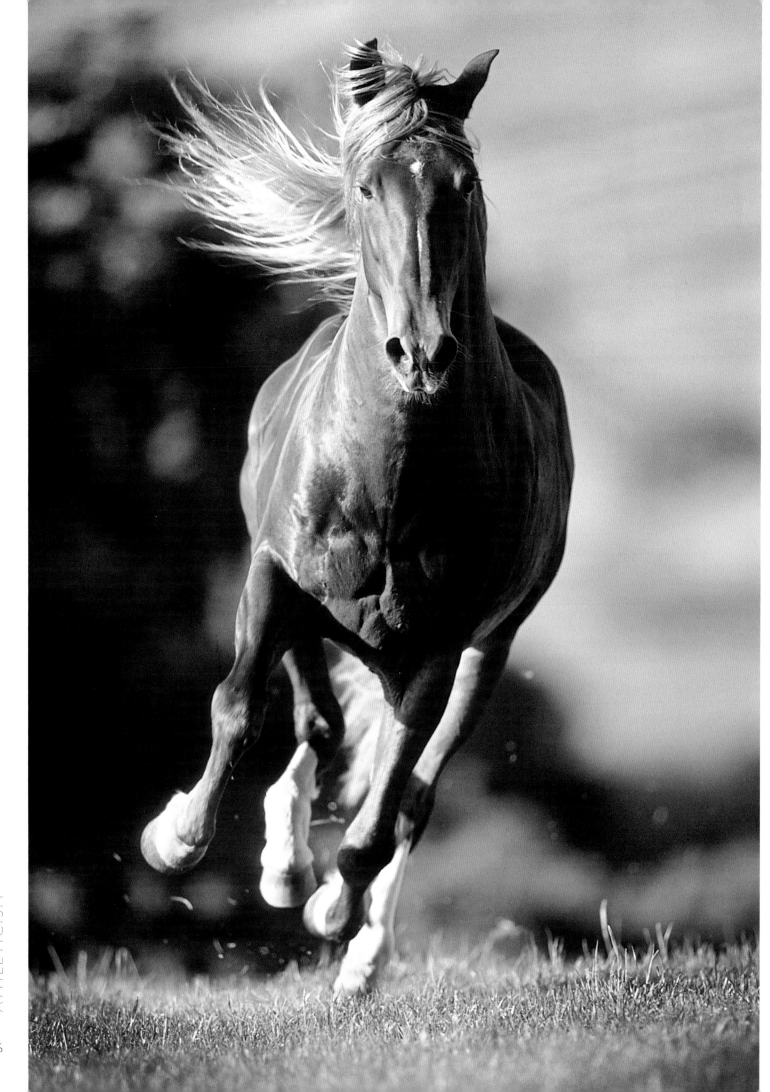

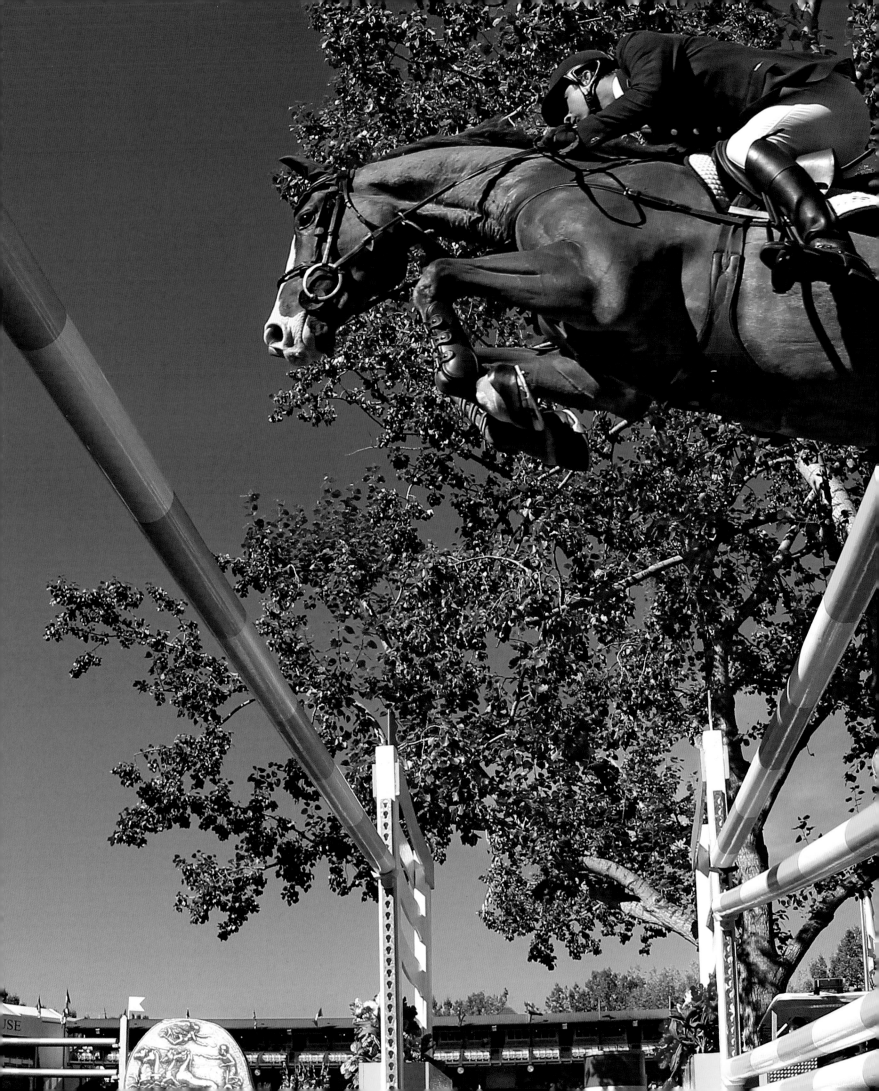

**PAGE 106** As a prey animal, the horse is naturally athletic and sure-footed, and will find its own self-carriage, as demonstrated by this handsome Peruvian Paso stallion (*left*).

**PAGE 107** You can just see the studs that are screwed into holes in the showjumper's shoes, which afford it more grip on the approach to the challenging jumps.

**LEFT** Showjumping is a great sport to watch, an exciting demonstration of equine accuracy, athleticism and power as demonstrated here by Rodrigo Pessoa of Brazil and Belgian Warmblood Ferro Chin van het Lindenhof. The difference between success and failure may be a single misplaced pole.

# POLO

Mounted nomads, sometimes with as many as a hundred men on each side, played a version of polo that was part sport and part training for war. The game followed their migration to Persia (now Iran) some time between 600 BC and AD 100.

The game became Persia's national sport, played more or less exclusively by the nobility and the military, spreading west from central Asia to Constantinople, east to Tibet, China and Japan, and south to India. But it was the British military stationed in Manipur, India, who created and formalized the modern game. The Silchar Polo Club was founded in 1859 after a Lieutenant Joseph Sherer watched the locals playing and said: 'We must learn to play that game.' Its popularity spread rapidly: to Malta in 1868, England a year later, Ireland a year after that, Argentina in 1872 and Australia in 1874.

When the game became more standardized, so did the players' mounts. Once limited to a height of 14hh (142.2cm at the withers), the upper height of the ponies was abandoned in 1919. Most polo ponies today are about 15hh (152.4cm), or a shade over. These smaller equines are exceedingly agile and athletic, vital attributes for a pony competing in this fast and thrilling sport.

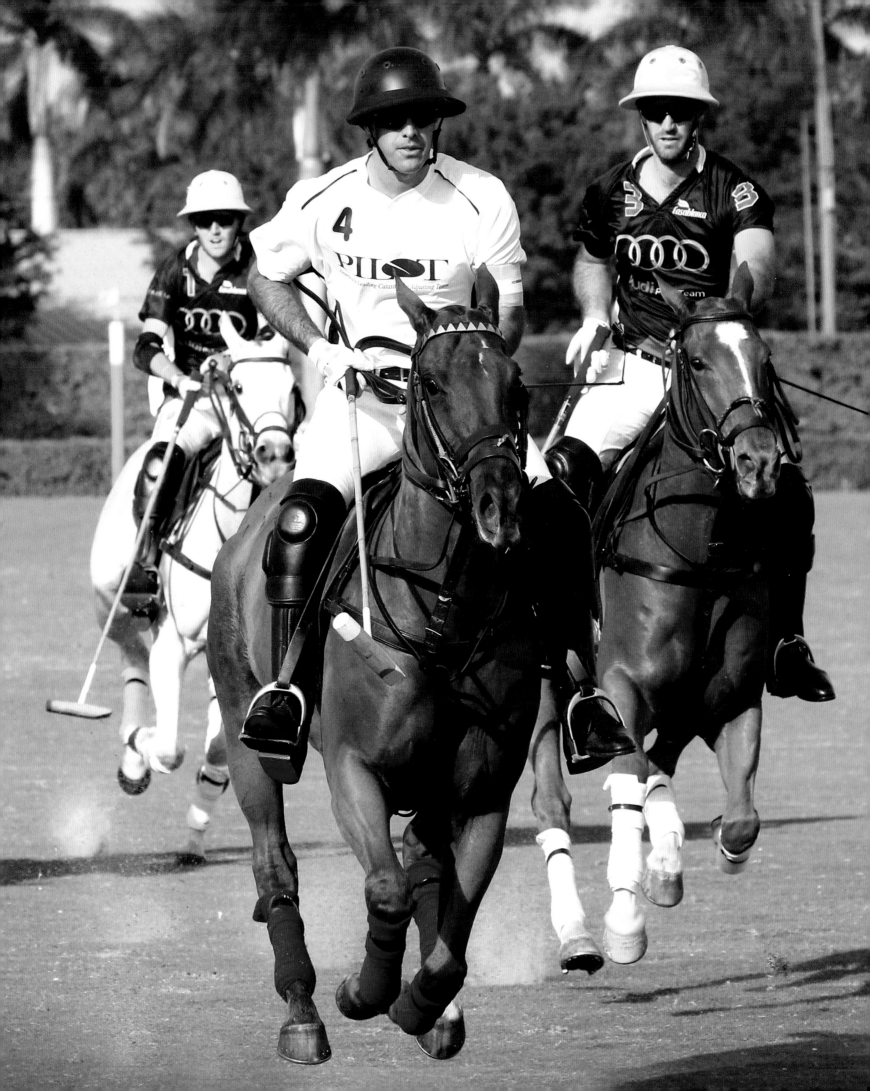

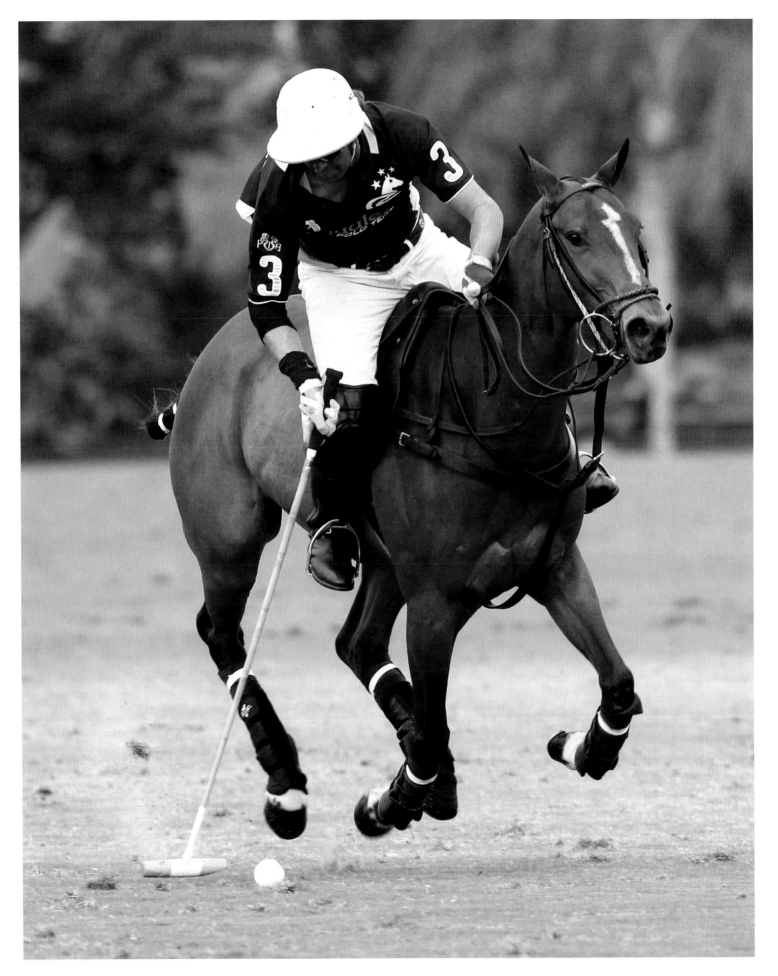

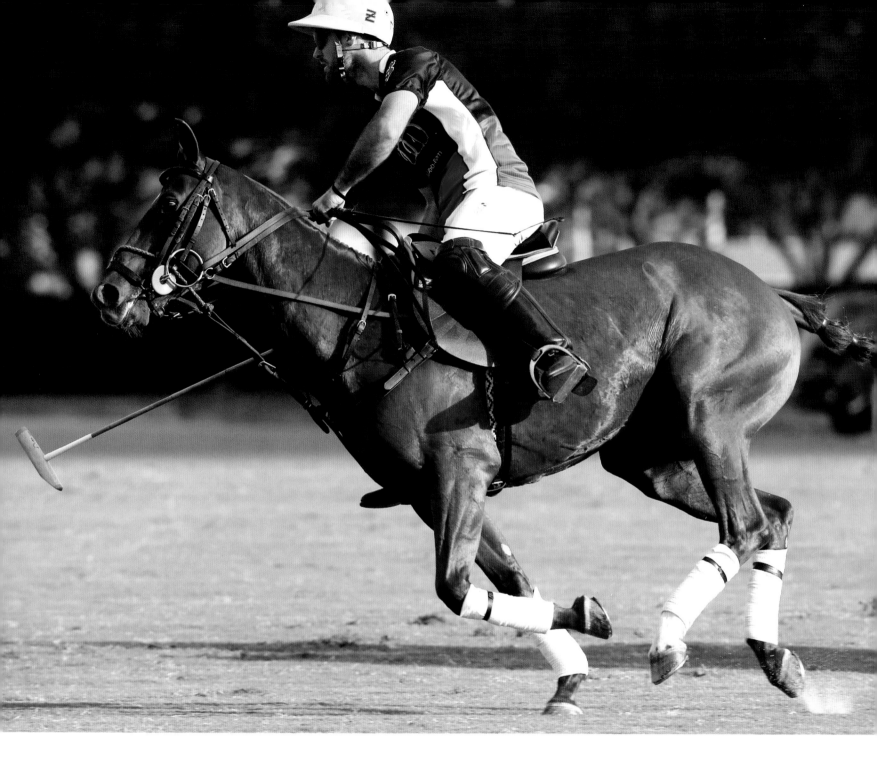

**ABOVE** Mostly Thoroughbreds, polo ponies are supremely agile and athletic – able to stop and turn immediately when asked, and then gallop off at top speed from a standstill to continue the game.

**PAGES 112 AND 113** The polo mallet is typically 122–137cm (48–54in) in length, depending on the height of the pony and the reach of the player. Players must carry the mallet in their right hand and strike the ball with the broad side of the head, not the flat end. In the mid-1930s playing left-handed was banned for safety reasons. A player must not intentionally touch another player or his pony with his mallet.

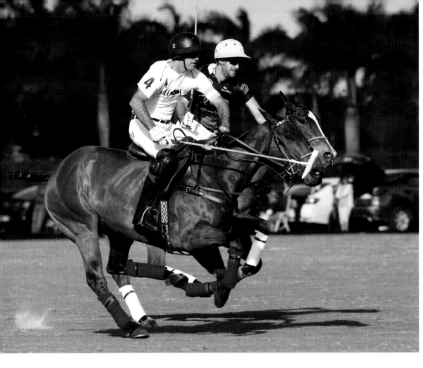
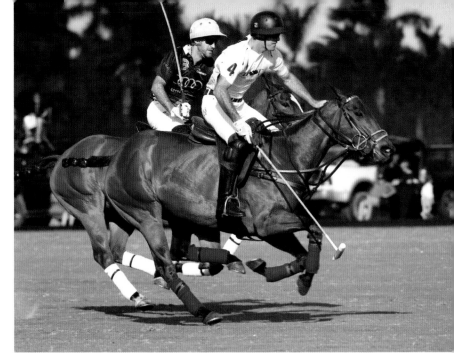
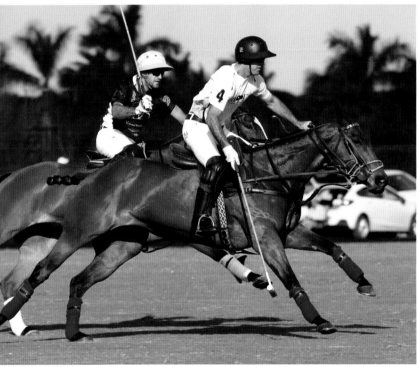
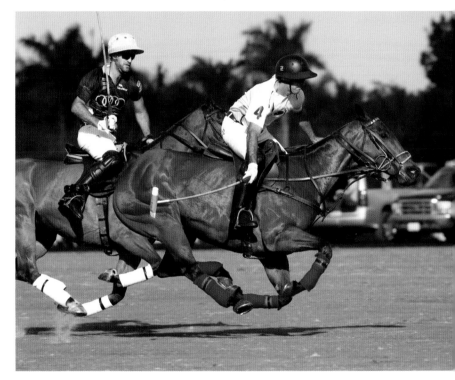

**ABOVE** The International Polo Club Palm Beach, Wellington, Florida, hosts the largest field of high-goal teams and some of the most prestigious polo tournaments in the United States. The equine athletes must be agile and quick, as they work instinctively with their riders to propel the ball towards the goal.

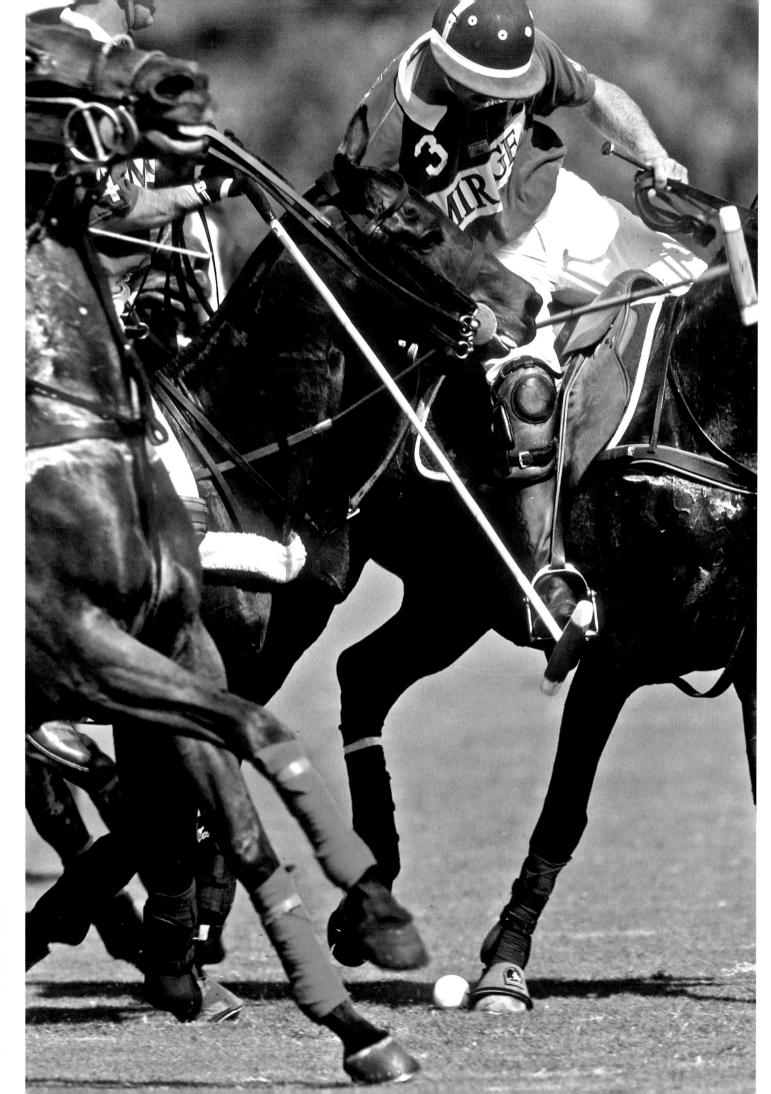

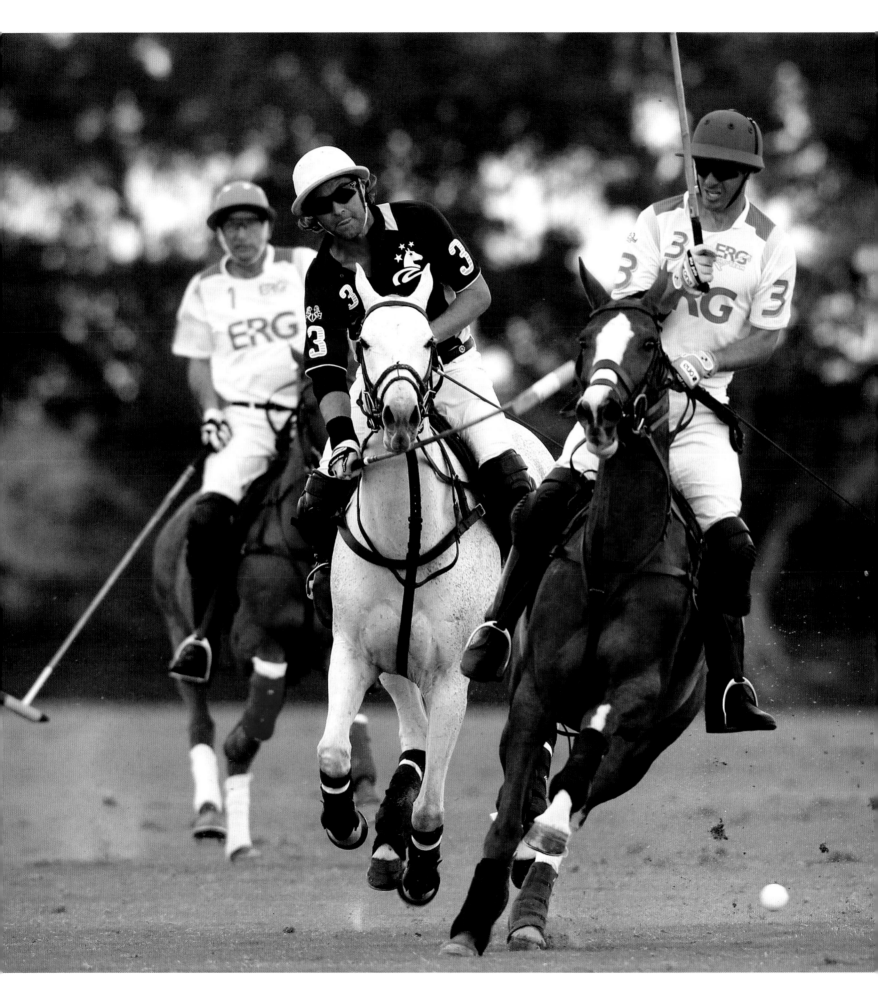

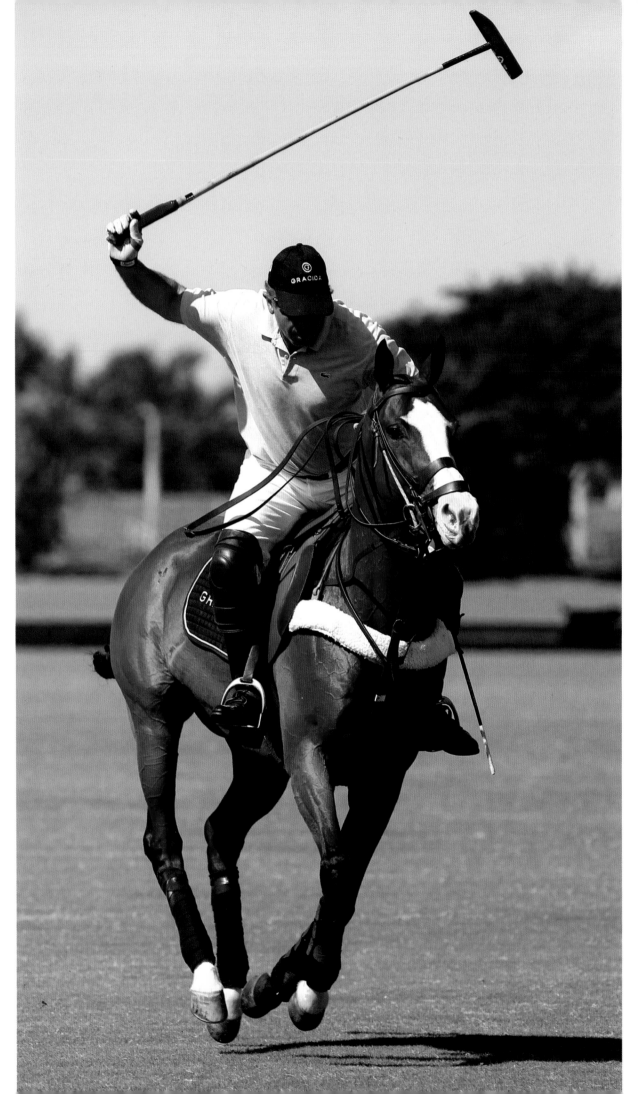

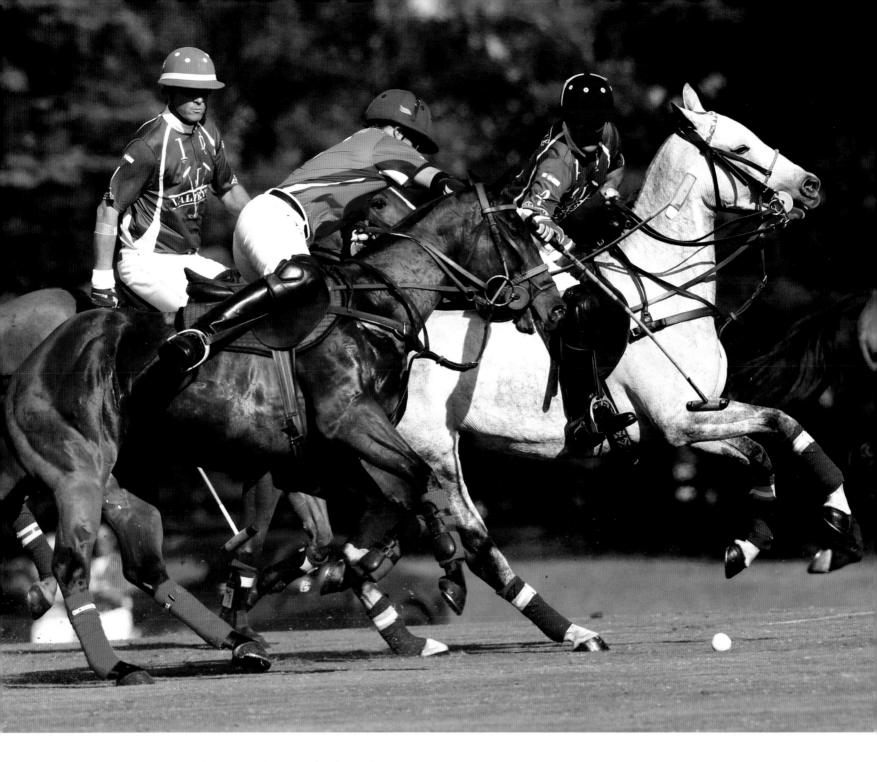

**OPPOSITE** Although restrictions on the size of polo ponies were lifted a century ago, most ponies playing today are still quite small at around 15hh (152.4cm). Top players will have at least eight ponies in their string. The highly trained ponies may only play one chukka before being swapped so they can rest.

**PAGES 116 AND 117** Popular worldwide, polo is unusual among team sports in that amateur players may compete alongside the sport's top professionals. The dominant nations are Argentina, the USA and the UK, each of which supports a thriving polo industry. Annual tournaments for international and high-goal polo take place seasonally around the world.

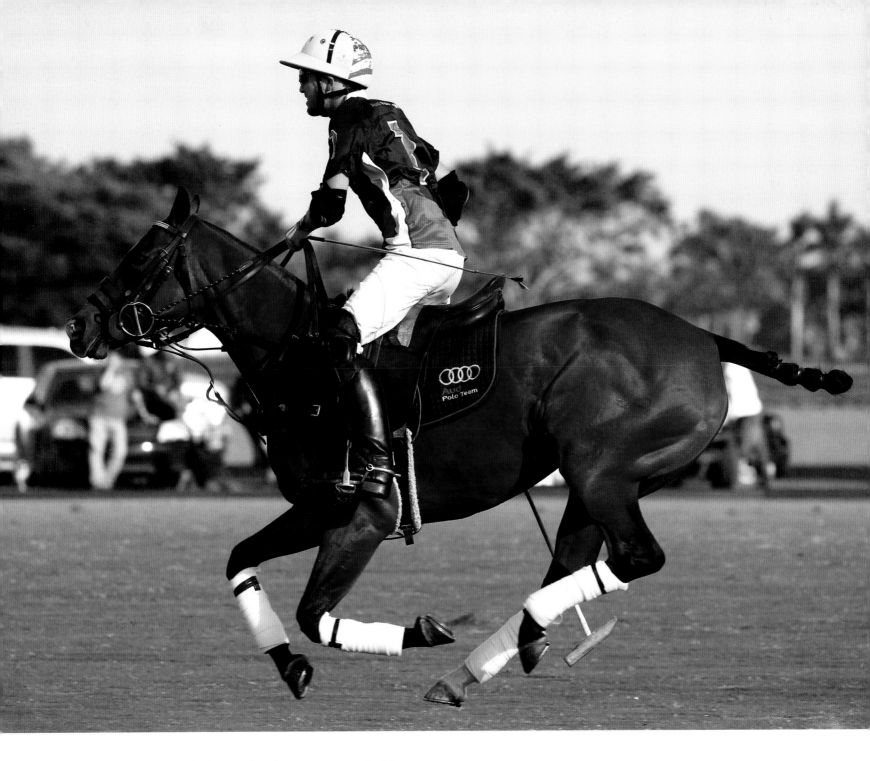

**ABOVE** Polo ponies routinely wear bandages to protect their legs during play. Their manes are shaved and tails are tied up to keep them out of the way of the mallet and reins.

**OPPOSITE** To prevent the animal accidentally hitting the rider in the face, polo ponies wear a piece of tack that controls the height of the head. The standing martingale is a strap that runs from the back of the noseband, through a neckstrap around the pony's neck and between its front legs to connect to the girth.

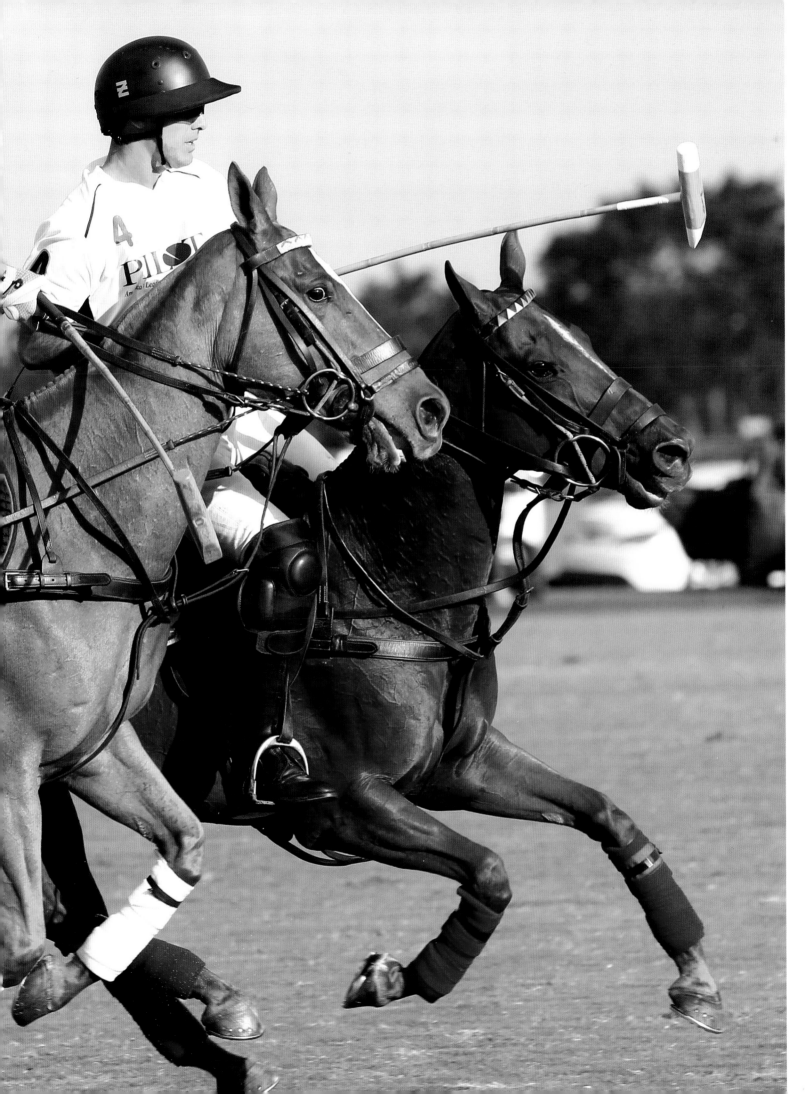

ENDURANCE

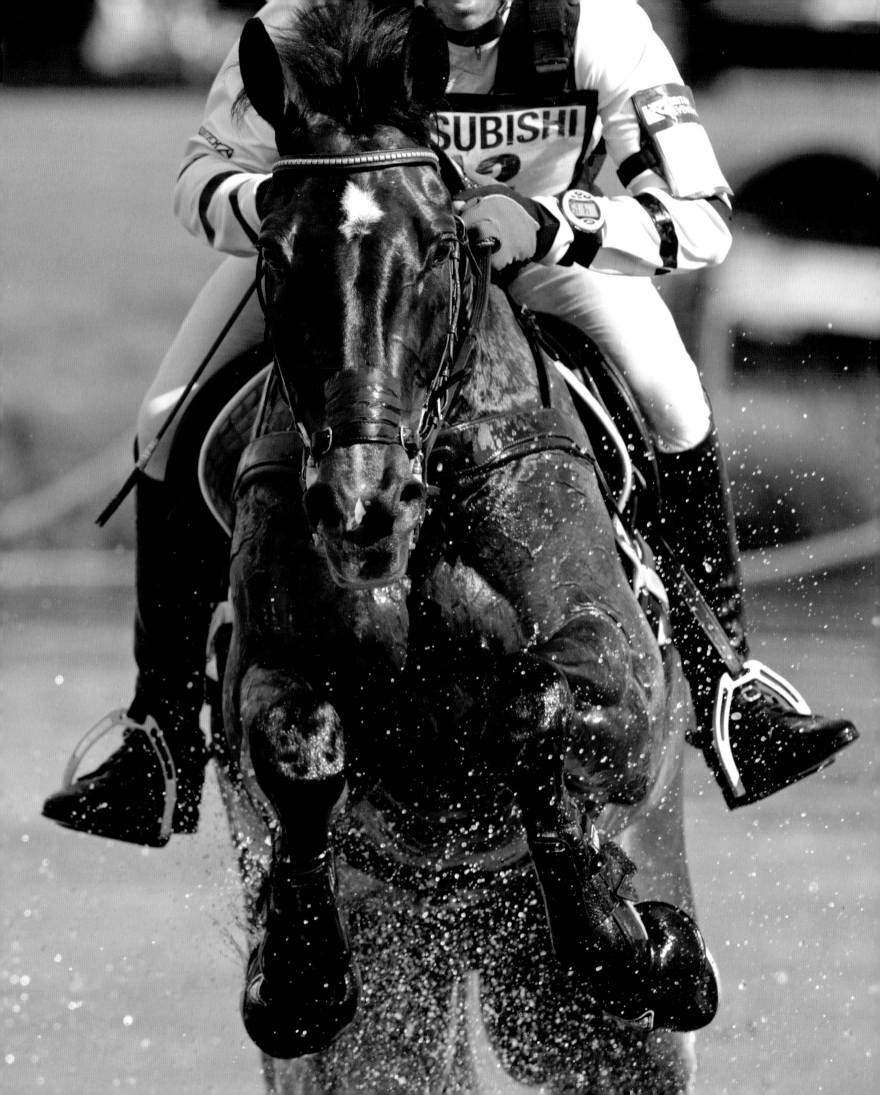

# STAMINA AND POWER

To get some idea of the level of horsepower and horsemanship required to compete at the very top level of eventing, consider that there are only six four-star three-day events held worldwide each year.

This sport comprises dressage, a cross-country obstacle course and a round of showjumping. In its previous incarnation, it also featured a steeplechase and a section of roads and tracks. That was termed long-format, of which more later. The horses have to be athletic, agile, supremely fit, brave and, perhaps most of all, possess incredible stamina for this ultimate test of equine endurance.

Three-day eventing – sometimes referred to as horse trials – first appeared in an Olympic Games in Sweden in 1912. The new sport was called the Militaire. In its earliest form, it was devised by Count Clarence von Rosen, Master of the Horse to the King of Sweden, who was responsible for reintroducing equestrianism to the Olympics, which had been dropped after the 1904 Games. The object of the Militaire was to test cavalry officers' chargers for their fitness and suitability. The different phases each had a particular purpose: dressage for precision, elegance and obedience on the parade ground; speed and endurance for stamina, versatility and courage on marches and in battle; cross-country jumping ability and endurance for travelling great distances over difficult terrain and formidable obstacles when relaying vital despatches; and jumping ability in the arena to prove the horse's fitness to remain in service.

Held on consecutive days, these elements combined to make a complete test for the army horse. At the 1912 Olympic Games, only officers on active duty, mounted on military chargers, were allowed to compete. Each competitor was required to carry 82kg (180lb) in weight and ride with a double bridle (that is, one with two bits and two reins) except for during the steeplechase section.

On the first day, each rider had to complete a long-distance ride of 53km (33 miles), followed by a cross-country test of 5km (3 miles) over natural obstacles with a time limit of fifteen minutes. On the second day, officers

**OPPOSITE** Horses that compete at the very top level in three-day eventing need power and stamina to negotiate the varied jumping challenges of a cross-country course.

rode over a steeplechase course; the third day was devoted to showjumping and the fourth day to dressage. The ten-minute dressage test was assessed by seven judges and included a collected and fast walk, collected and fast trot, rein-back, gallop, pirouette and jumping.

Twelve years after its Olympic debut, at Paris in 1924, the format of the three-day event was established. The dressage test was on the first day, an endurance test on the second that included a short roads and tracks (Phase A), followed immediately by a steeplechase (Phase B), with a long roads and tracks (Phase C) straight after. A compulsory halt was instituted after Phase C for a veterinary examination, after which the competitor began Phase D, the challenging cross-country. In Paris there was a Phase E on the second day, a 2km (1¼ mile) run-in on the flat after the cross-country, but this phase was dropped by the next Olympics. The third and final day was the showjumping. And, importantly, from 1924 the three-day event was open to civilian competitors.

The emphasis was on completion, not competition. When horse and rider completed the entire speed and endurance test, they would have covered about 19km (12 miles) of roads and tracks – a timed section taken at medium pace, 4km (2½ miles) at steeplechase speed (around 500m/550yd per minute), 8km (5 miles) of cross-country, and roughly 1.6km (1 mile) in the final cool-down phase. It was as much a test of the rider as the horse; the dressage was designed to train mounted officers and men to manoeuvre on the parade ground. It was a necessary part of a cavalryman's training because the same commands and formations would be used to control and direct mounted troopers during combat. The speed and endurance test was designed to show that a young officer could ride at speed and, after a period of recuperation, gallop and jump over cross-country obstacles.

When the Games came to London in 1948, the British finished out of the medals. But the 10th Duke of Beaufort was inspired to build a horse trials course at his family seat, Badminton House in Gloucestershire, to train future eventers. He recognized that the hunting and racing traditions in Britain should enable riders to do well in future Olympic competition and the first trials at Badminton were held in 1949.

The Duke's vision grew into the Badminton Horse Trials, the world's most prestigious eventing competition, and one of the six four-star fixtures. It is the second in the calendar year, held over the first weekend in May, following the Kentucky Three-Day Event at the end of April. The other fixtures are Luhmühlen in Germany in June, Burghley Horse Trials in England at the end of August, Les 4 Etoiles de Pau in France in October and the Australian International Three-Day event in Adelaide at the beginning of November.

**RIGHT** At only 15.2hh (157.5cm), Camilla Speirs' Portersize Just a Jiff is clearly enjoying his job as he makes the huge jump look easy – tucking his forelegs neatly beneath him and looking eagerly for the next fence at Badminton in 2015.

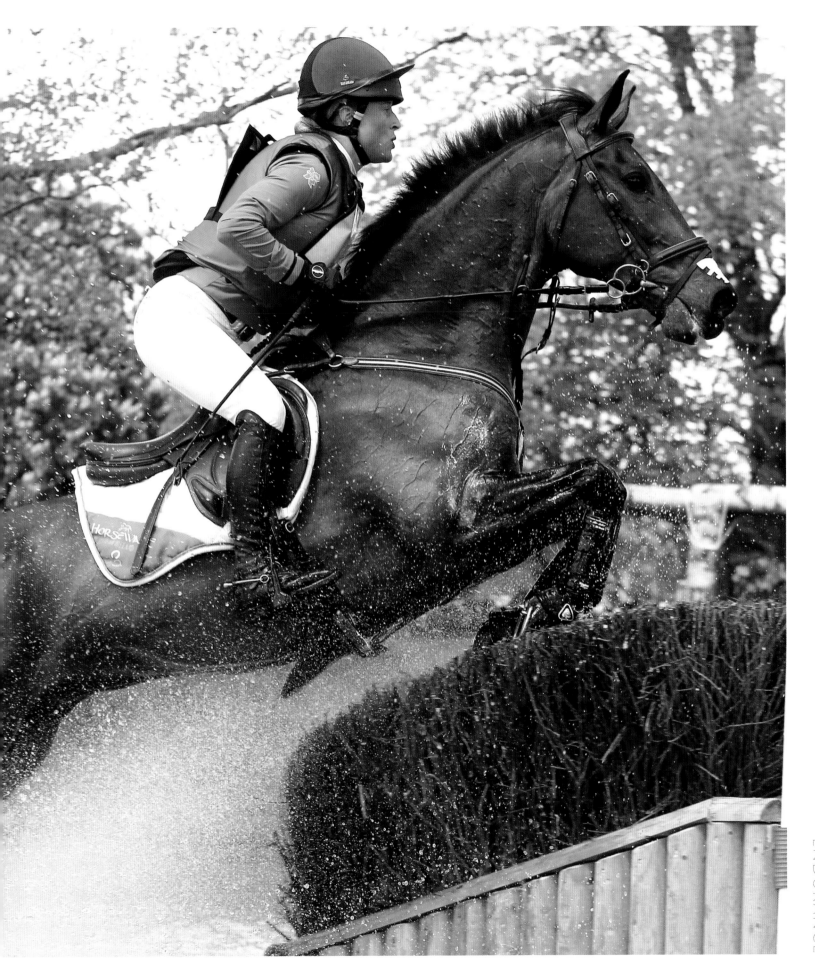

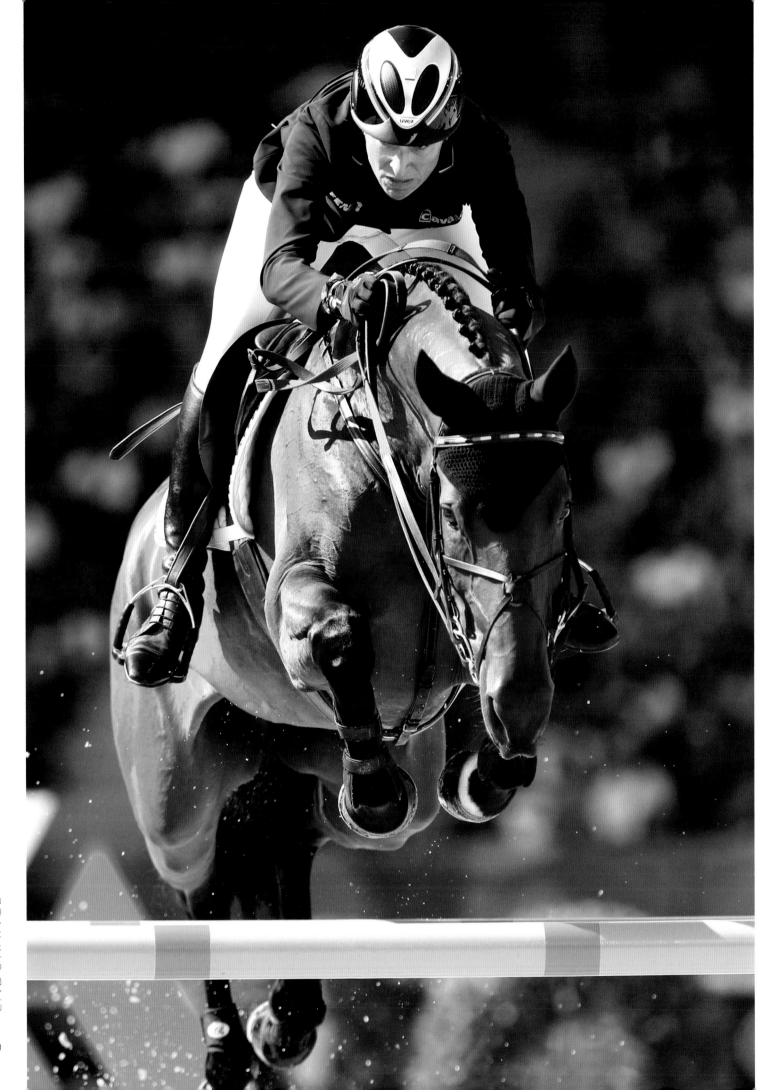

In terms of the Olympic Games, a new short-format was adopted relatively recently. The long five-phase format that had been established after the Paris Olympics of 1924 went by the board in Athens in 2004, a mere eighty years later. Crucially the steeplechase phase was dropped. Equestrianism's governing body FEI (*Fédération Équestre Internationale*) suggested the change as an alternative to a proposal to eliminate eventing from the Games altogether.

But it was not a universally popular decision as it was felt by some that endurance – the mark of the eventer at the very peak of its ability – would no longer be at a premium, and that horsemanship and all-round equestrian knowledge would cease to be the prime necessity for the rider. It could be argued that preparing a horse to gallop round a 5.6km (3½-mile) course with thirty-five jumps demanded no great feat of horsemanship. However, preparing the horse to do that same course immediately following the first three phases – dressage, steeplechase and roads and tracks – of a full-scale three-day event was an entirely different prospect. The three-day event in traditional long-format had been considered the ultimate test of both horse and rider; while the fitness of the horse was paramount, the rider had to be in absolute tune with their horse to know intimately its capabilities and its limits. Nevertheless, the short-format three-day event has now been fully established and continues to attract competitors from around the world.

The Thoroughbred was bred to gallop at speed for long distances and to be brave enough to take on daunting obstacles. It had been doing this in steeplechases almost since the breed was first developed in the eighteenth century. However, once the roads and tracks and steeplechase sections were lost to the new short-format, the event horse no longer needed quite so much Thoroughbred blood. Those early cavalry chargers would perhaps be outclassed now, as the emphasis shifts from endurance to the agility in the dressage phase, though Thoroughbred blood will always be a requirement.

Great Britain team stalwart Ian Stark once commented that the most important attribute for an event horse was the desire to get to the other side of the fence. But more recently, as eventing horses are bred for their stamina and athleticism, the attributes necessary to perform the dressage test have become increasingly influential.

The Thoroughbred, with its intelligence, speed and stamina, has played a huge role in modern three-day eventing. But whatever the breed, there must be mutual trust between horse and rider – a brave rider emboldens their horse, but the giving of confidence is a two-way street. The cross-country phase is demanding and the obstacles daunting. From giant steps to lakes, tight corners and yawning ditches, obstacles at the world's four-star events demand accuracy, scope, courage and, above all, trust. For the horses, it is quite literally a leap of faith (see page 80).

**OPPOSITE** After an exhausting gallop across country, Germany's Ingrid Klimke and SAP Escada FRH must have the stamina to complete a showjumping round, as well as the accuracy and athleticism to clear the coloured poles and set up for the next jump.

It is testament to the enduring ability of the Thoroughbred that one of the most medalled horses in three-day eventing history is a 'racing reject' called Over To You. Ridden by Jeanette Brakewell, he was a regular member of the British eventing team, winning team gold at the European Championships in 1999, 2001, 2003 and 2005, and Olympic team silver at Sydney in 2000 and at Athens in 2004. The partnership also won individual silver at the 2002 World Equestrian Games in Jerez, Spain. Having completed Badminton Horse Trials for an incredible seventh time, at the age of nineteen in 2007, the gelding was retired. At the time, Brakewell said: 'He is such a good, sound horse who gallops and jumps. But that's the Thoroughbred for you.'

Thoroughbred bloodlines run through the world's top eventers like a golden ribbon. Stallions such as Ben Faerie can be found in the pedigrees of many leading horses, such as Primmore's Pride, who was seven-eighths Thoroughbred, and helped Great Britain's Pippa Funnell to an epic victory in the Grand Slam of Eventing in 2003. This competition offered a cheque for $250,000 at the time; to claim it, a rider had to win three of the four-star three-day events consecutively. Funnell completed the trio by winning Kentucky and Burghley on Primmore's Pride, sandwiching her win at Badminton on Supreme Rock. This pairing had also triumphed at Badminton in 2002.

Funnell, née Nolan, was one of the leading eventers of her generation and was well aware of the importance of the bond between horse and rider. 'You can't separate the physical and the mental. It's feel. If the horse is starting to lose a little bit of concentration, you have to sense it almost before it happens, then make a tiny adjustment hardly visible to anyone watching,' she once explained. 'But some riders don't have that feel. Suddenly they've lost the horse and have to make a major adjustment. If I'm on a horse before a dressage competition, someone might talk to me and I don't even notice them. ... I've already started to find the feel. The horse is incredibly sensitive to that, too.'

Supreme Rock was by the Thoroughbred sire Edward Burke out of an Irish Draught sport horse mare. As well as those back-to-back Badminton victories, he also earned two consecutive European Championship titles, team bronze at the World Championships and Olympic silver. To have two championship-level horses at her disposal obviously enabled Funnell to reach the eventing heights, but she still required the skill and perseverance to complete the courses.

**RIGHT** The Thoroughbred has always excelled at eventing because it possesses bravery, as well as the stamina demanded by this equestrian sport.

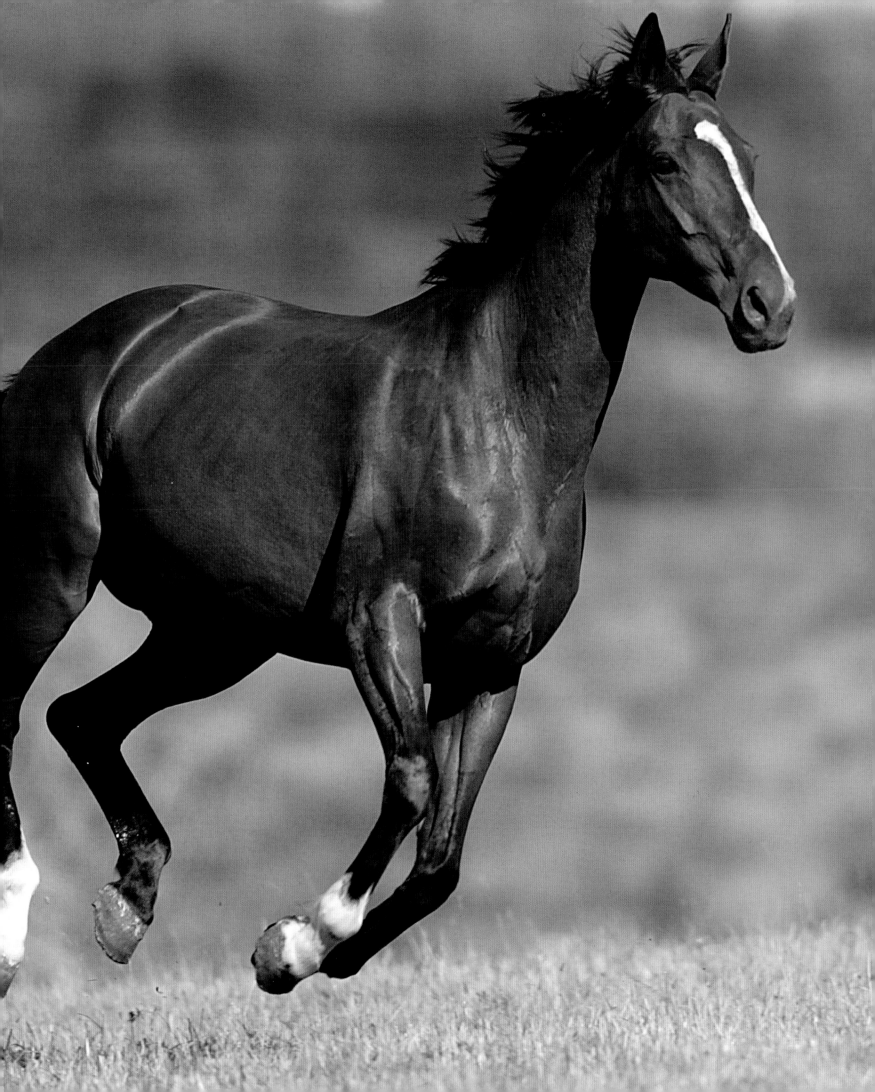

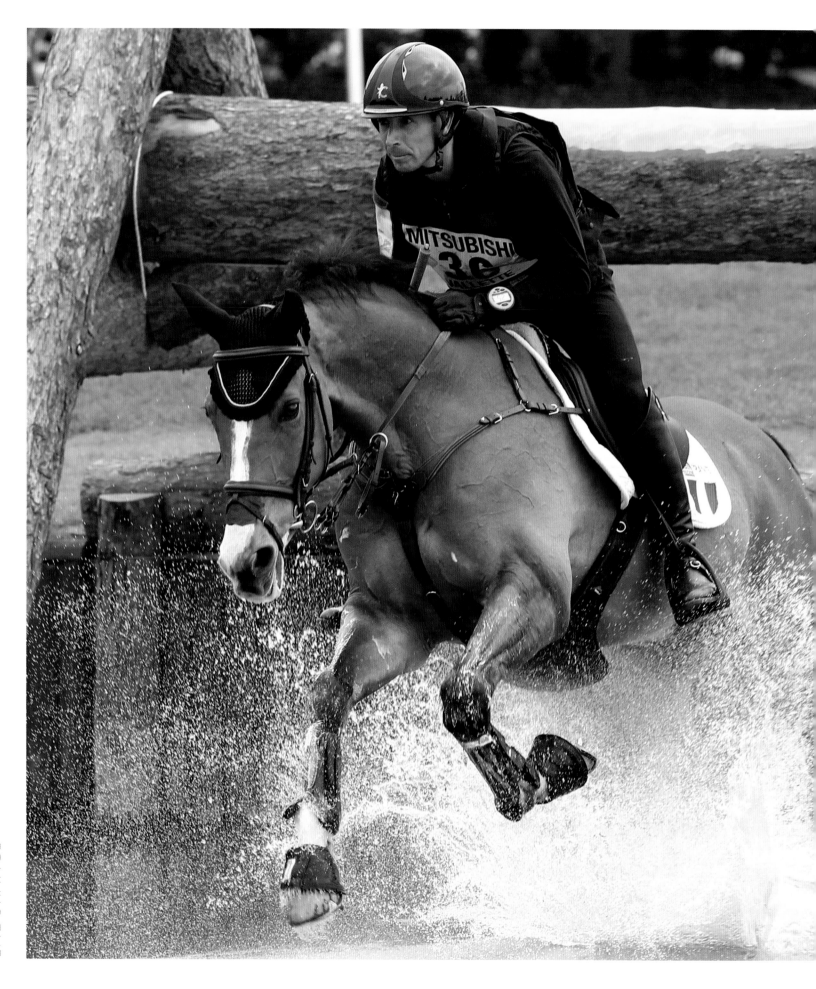

Great Britain's Ginny Elliot (formerly Leng, née Holgate) also had some superb horses, including two by Ben Faerie: Priceless and Night Cap II. Priceless won Olympic team silver and bronze individual in Los Angeles in 1984, a World Championship gold medal in Gawler, Australia, took European team gold, and won Burghley (twice) and Badminton. He never had a refusal or a fall in his eventing career. 'He was brave, genuine as the day is long, and incredibly intelligent,' said Elliot. 'He knew when it was a three-day event because he went quiet when he arrived and would lie down and rest.'

But like many of the best competition horses, Priceless – known simply as 'P' at home – had his quirks. He did not like to be told anything and would buck if asked to canter or given a wake-up tap with a whip. At Burghley during the European Championships he once bucked within six strides of the fearsome bullfinch – a fence with soft brush on top of the main jump obstacle which horses have to push through. He did the same trick coming into the first fence at the World Championships in Gawler, banking it with his hind feet and almost unseating his rider. But he was clever enough on both occasions to clear the obstacle and help Team GB to gold.

While Elliot describes Priceless as a 'bossy' horse, by comparison Night Cap II was rather timid and had a tendency to blow up in the dressage. At the Luhmühlen three-day event in 1987, to try to combat his timidity, Elliot persuaded a 'rent-a-crowd' to clap in the run up to the competition. 'On the day of our test, we took him up to the dressage arena early, fed him his lunch, and let him graze and listen to the clapping. It worked amazingly well,' she recalled.

Two horses that could not have been more different, yet the same rider managed to get a superb tune out of both of them. Elliot was one of the best riders of her time but it is also a testament to the lines of sires like Ben Faerie, who pass their valuable genes on to their progeny.

While the Thoroughbred influence undoubtedly gives horses such as Priceless and Night Cap their speed and endurance, Irish blood is found in many top eventers. An obvious example is Lenamore, one of the most popular and enduring event horses of all time, who retired from the top of the sport at the age of twenty. The Seacrest gelding, bred by trainer Ted Walsh in Ireland and competed by his owner Lexi Jackson up to three-star, was out of an Irish Draught sport horse mare. The draught blood provides the all-important bone and some of the horse's 'engine'. Eventers need sound limb and plenty of power to get across country.

**LEFT** Water challenges often feature more than once in the big four-star three-day events. The obstacles encountered tend to be 'natural' in design and may involve jumping into and then out of a lake, as demonstrated here by France's Thibaut Vallette and Qing du Briot Ene HN at Badminton, 2017.

The two American riders to win Badminton were both riding Thoroughbred-Irish Draught sport horse crosses, Bruce Davidson on Eagle Lion in 1995 and David O'Connor on Custom Made in 1997. Indeed, in recent years, the prevalence of full Thoroughbred or half-bred stallions has dropped like a stone. As in dressage and showjumping, perhaps unsurprisingly, the warmblood is becoming far more popular. One of the most enduring partnerships of recent years is New Zealand's Mark Todd and the plucky little Charisma, standing under 16hh (163cm) compared with Todd's 1.88m (6ft 2in). The dark brown gelding was by a Thoroughbred sire but his dam was one-sixteenth Percheron.

Another notable eventer was Tamarillo, ridden by Great Britain's William Fox-Pitt, with whom he won medals at an Olympic Games (2004), two World Equestrian Games (2002 and 2006) and a European Eventing Championships (2005). He has also won both Badminton and Burghley, an impressive feat for any event horse. But there something else notable about the gelding – he was an Anglo Arab. His sire Tarnik was a Thoroughbred Polish endurance stallion, who was 23 per cent Arabian. Having won the 42km (26-mile) Arab Horse Society Marathon, Tarnik undoubtedly passed on that endurance to his son.

Undeniably talented, Tamarillo was also, like some of the best horses in any discipline, decidedly quirky, to his rider's exasperation. 'He could be everything all at once – spooky, lazy, sharp, exuberant, sensitive. He was extraordinary and unique,' said Fox-Pitt. 'His personality has been both his gift and his Achilles heel. He's probably one of the most talented athletes the eventing world has ever seen, but his career has been one of great highs littered with "what ifs".'

Tamarillo died in 2015 at the age of twenty-three but he was the first event horse to be cloned. Named Tomatillo, his clone was born in 2013. He stood at stud for the first time in 2016 and his first foals were on the ground in 2017. Tomatillo was not an exact copy of Tamarillo, though he was said to be very similar, as an identical twin might be.

An Anglo Arab is a mix of Thoroughbred and Arabian – two 'hotblood' breeds – but it is the warmblood that is now the eventer of choice. In the Rio Olympics of 2016, the victorious French team were on Selle Français and Dutch Warmbloods, the German team, in silver, rode a Selle Français, an Oldenburg and a German Warmblood. This last was La Biosthetique-Sam FBW, ridden by Michael Jung, a formidable partnership and one of the most successful of the twenty-first century. Former British Olympian and German team trainer Chris Bartle said of the pair: 'It's 75 per cent Michael and 25 per cent Sam's heart. But his heart counts for a lot. He wasn't born with exceptional ability, but he tries his heart out.'

**RIGHT** Peak fitness is vital for the cross-country phase of a three-day event. The obstacles are daunting and both New Zealand's Andrew Nicholson and his horse Nereo required courage and absolute trust to tackle them at the World Equestrian Games in France in 2014.

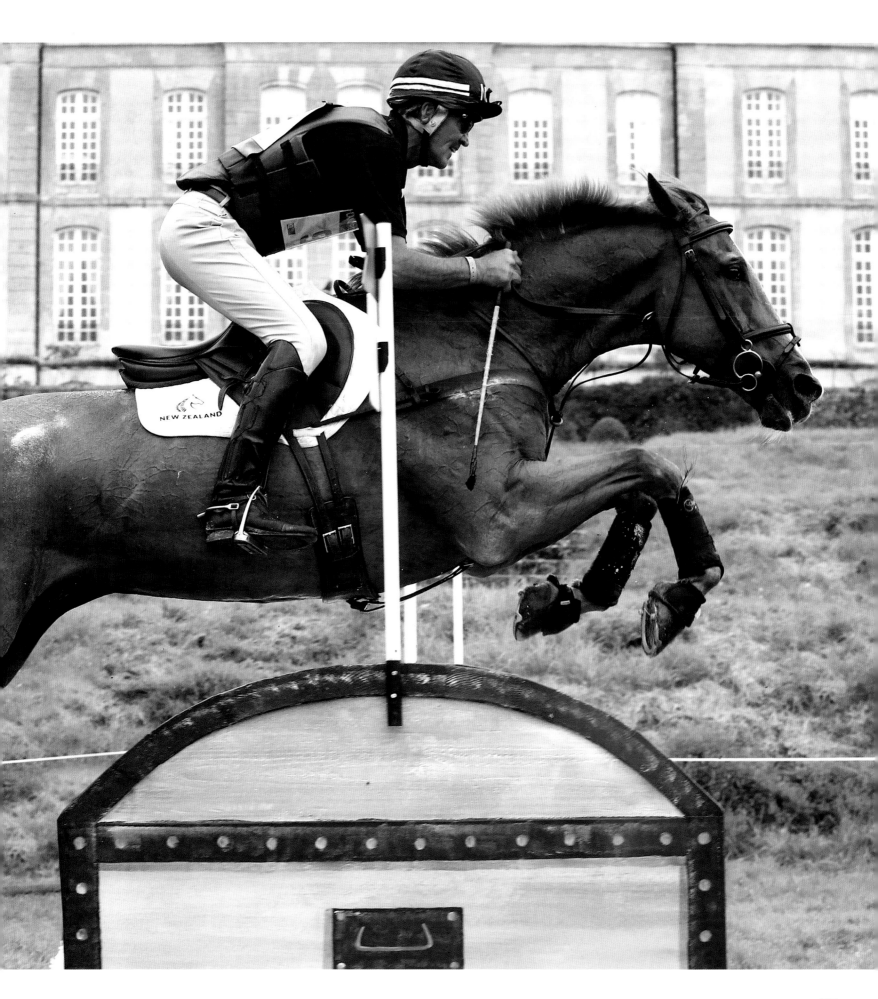

Their results prove his point – they also claimed individual gold in Rio, adding to the ones they claimed at London in 2012, European (2011) and World (2010), as well as Badminton in 2016 and Burghley in 2015. And that victory at Badminton was even more notable as it meant that Jung claimed the Rolex Grand Slam, only the second time a rider has completed the four-star hat-trick since Pippa Funnell in 2003. Jung had won Kentucky and Burghley, and his historic win at Badminton – by a massive nine-penalty margin and the lowest-ever winning score at the event – sealed the deal. This time the prize cheque was for $350,000.

No doubt the Rolex Grand Slam will be claimed again, though it remains to be seen if it will take another thirteen years. But as three-day eventing continues to evolve so too will the horses. Certainly lessons have been in learned in horse welfare – which must be paramount whatever the sport – after concerns were raised prior to the Atlanta Olympic Games of 1996. The heat and humidity of a Southern summer had led to extensive research into how the equine athletes would cope. The horses were given three weeks to acclimatize: seven days to recover from the effects of the transport and fourteen to adapt to the new climate. Eighty-five misting fans were installed all around the venue, sixty of which were set at the halt boxes on the endurance day. The distances were also greatly reduced. From the usual total of just under 27km (17 miles), the overall distance in Atlanta was cut down to around 20km (12¼ miles). Thankfully, no horses were adversely affected, but the logistics involved no doubt contributed to the short-format being adopted just eight years later.

While the humidity of the deep South could have caused problems for the modern eventer, the breed long accustomed to desert heat – the Arabian – has dominated the sport of distance riding. The breed, one of the world's oldest, was developed in the desert by the Arab Bedouin people and, due to the harsh environment, only the very strongest survived. The modern Arabian is probably very different from those early equines, but it is still the breed of choice for endurance competitions.

Of all the equestrian disciplines, the sport of endurance is arguably the one that demands the greatest knowledge of the individual horse's abilities and limitations. Just as the three-day eventer must keep enough in his equine partner's 'tank' so that it does not run out of wind and energy before the end of the cross-country phase, so must the endurance rider conserve his horsepower – for much longer distances.

Although the modern sport is still in its infancy, long-distance riding is nothing new. In January 1912 a thirty-year-old American called George Beck hatched a plan to ride his horse, Pinto, from his home on Bainbridge Island, Washington, to every state capital. The journey would span 32,752km (20,352 miles) and he would complete it in three years, ending in San Francisco in time for the Panama-Pacific International Exposition, or World Fair. Something of a ne'er do well, Beck figured the epic ride would make him famous – and rich.

He and three companions, who called themselves the Overland Westerners, completed the trip in thirty-seven months, but they didn't find

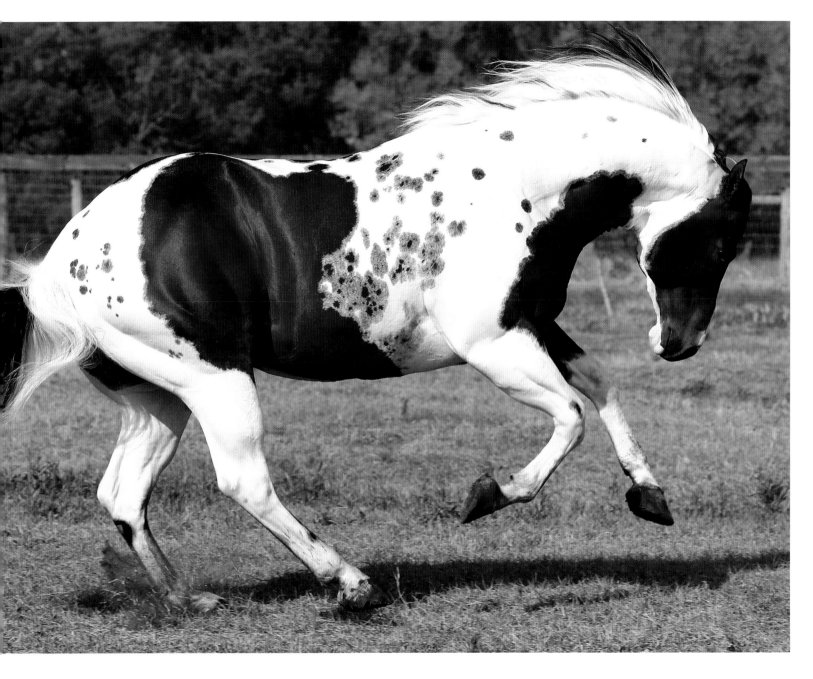

fame. Pinto was the only horse to complete the whole distance, as the others were traded for fresh ones, and he clearly forged a strong bond with Beck. But like the four riders, he too has been largely forgotten over time.

Perhaps it is no surprise that endurance as a sport began in the United States. The US cavalry tested its horses on a five-day, 480km (300-mile) ride, with each horse carrying more than 90kg (200lb) in weight. It didn't become a competitive sport until the 1950s, when Wendell Robie rode the rugged 160km (100-mile) trail from Lake Tahoe to Auburn in less than twenty-four hours. He subsequently founded the Tevis Cup, held in California, which is the oldest modern-day endurance ride. The Tevis Cup goes to the rider who completes the trail in the quickest time and whose horse is in sound condition and 'fit to continue'. At the same event, the Haggin Cup is awarded to the rider whose mount is judged by the Veterinary Committee to be in the 'most superior physical condition' of the first ten horses to cross the finish line.

**ABOVE** In 1912 the Overland Westerners set off to ride across the United States. Not much is known about their horses, but some of them were pintos or paints, like the stallion above, and they were certainly very tough. The journey took more than three years.

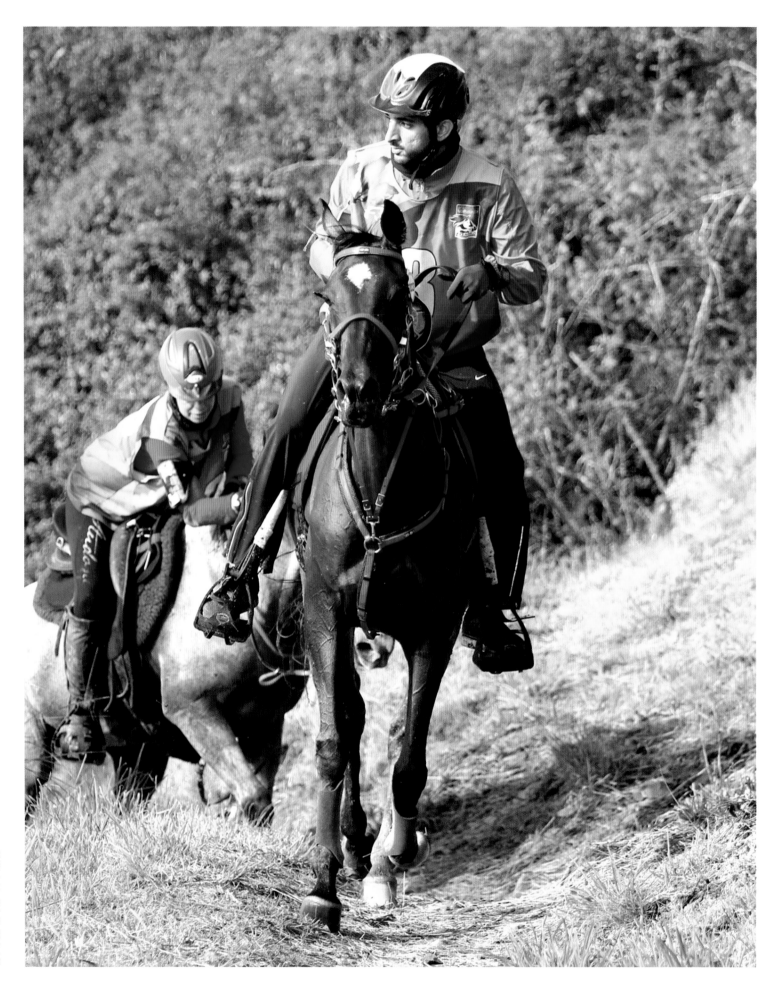

The sport in the twenty-first century has the horses' welfare at its heart. During organized rides, which vary in length and terrain, veterinary checks are held both during and at the end. The vets will only allow horses to resume the race if they are deemed 'fit to continue'. If a horse does not recover sufficiently in a set time at the end of a race, it will be eliminated. Sadly, in recent years, some countries that compete to a high level in international events have been found to have a 'win at all costs' attitude and the FEI, the governing body of equestrian sports worldwide, has been forced to take action.

For the endurance enthusiast, however, the sport offers the opportunity to pit themselves and their equine partner against challenging rides across beautiful countryside. Endurance GB, which governs the sport in Great Britain, has access to ancient routes and rights of way. It organizes pleasure rides and endurance rides, the former being social events for groups of people to enjoy on horseback. These are not vetted but must be ridden at a speed of no more than 12kph (7.5mph), though advanced pleasure rides may be ridden at 15kph (9.3mph). The rides vary in distance from 10 to 40km (6¼ to 25 miles).

There are two types of endurance ride: graded and competitive. Graded rides are held over one or several days, with speeds between 8 and 18kph (5 and 11mph), and horses must comply with set veterinary parameters before and after the ride. Those that successfully complete the ride are awarded a grade based on pulse and speed.

The competitive rides – which are included in the World Equestrian Games and have both World and European Championships – are the hardest tests for both horse and rider. Held against the clock, they test the speed and endurance of a horse and challenge the rider over their effective use of pace, thorough knowledge of their horse's capabilities and ability to cross all kinds of terrain. Although the rides are timed, the emphasis is on finishing in good condition rather than coming in first. Each rider must safely manage the stamina and fitness of their horse and each course is divided into phases – at least every 40km (25 miles) – with a compulsory halt for a veterinary inspection, or 'vet gate', after each. Each horse must be presented for inspection within a set time of reaching each vet gate, which determines whether it is fit to continue.

An impressive 133 riders and horses from forty-five countries and five continents competed in the World Endurance Championships in 2016, hosted by Slovakia at Samorin, where much of the ride followed the River Danube. The title was taken by Spaniard Jaume Punti Dachs, who also took team gold, riding Twyst Maison Blanche. They were not the first over the finish line, but the first two home, both from the United Arab Emirates, were vetted out. Punti Dachs completed the 160km (100-mile) course at an average speed of 23.6kph (14.7mph) to add the World accolade to his European Championship double gold won at the same venue twelve months previously.

'It was a very tough day,' Punti Dachs said afterwards. 'There were magnificent horses in front of me, but endurance sometimes happens like this. You do everything right and then something goes wrong. It's like life.

**OPPOSITE** Organized endurance rides take place over all kinds of terrain – providing a searching test of a horse's stamina. Here Sheikh Hamdan bin Mohammed bin Rashid Al Maktoum of the United Arab Emirates is tracked by Spain's Maria Alvarez Ponton at the World Equestrian Games that were held in Normandy in 2014.

This is so emotional … I had a young horse and he did really very well on the course. That was the most important, that he managed the race so well.'

His equine partner, Twyst Maison Blanche, a pure-bred Arabian gelding, was then nine years old. But while Arabians are usually among the medals, other breeds – including part-breds and some of Britain's native ponies – are also perfectly suited to the challenging sport, where the rewards are not in medals but in having a fit and sound horse at the finish line.

A fit and sound horse is a requirement for the hunting field, too. The sport of hunting has its roots in the Inclosures Acts of the eighteenth century. Once farmers and landowners were entitled to enclose their property, the only way to get across country on horseback was to jump those hedges and fences. At the same time, the population of the preferred quarry – deer – went into steep decline. As the increasing number of roads and railways further gobbled up the large tracts of land needed for deer hunting, they also made it easier for the hunt follower to travel to pursue the increasingly popular pastime of fox hunting.

Today there are some 170 packs of foxhounds in Britain, although the sport of fox hunting was banned in 2005. In its place, the hunts use a rag dipped in a pungent concoction to lay a trail; this is called trail hunting or drag hunting, as the rag is dragged behind a horse. The fox hunts have adapted extremely well to the 2004 Hunting Act that banned the hunting of wild animals with dogs and trail hunting is increasingly popular.

In many ways, trail hunting is more fun than fox hunting as the trail-layer can ensure he takes a route that includes the choicest fences, hedges, gates and hunt jumps for the followers. A good horse is needed, though some hunt countries – the area that the hunt covers – require a more athletic jumper than others.

While obstacles encountered in Great Britain are mostly natural barriers, those encountered across the Atlantic are often man-made. In Georgia, the most common 'jump' is likely to be a chicken coop, although in California, you're more likely to have to negotiate a natural crevice than a hunt jump.

The 'special relationship' that exists between the United States and Great Britain extends to the hunting field. From the coast of Malibu to the pine woods of Alabama, from the arid plains of the Midwest to the sand dunes of Long Island, there are more than 150 hunts in North America and Canada.

Hunting was introduced to North America by the British in the seventeenth century. The earliest record is from 30 June 1650 when Robert Brooke arrived in Maryland with his family, twenty-eight servants – and his hounds. George Washington was a passionate hunter who owned a pack of hounds and his diaries record an occasion when congressmen, seeing a passing hunt, abandoned their work and leapt on to their horses to join in.

While still called 'foxhunting', the majority of hunts in North America actually hunt coyote, which is a worthy opponent of the hounds. A coyote can run at up to 64kph (40mph) and is capable of outdistancing the hounds through sheer speed if it chooses to. The object of the hunt is not to kill the prey, but to enjoy the thrill of the chase and the pleasure of riding in open country.

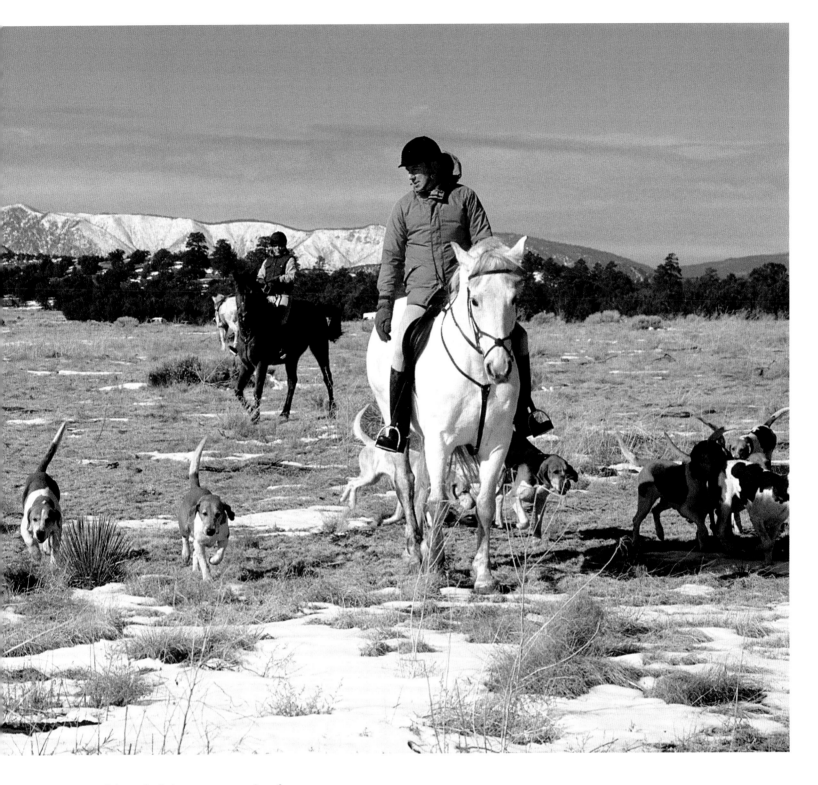

**ABOVE** A hunt in Arizona; most packs of foxhounds in the United States hunt coyote, but red and grey foxes are also quarry in some parts of the country. Coyotes predominate in the western states.

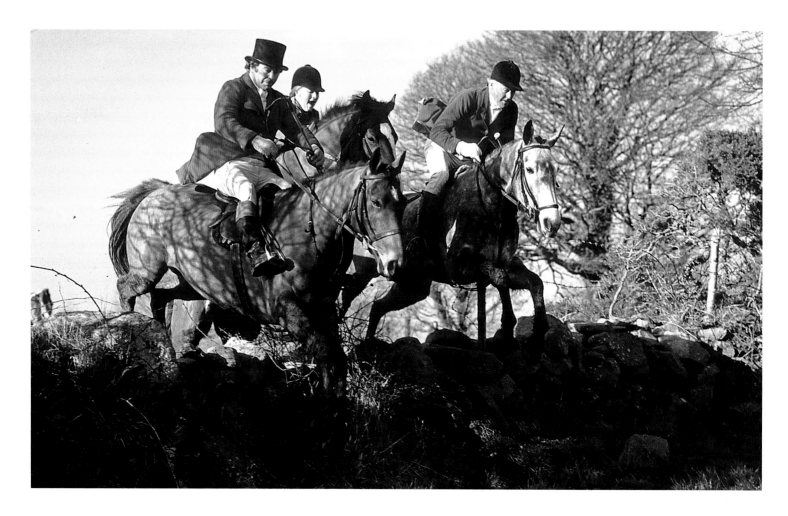

**ABOVE** Three experienced hunt followers fly a stone wall in Ireland. The beauty of hunting is that you take your fences as they come and trust your horse to look after you both when you jump.

Many of the earlier hunters probably had several roles at home, such as pulling a cart or working the land, but now hunt horses are bred for the job. It is hardly surprising that the Thoroughbred crossed with Irish Draught often seen in eventing is, for many, the ideal mix. The Thoroughbred's speed and endurance, combined with the Irish Draught's bone and power, gives you a horse that can cross country at steady speed and keep going all day.

For the huntsman, a full or three-quarter Thoroughbred is often most suitable. And, as with so many horses at the top of their game, some of them may be a little quirky. Phillip Fergus, who hunted the Fife – the most northerly pack of hounds in the UK – said: 'It takes a horse with a very different attitude to go up in front all the time – they need to be a bit odd.' Peter Collins, former huntsman of the Quorn, considered Britain's premier pack, added: 'My ideal hunt horse would be sixteen-two hands and agile with it. They've got to be good with hounds and they must jump. A hunt horse has to turn against 120 other horses and jump away from them. The best one I had was a Thoroughbred called Charlie Brown. He did all my big days for eight seasons and never stopped or fell. Twice I jumped the river on him – it was twenty feet wide, he jumped from bank to bank and a hundred yards later popped over a six-bar iron gate. You only get one like that in a lifetime.'

Huntsmen will tell tales of horses that knew where the fox was before they did, that will jump five-bar gates with barely taking a breath, and gallop all day. But for the hunt follower, a reliable horse that won't kick out at hounds – a terrible sin for which the unfortunate rider will be sent home

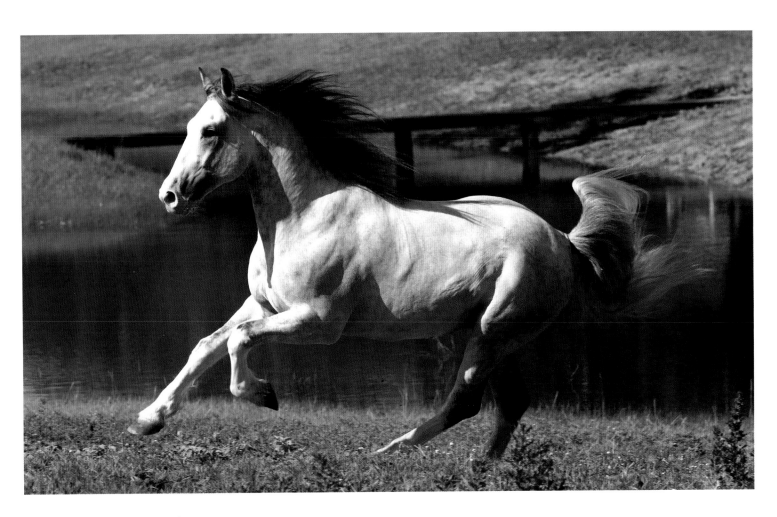

in disgrace – and can jump safely is enough. When you are galloping across unknown countryside, you need to be sure your horse can get you over any obstacle and out of trouble. You will hope it has the much-vaunted 'fifth leg' where a horse seems to find an extra leg to get itself out of trouble and prevent a fall, and many riders like a touch of pony in their horse to give it that cleverness and spring. This is where another Irish breed comes in.

The Connemara has speed, agility, athleticism and stamina, and is clever enough to find that extra leg. The rocky, almost lunar, landscape of Ireland's west coast, lashed by the Atlantic Ocean, is harsh and any creature that lives there has to be hardy and sure-footed; one misstep could mean plunging to a certain death. Celtic warriors brought their small dun-coloured ponies to Ireland some 2,500 years ago and some undoubtedly escaped capture, establishing a wild pony population in the mountains. Considered by many to be Ireland's only native breed, the Connemara is today much in demand for all equestrian sports, not just hunting.

Indeed, many of today's equine athletes are taken hunting as part of their general education. Most horses enjoy hunting because it is just as exhilarating for them as it is for their riders. Eventers routinely hunt their horses as it's a wonderful way to teach them how to negotiate obstacles that resemble those seen in the cross-country phase, while showjumpers are keen to encourage their horses to be able to think for themselves and learn how to get out of trouble. The endurance required to hunt all day is vital in a horse that must gallop for miles over an eventing course.

**ABOVE** The Irish Draught is used to add bone and substance to the Thoroughbred to make a superlative hunter that will carry you all day.

# EVENTING

It is the ultimate test of horse and rider; a heart-bursting, stamina-sapping gallop across country for 6.4km (4 miles), taking on obstacles of up to 1.2m (3ft 11in) in height. But the cross-country phase of three-day eventing is only part of that challenge. Before it, the horse and rider must perform a dressage test and afterwards complete a showjumping course.

The aim of the elite three-day event – and the summary above describes the highest level of competition, four-star, of which there are only six competitions in the world each year – is to reveal the partnership between horse and rider. The dressage phase tests the basic training of the horse, its obedience to the rider and the efficacy of the rider's aids. The cross-country is a test *par excellence* of the horse's endurance and its rider's skill; the course must be completed within an optimum time. The fences at four-star are truly awe-inspiring, designed as 'rider frighteners' rather than 'horse frighteners'.

Finally, the pair must complete a showjumping course, tackling fences up to 1.3m (4ft 3in) high and 2m (6ft 6in) wide. This showcases the horse's accuracy and agility. The whole event is an incredible test of a horse's all-round quality, with the cross-country endurance segment standing at its very heart.

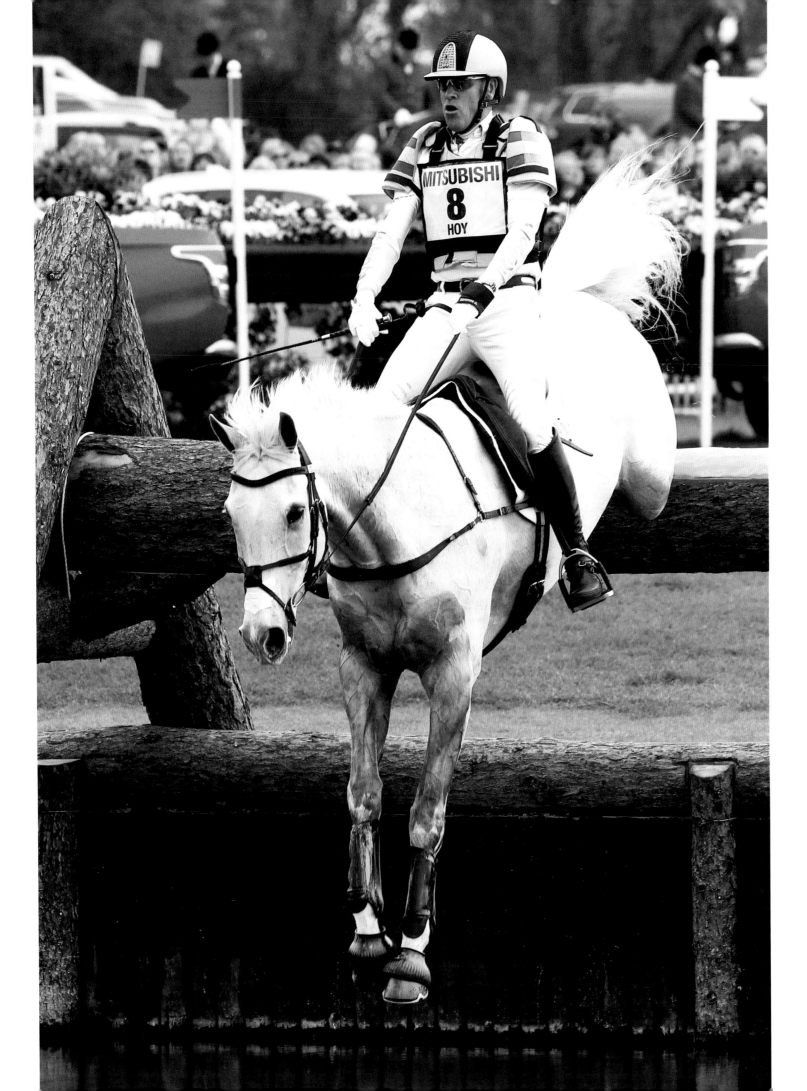

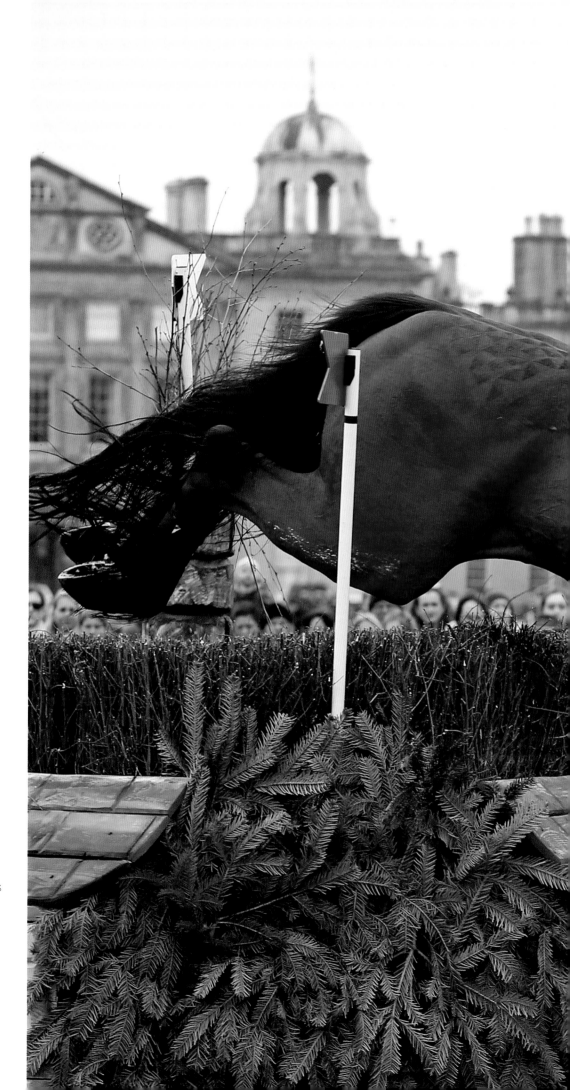

**RIGHT** By the time the event horse takes to the imposing cross-country course, it has already completed a dressage test, which is a discipline that demands very different skills. Germany's Ingrid Klimke and Horseware Hale Bob show how it's done at Badminton in 2017.

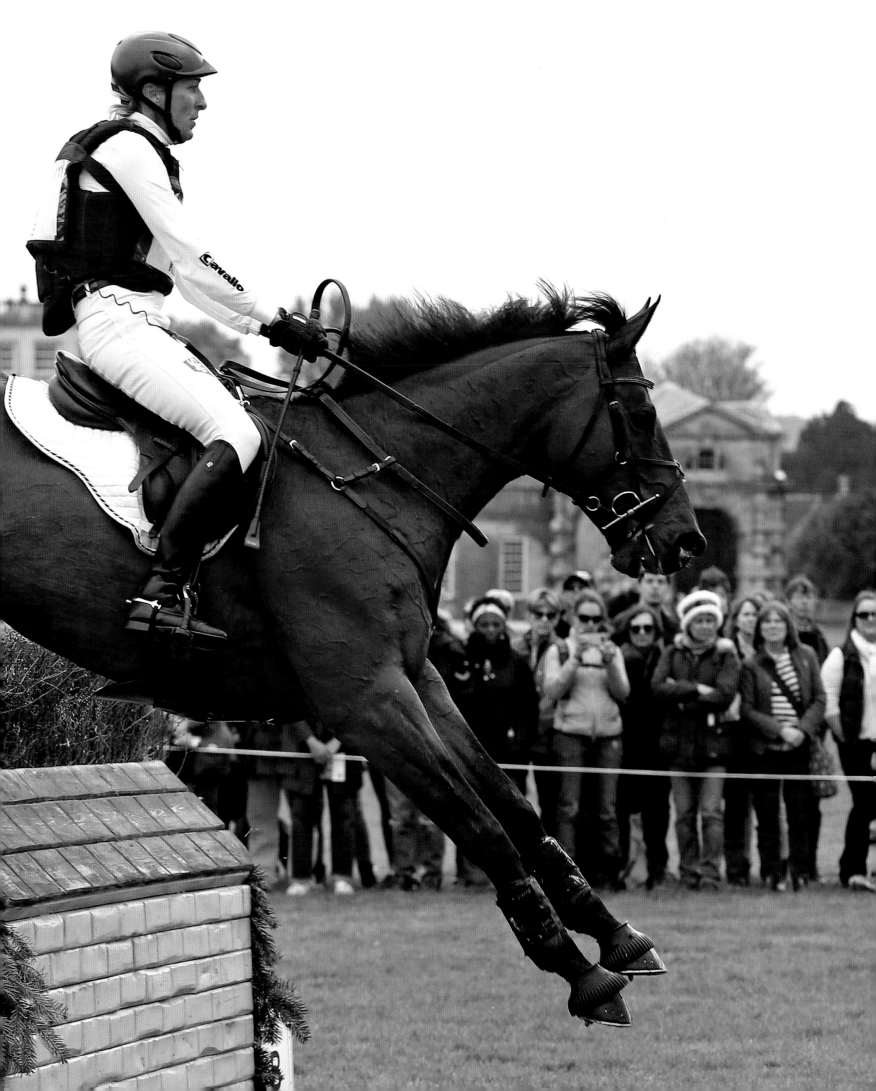

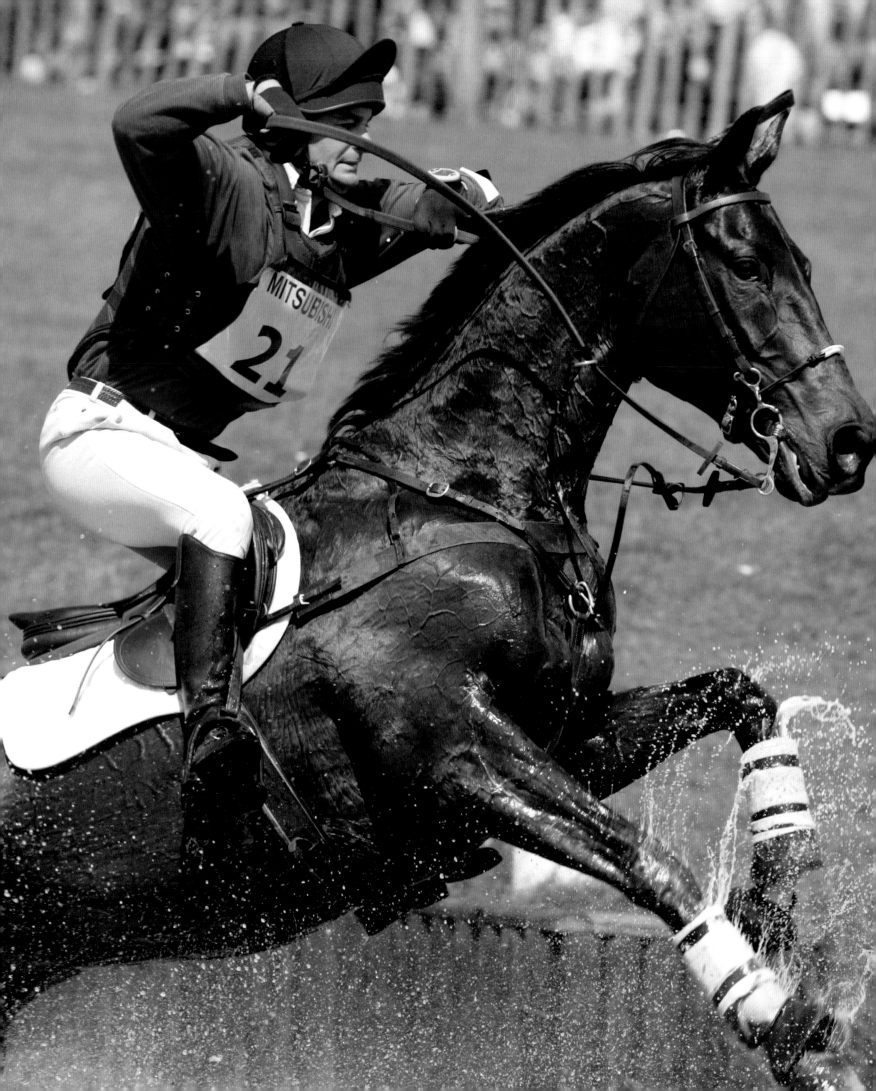

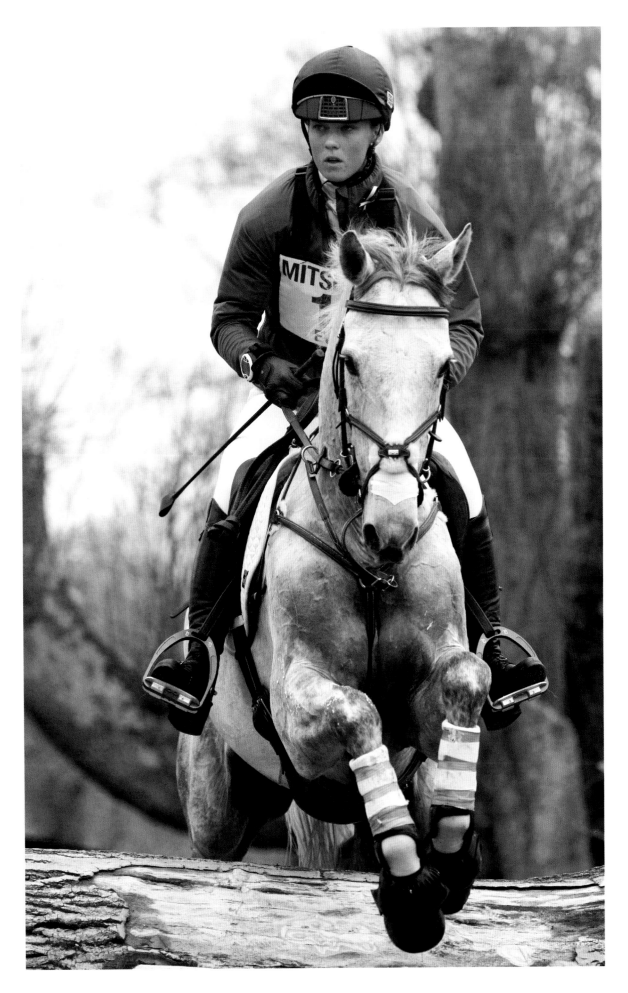

**LEFT** Both Dani Evans and Smart Time are looking for the next obstacle as they take on the exacting course at Badminton in 2016 on what was only the British partnership's second visit to the three-day event.

**OPPOSITE** Brook Staples and Daws Willowherb jump out of the water at Badminton in 2005. Jumping into water requires the horse to have great trust in its rider as it has no idea how deep the water might be.

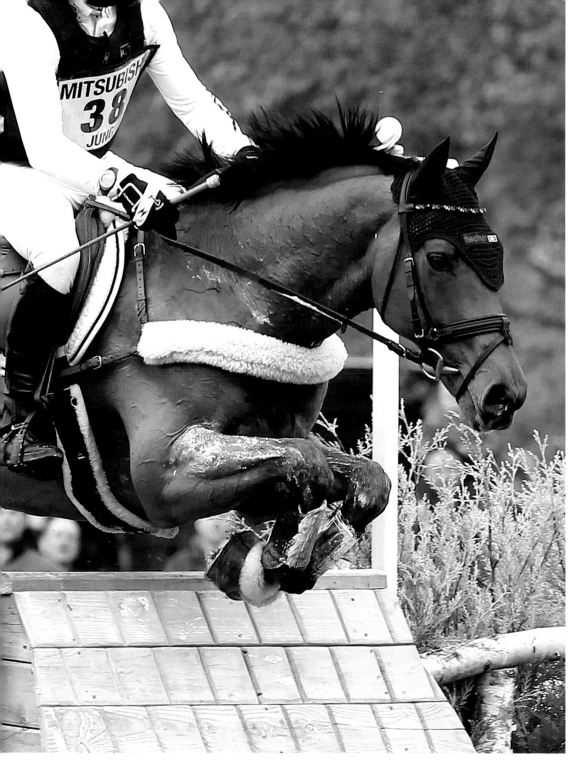

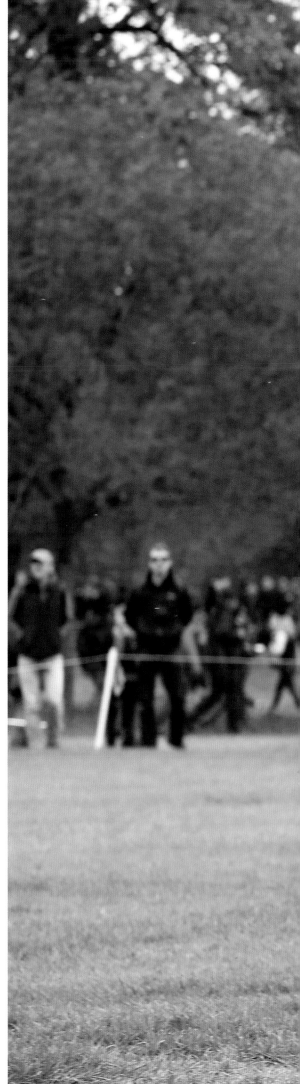

**ABOVE** The event horse must be bold and accurate as it has to tackle a variety of obstacles designed to challenge both horse and rider, like this narrow fence.

**RIGHT** Horses must gallop between fences because there is an optimum time prescribed to complete the cross-country course, and seconds over incur penalties. New Zealand's Blyth Tait and Bear Necessity V don't waste any time at Badminton in 2017.

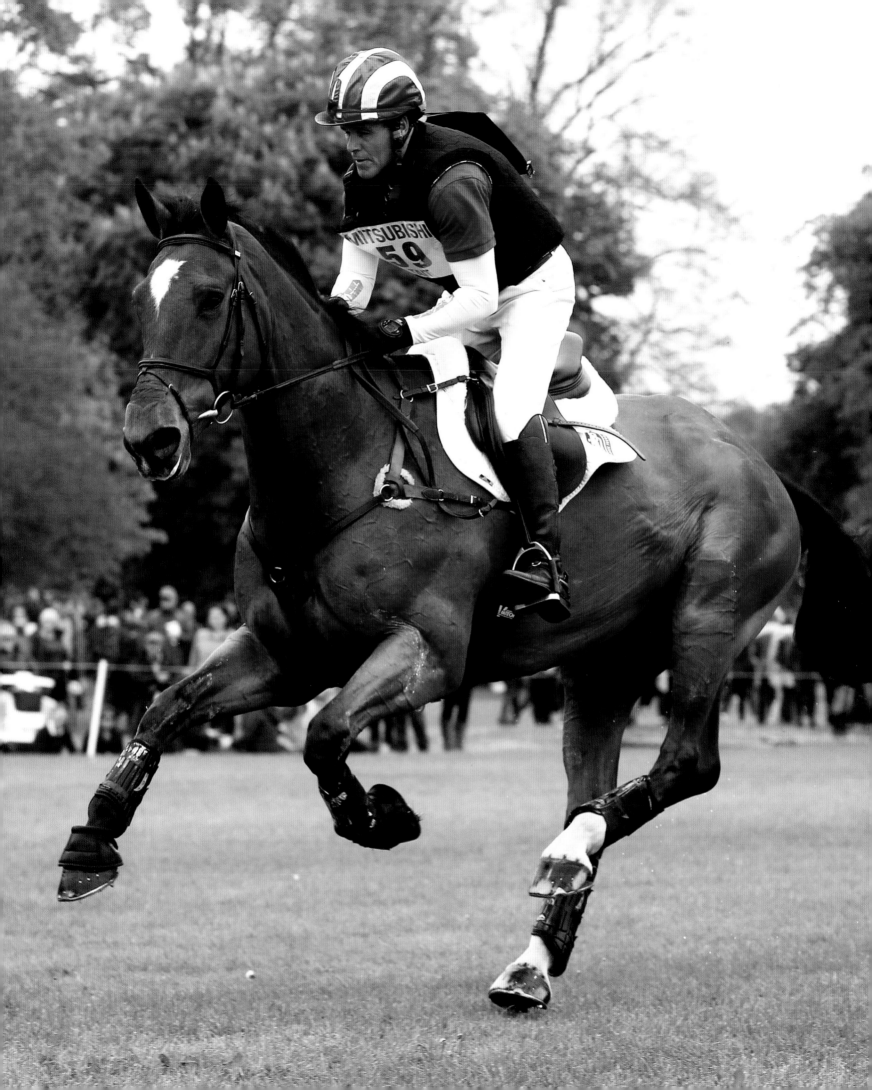

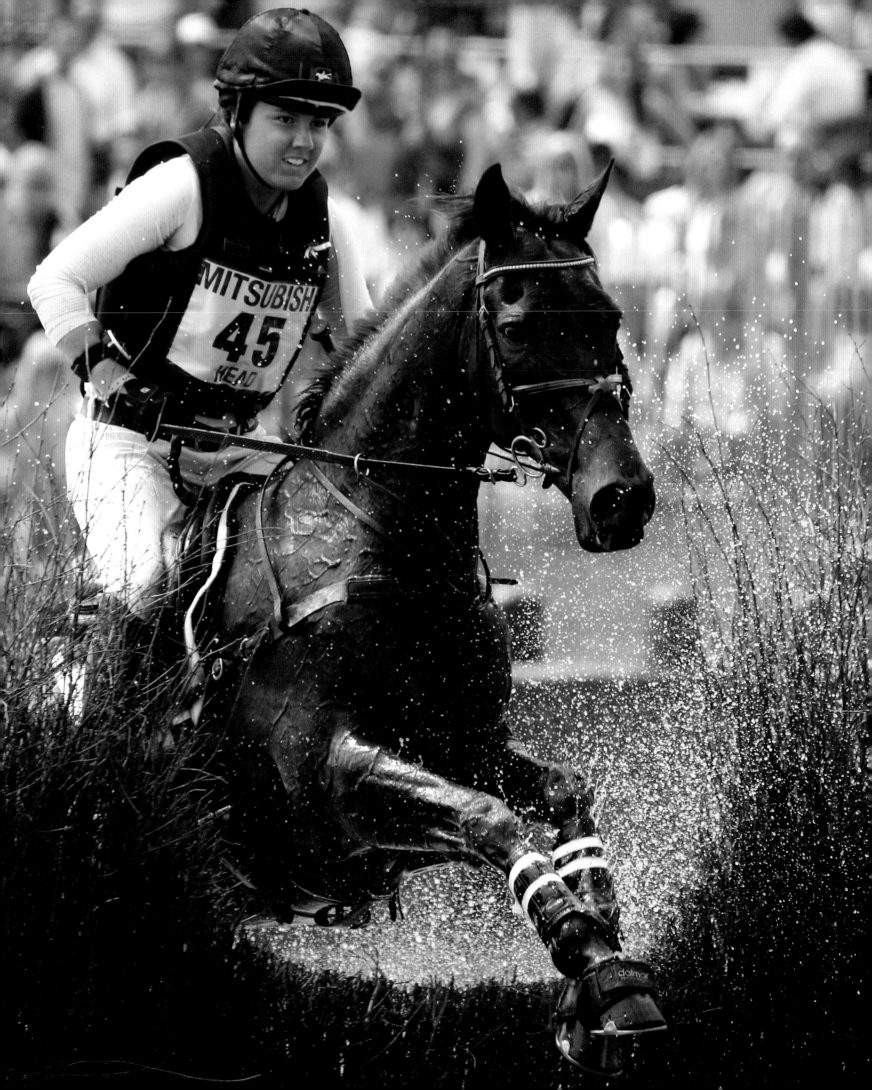

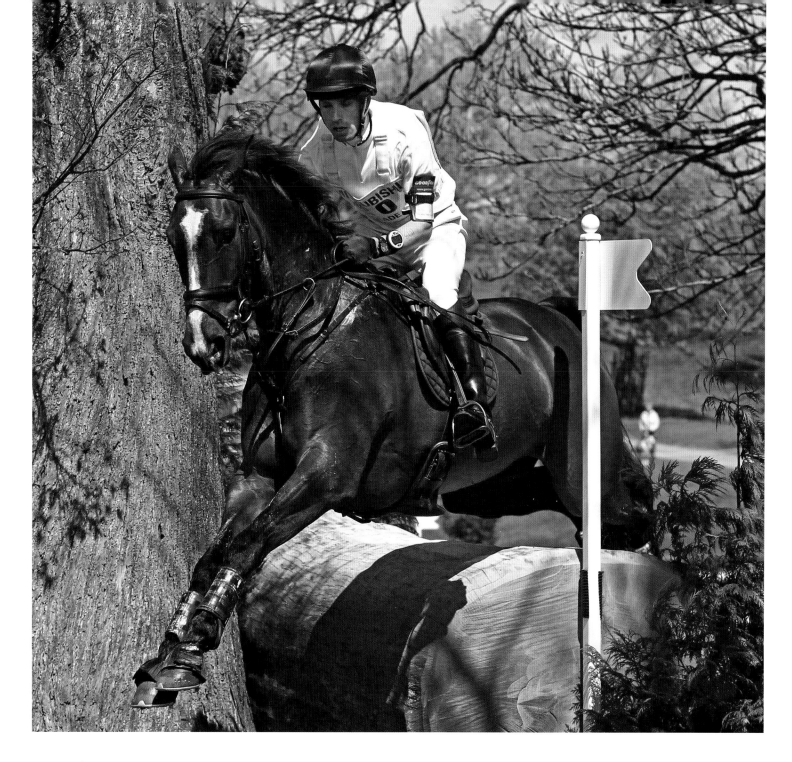

**ABOVE** Cross-country courses usually feature a longer – but easier – route that still tests the horses' endurance levels, but takes longer to complete within the time limit than the more direct route. Great Britain's Harry Meade and Wild Lone clear a skinny log at Badminton in 2013.

**OPPOSITE** Challenges involving water feature prominently on cross-country courses at all the top three-day events. They are designed to test the horse's courage as well as its rider's accuracy. Libby Head of the USA and Sir Rockstar take it all in their stride at Badminton in 2016.

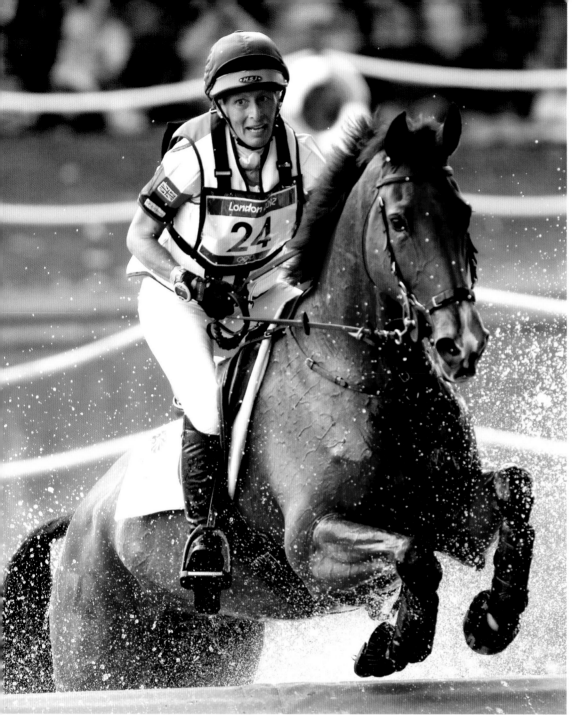

**ABOVE** One of Great Britain's most popular event riders, Mary King, and Imperial Cavalier en route to individual fifth place overall and team silver at the London Olympic Games in 2012.

**RIGHT** Zara Phillips – granddaughter of Her Majesty the Queen – and Toytown have a sticky moment jumping out of the water at the World Equestrian Games at Aachen, Germany, in 2006, but they went on to take individual gold.

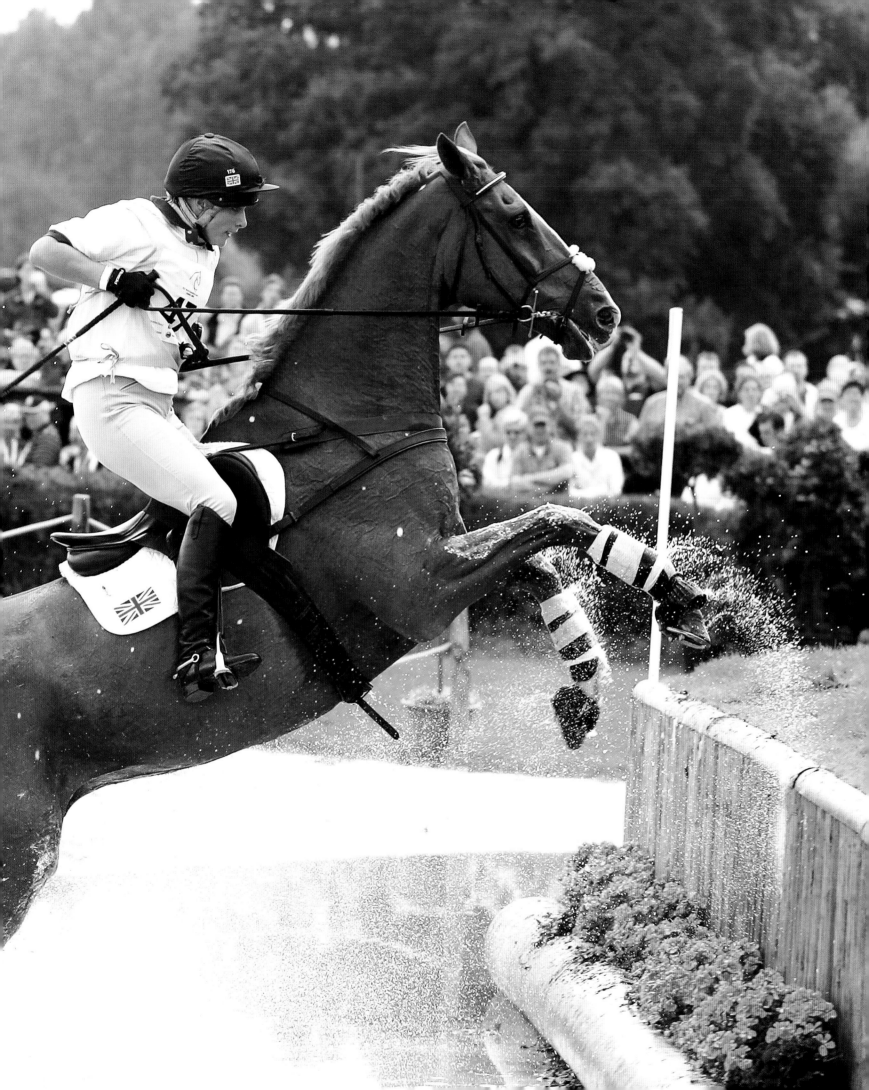

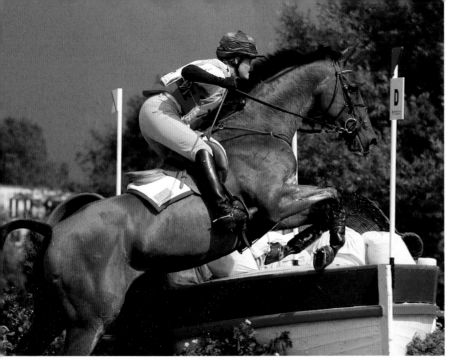

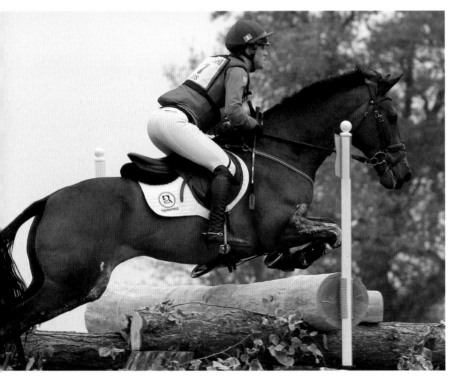

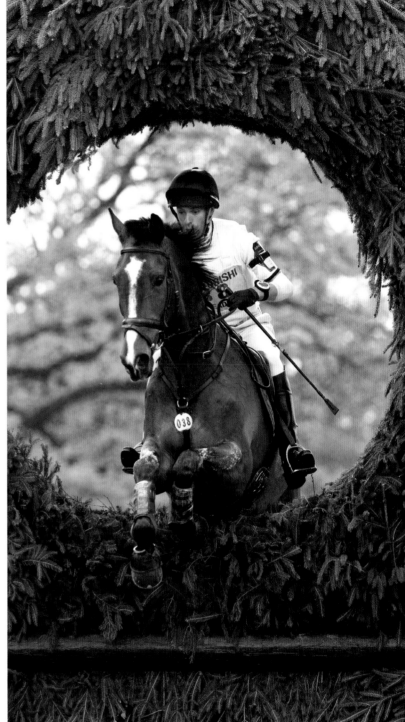

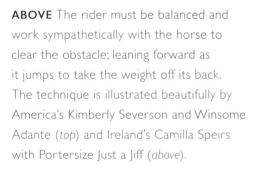

**ABOVE** The rider must be balanced and work sympathetically with the horse to clear the obstacle; leaning forward as it jumps to take the weight off its back. The technique is illustrated beautifully by America's Kimberly Severson and Winsome Adante (*top*) and Ireland's Camilla Speirs with Portersize Just a Jiff (*above*).

**ABOVE** Keyhole fences test accuracy as well as the horse's bravery. Here, Great Britain's Harry Meade rides confidently to the fence and sets Wild Lone up properly for the jump.

**OPPOSITE** Australia's Sam Griffiths and Paulank Brockagh, an Irish Draught Sport Horse, on their way to victory at the Badminton three-day event in 2014.

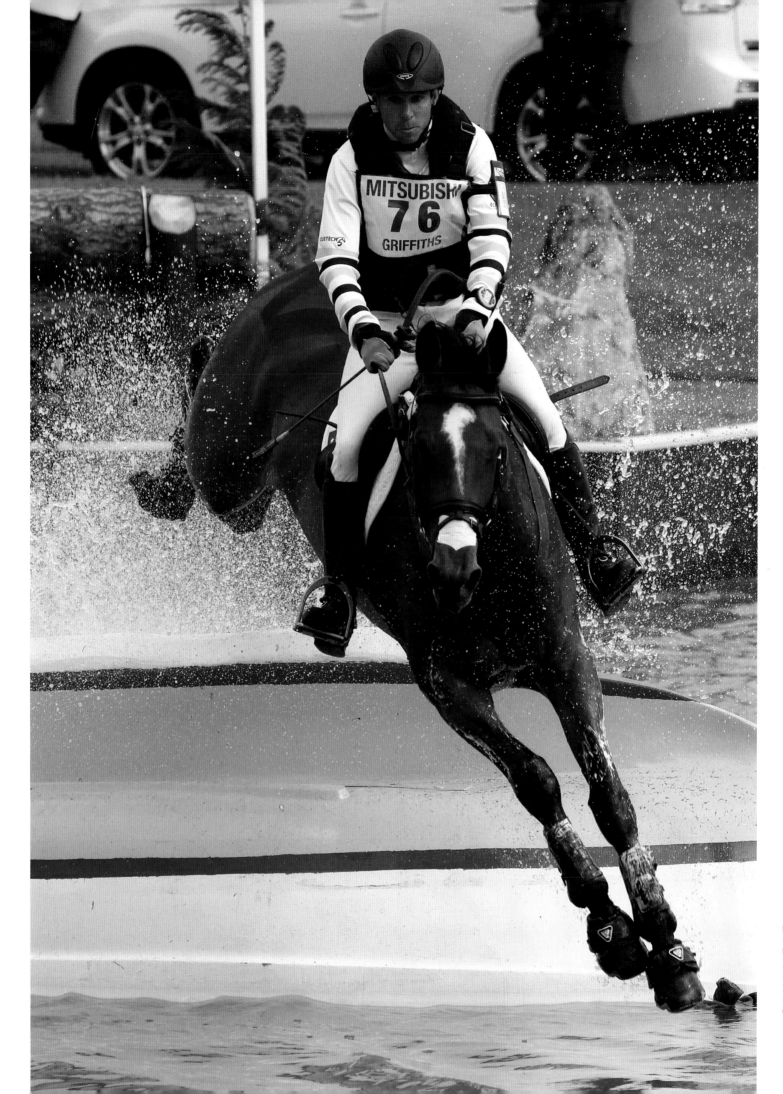

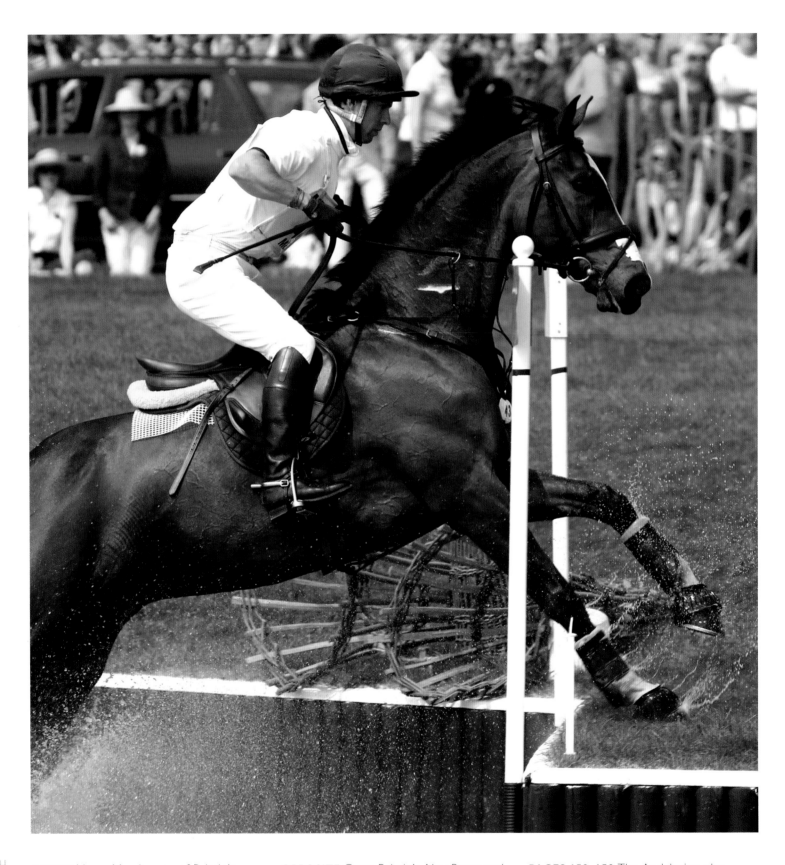

**ABOVE** Harry Meade, one of Britain's leading event riders, has competed Badminton Horse Trials nine times. Here, he and Wild Lone confidently power out of a water obstacle on the challenging cross-country course in 2011.

**OPPOSITE** Great Britain's Alex Bragg and Zagreb at the British Open Championships at Gatcombe in 2017. Alex was a semi-professional rugby player before switching to eventing to ride his wife's horse in 2004 when she became pregnant.

**PAGES 158–159** The Andalusian, also known as the Pure Spanish Horse or PRE (*Pura Raza Española*), is a breed from the Iberian peninsula. Strongly built, compact and elegant, this athletic breed excels in many equestrian disciplines.

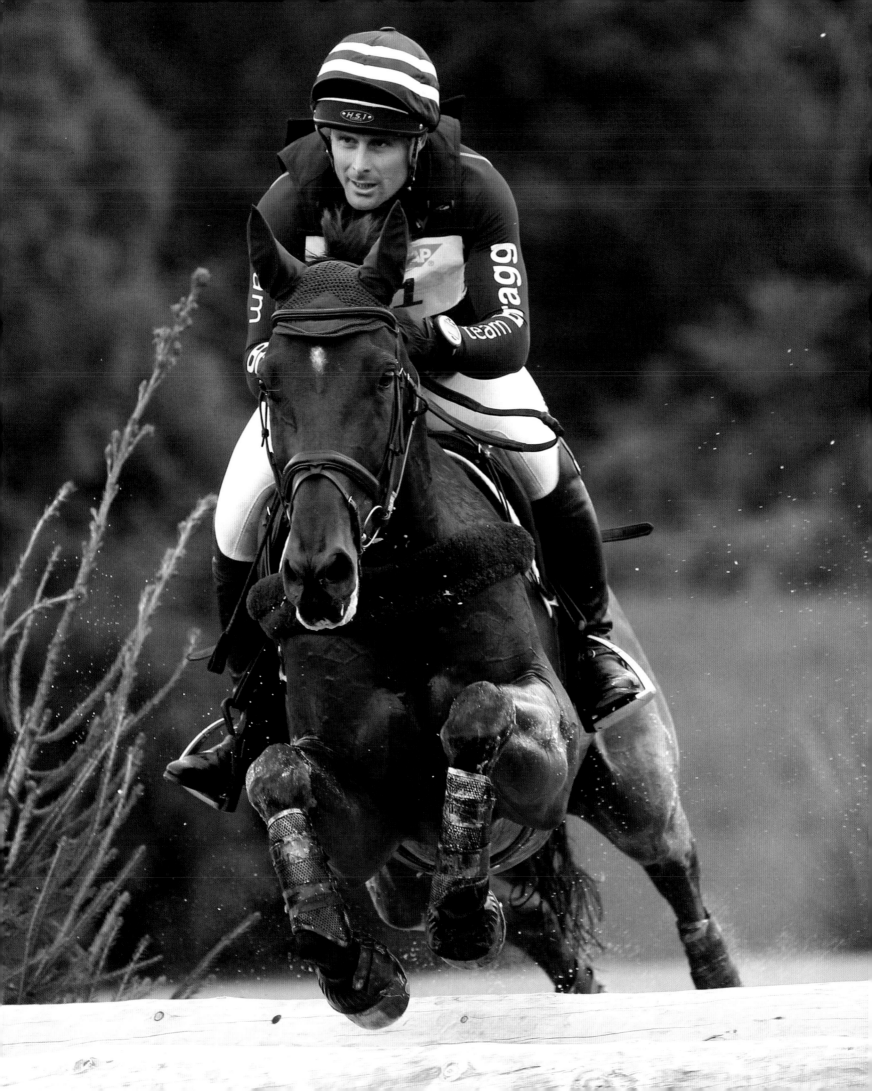

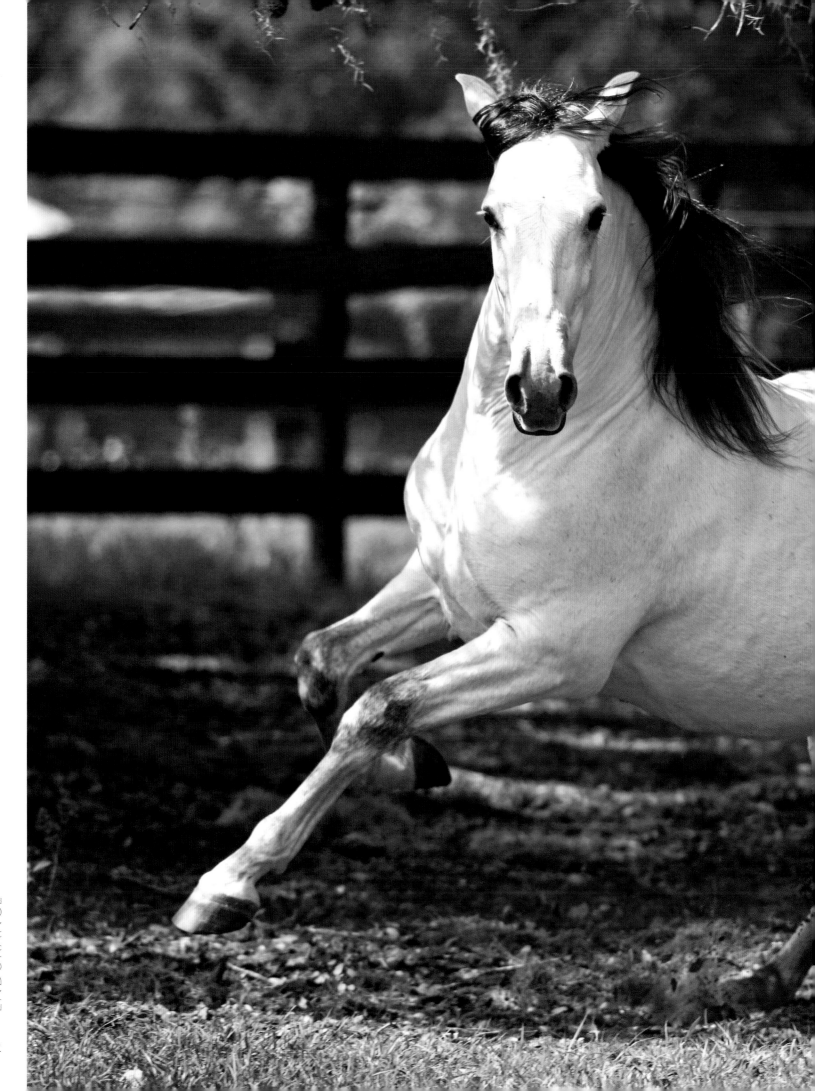

ENDURANCE

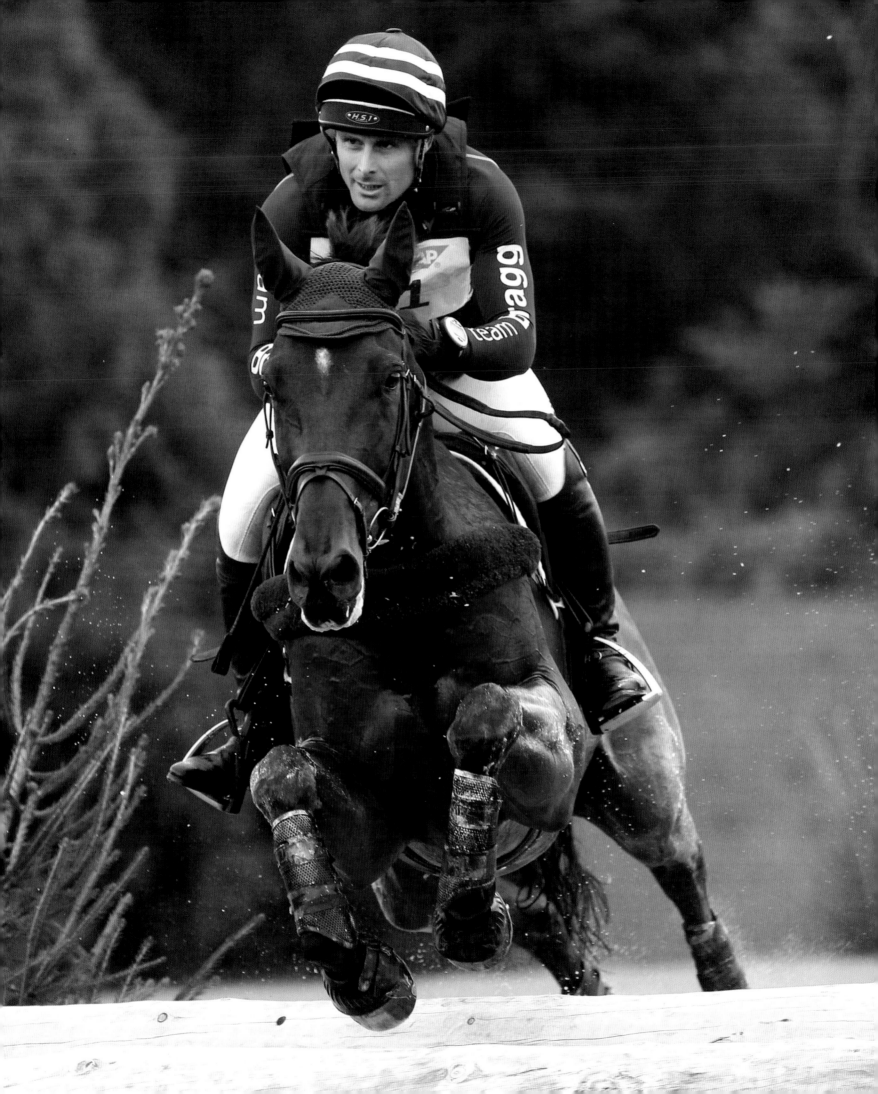

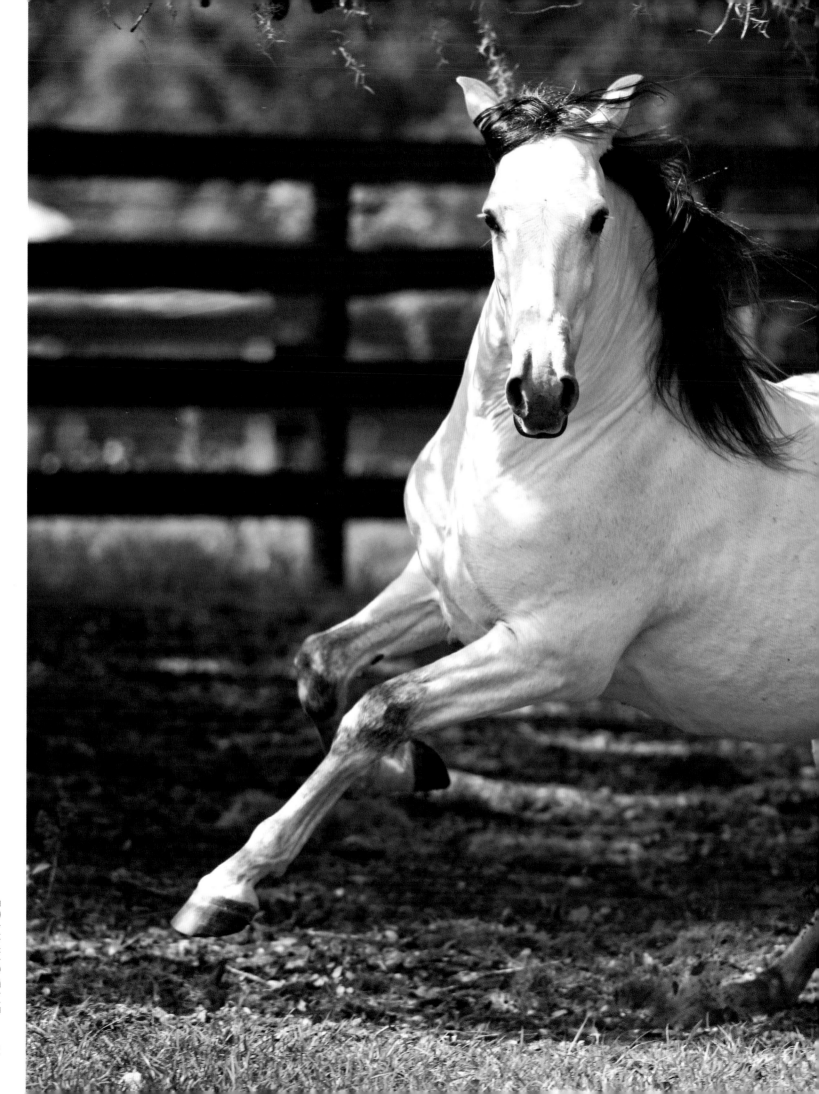

# ENDURANCE RIDING

At the pleasure ride level, endurance is a little like orienteering on horseback. At the highest competitive level, it is a gruelling challenge that tests the fitness of both horse and rider to the limit. In the long-distance contests, the rider must demonstrate effective use of pace as well as an in-depth knowledge of their horse's fitness and ability to cross terrain of all imaginable types.

Endurance riding began, as did so many kinds of equestrian sport, as a discipline in the US military, when cavalry horses were tested on a 480km (300-mile) ride, spread across five days. Modern endurance racing is considerably shorter – the longest distance race is just under 160km (100 miles) – and great emphasis is placed on the horse's welfare. The courses are divided into phases, at the end of each of which the horse must be assessed by a veterinary surgeon and passed as fit to continue.

The Arabian horse shines in this discipline; a throwback perhaps to its ancestors who crossed the vast deserts of the Middle East as mounts of the Bedouin tribes who owned them. It is perhaps the only modern equestrian sport that is not dominated by the warmblood.

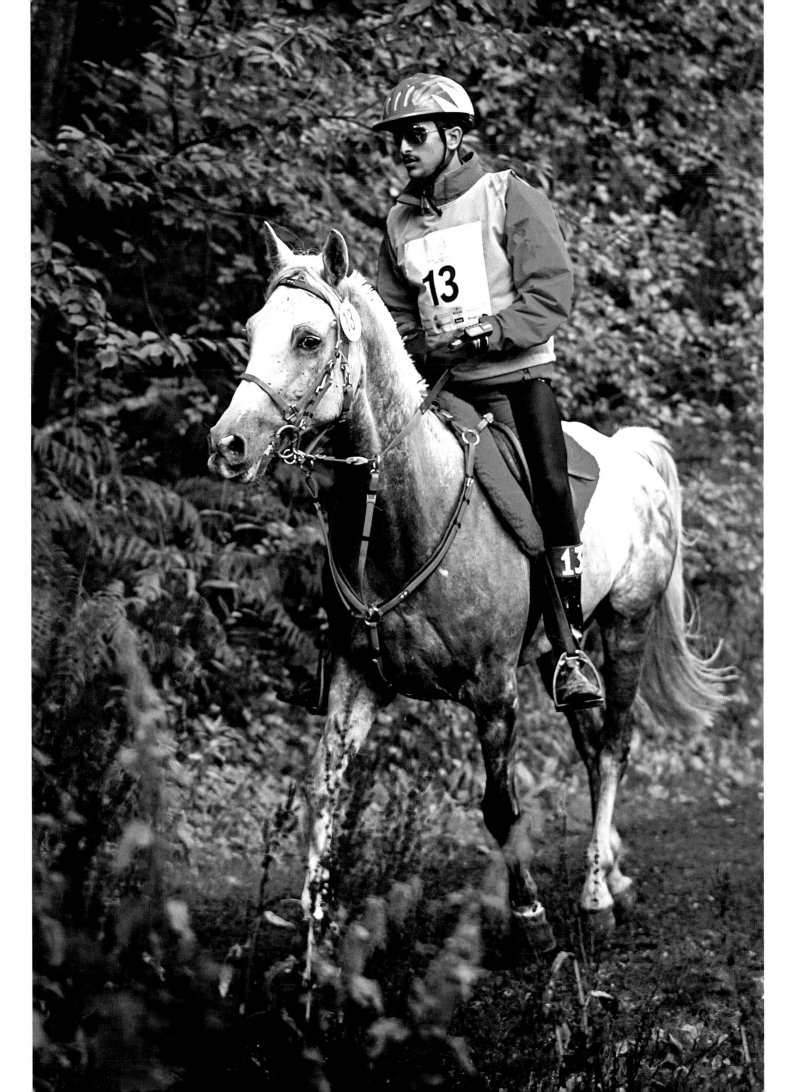

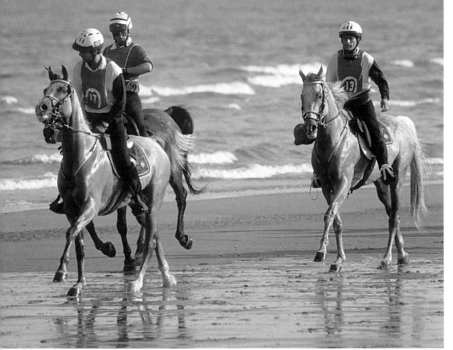

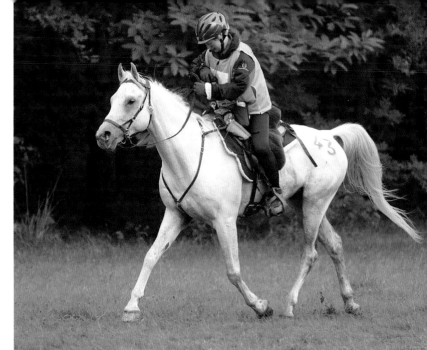

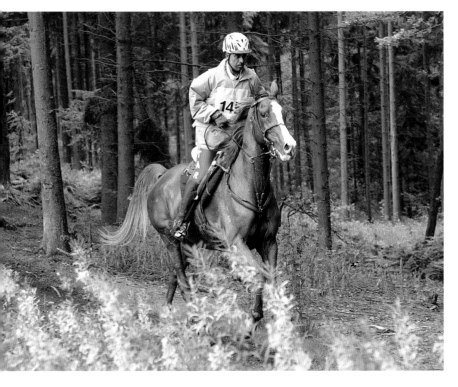

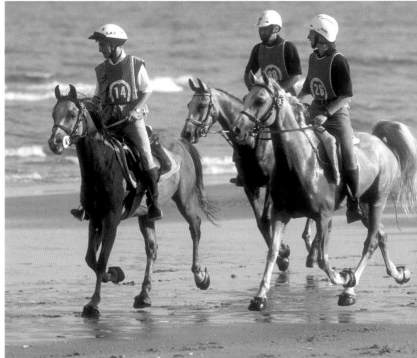

**ABOVE** Endurance riding is perhaps most often associated with the deserts of the Middle East, but competitive races are staged internationally across all sorts of different terrain.

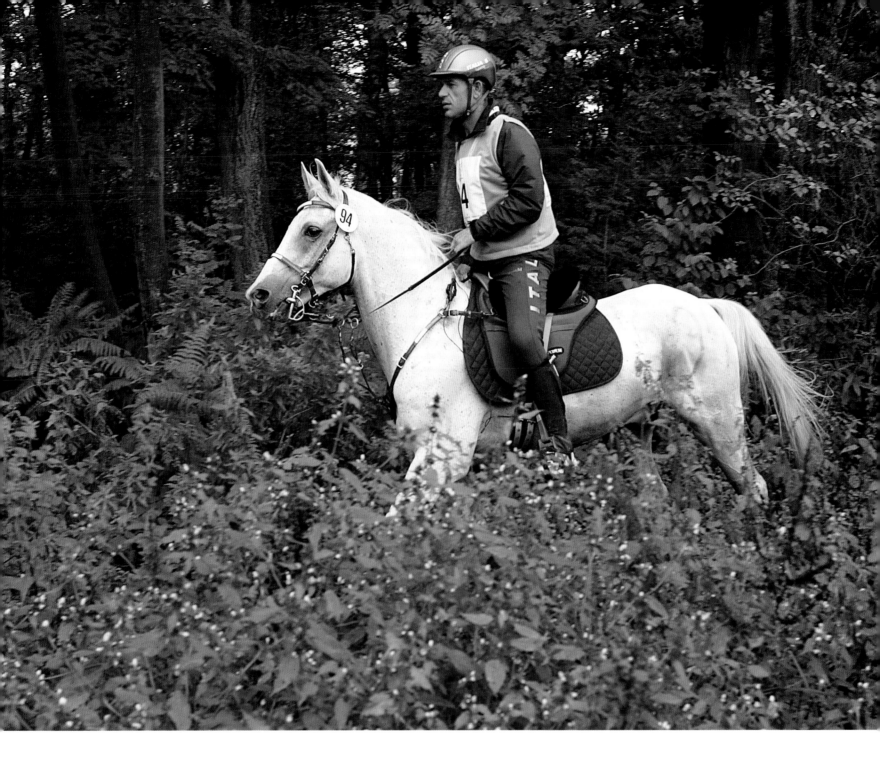

**ABOVE** Italy's Alfonso Striano and his own horse Sischi, competing at the World Equestrian Games, for which they qualified in both 2006 and 2010.

**ABOVE** The versatile Arabian is good natured and willing to please. Dominating the sport of endurance riding, this talented breed is also successful in most other equestrian disciplines, notably racing, dressage, showjumping and Western riding.

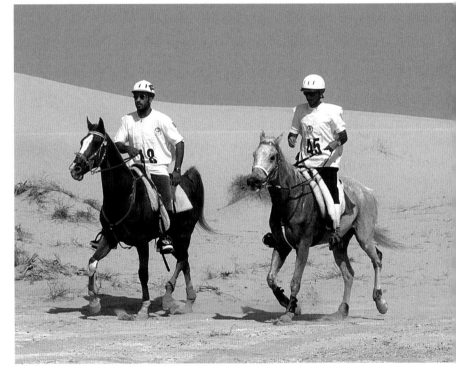

**ABOVE** Arabian horses, as seen here in Dubai, United Arab Emirates, do exceptionally well in endurance riding competitons because their distant ancestors survived on meagre rations and little water in the relentless desert heat.

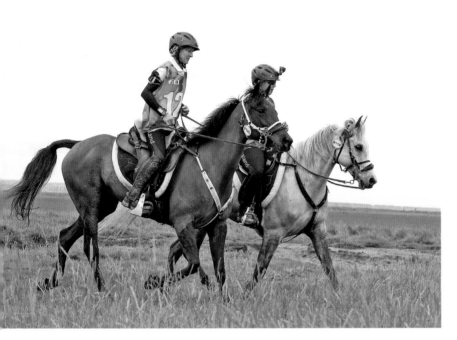

**ABOVE** The welfare of the horse in all endurance rides is paramount. The leading riders know their horse's capabilities – and their limits – intimately, so they are careful not to overtax them.

**RIGHT** The Arabian horse is renowned for its supreme stamina, making it a popular breed in endurance riding. This sport tests the stamina of both horse and jockey like no other.

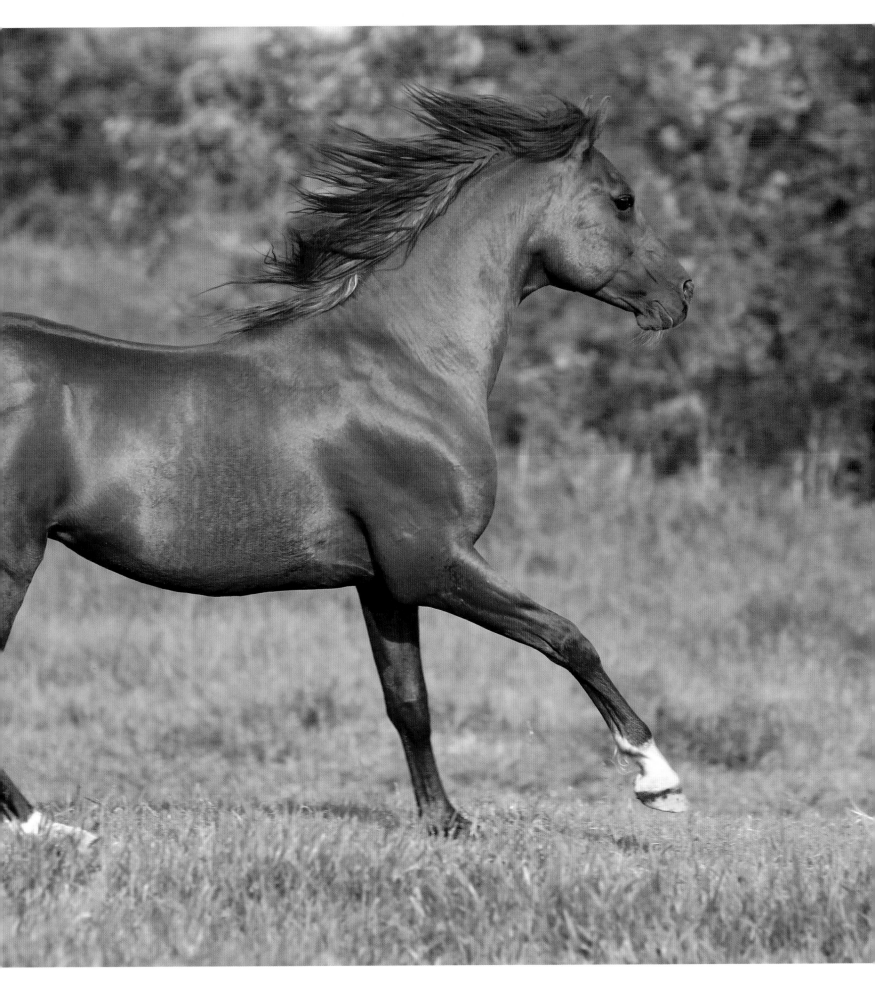

# HUNTING

There is little more exhilarating than galloping across country on the heels of the huntsman and his hounds when they are in full cry. Our horses love it too – as herd animals they are probably happiest in a group of their peers while allowed free rein to go as fast as they can.

It is no great surprise that some of the world's leading equestrians, whether showjumpers or eventers, use hunting as part of their horses' education. Just as hunting, with all its etiquette and decorum, teaches riders manners and respect, it also teaches the horse to stand still and wait – while hounds hunt in covert – and to find that crucial 'extra leg' as it flies the fences as they come.

'I freely admit that the *best of my fun* I owe it to horse and hound,' wrote the nineteenth-century Scottish novelist George John Whyte-Melville. The oft-quoted line, which appears on the masthead of the renowned British equestrian weekly magazine *Horse & Hound*, comes from a poem entitled *The Good Grey Mare*, a celebration of crossing the country on horseback after a pack of hounds in full flight.

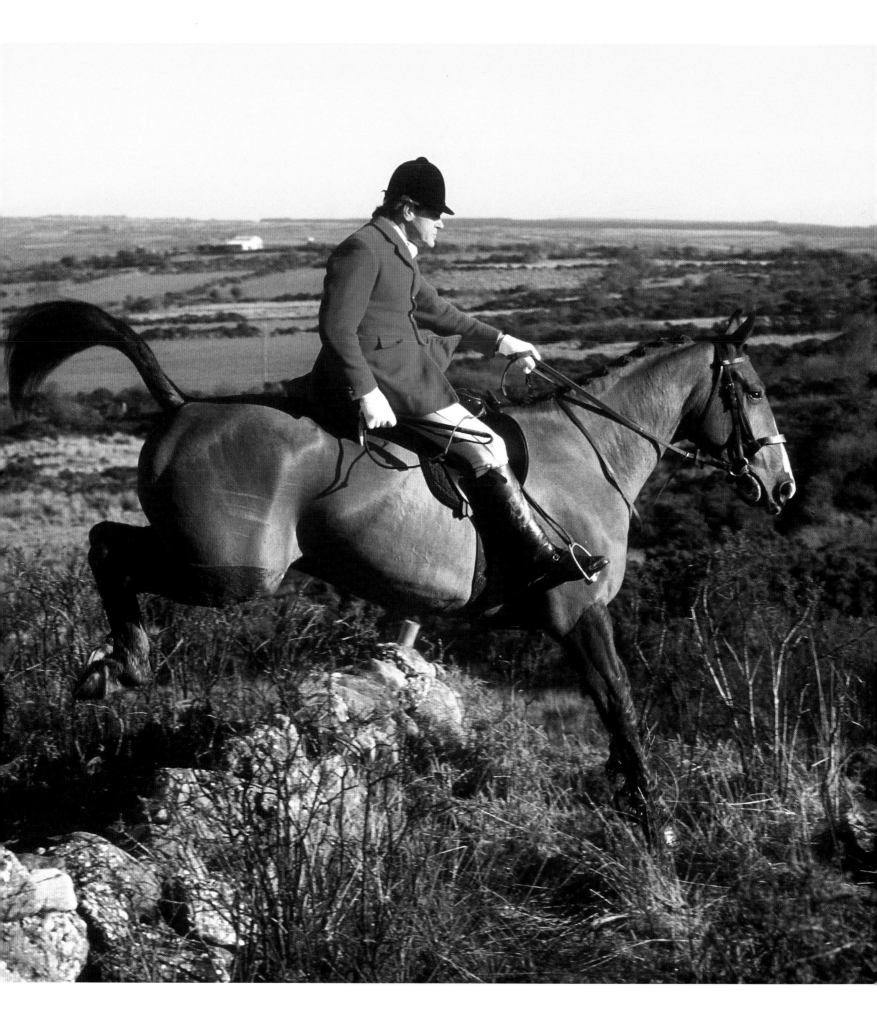

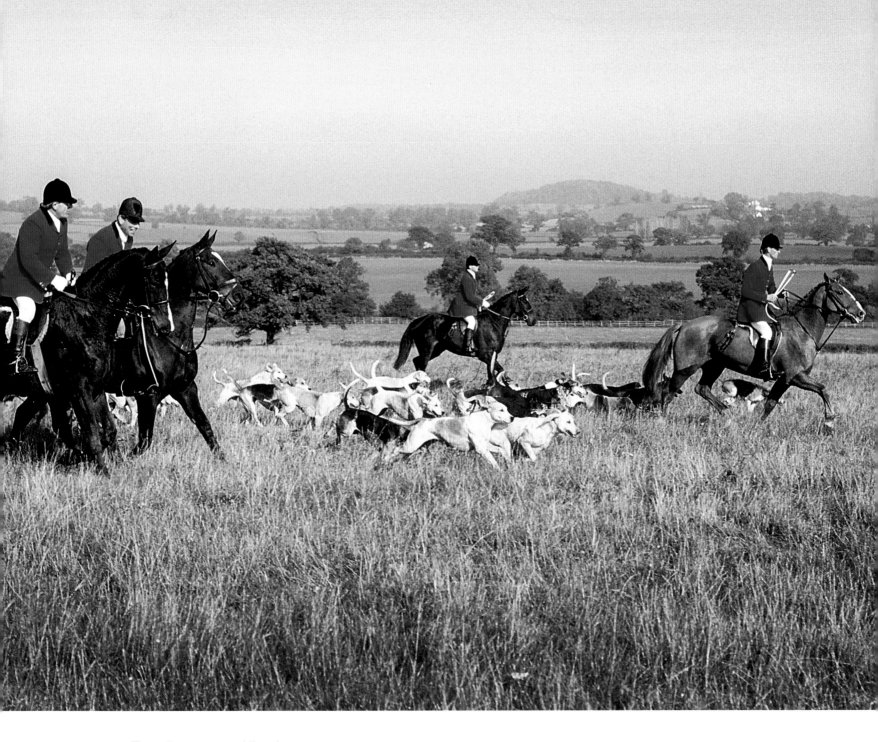

**ABOVE** There is no more exhilarating
way to see timeless English countryside
than from the back of a galloping horse,
following a pack of eager hounds for a day.

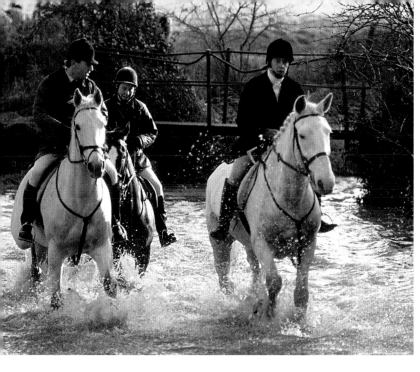

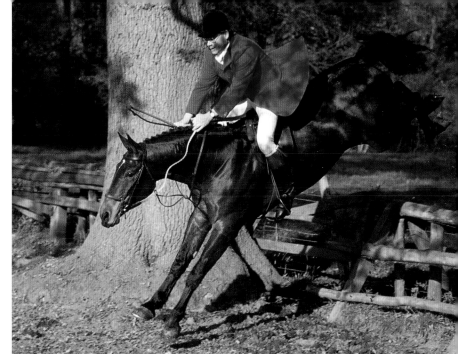

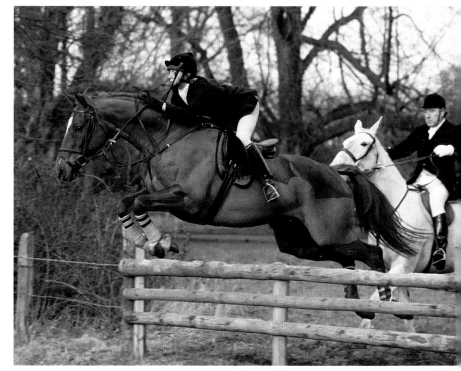

**ABOVE** Those who follow hounds get the chance to ride across glorious countryside and through all kinds of terrain. The huntsman controls the hounds and lets the followers know what is happening by blowing different notes on his hunting horn.

**ABOVE** Following hounds, horse and rider will encounter all sorts of field obstacles that will test the hunter's jumping ability as well as its stamina. It is a great education for the horse.

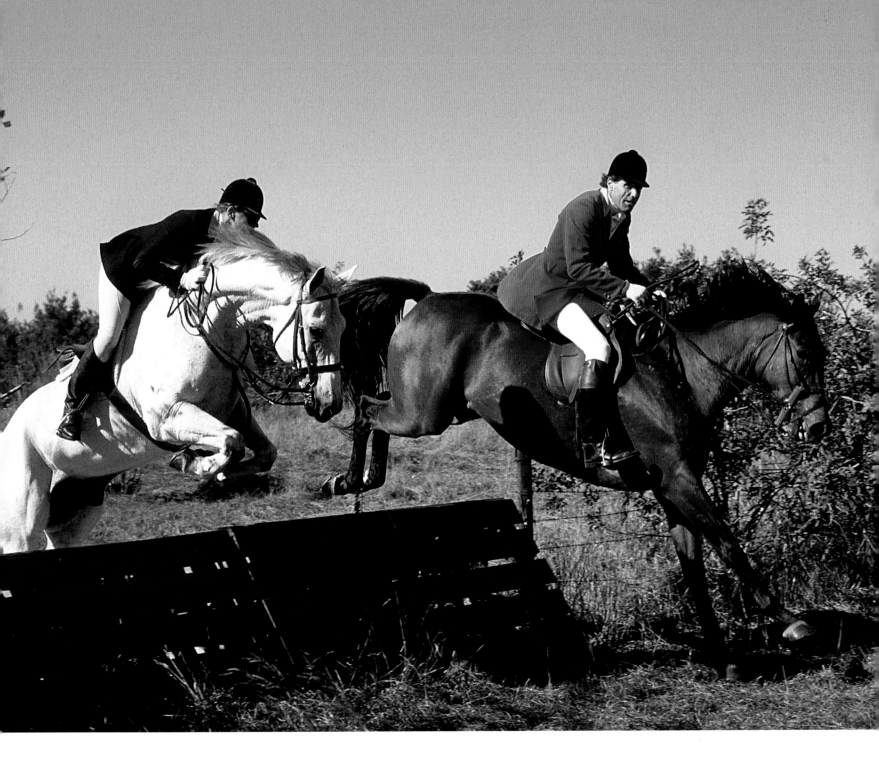

**ABOVE** Hunt jumps in the United States
are frequently chicken coops – existing
barbed wire fences with a coop sitting
neatly on top of them. There are far fewer
natural obstacles.

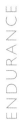

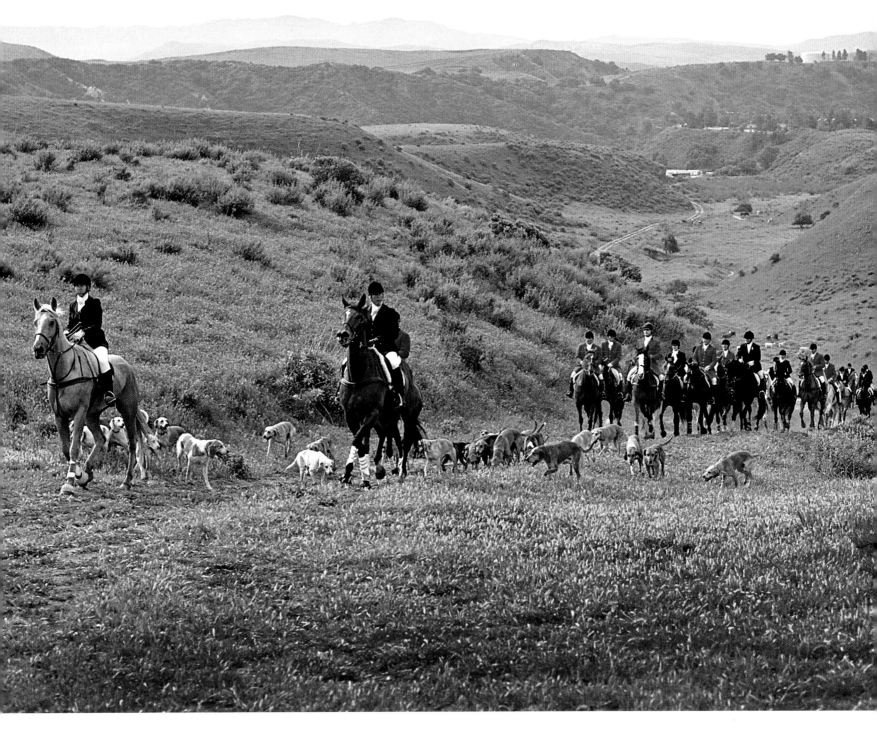

**ABOVE** You need a horse with a lot of stamina to follow Southern California's West Hills Foxhounds. They hunt from October to March over some of the most demanding terrain in North America.

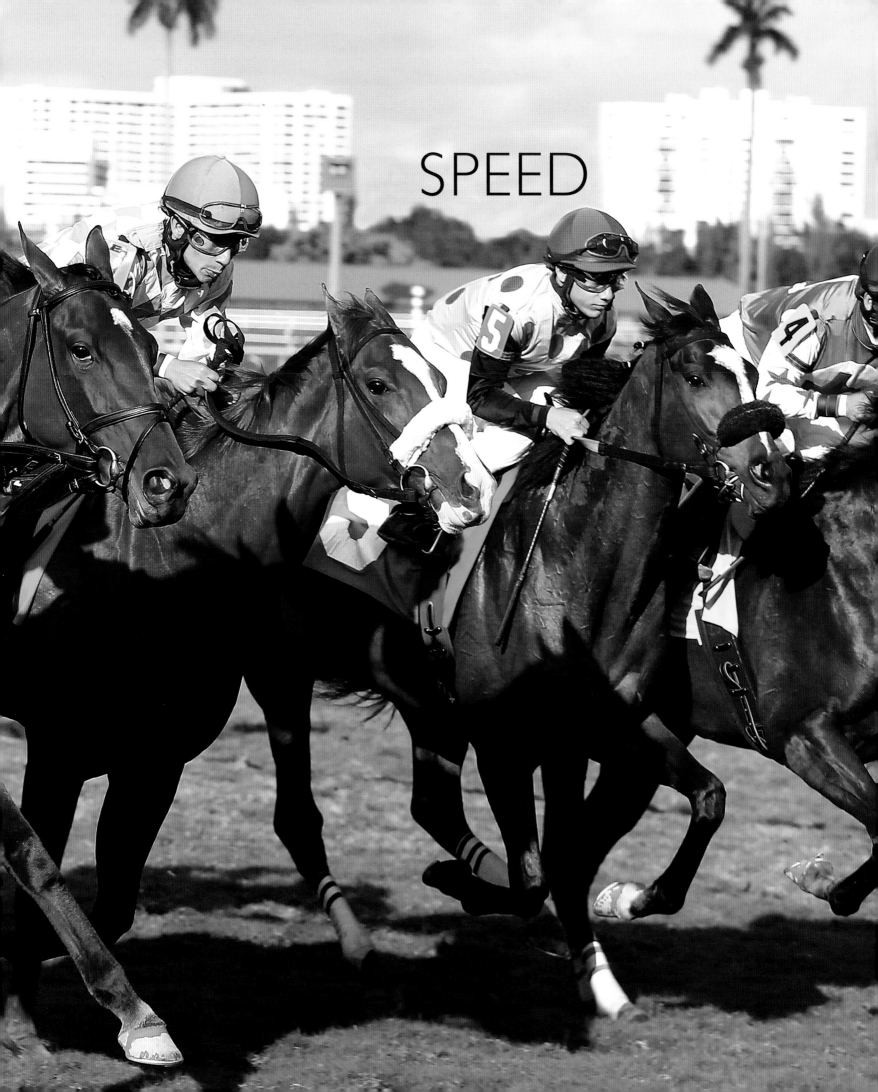

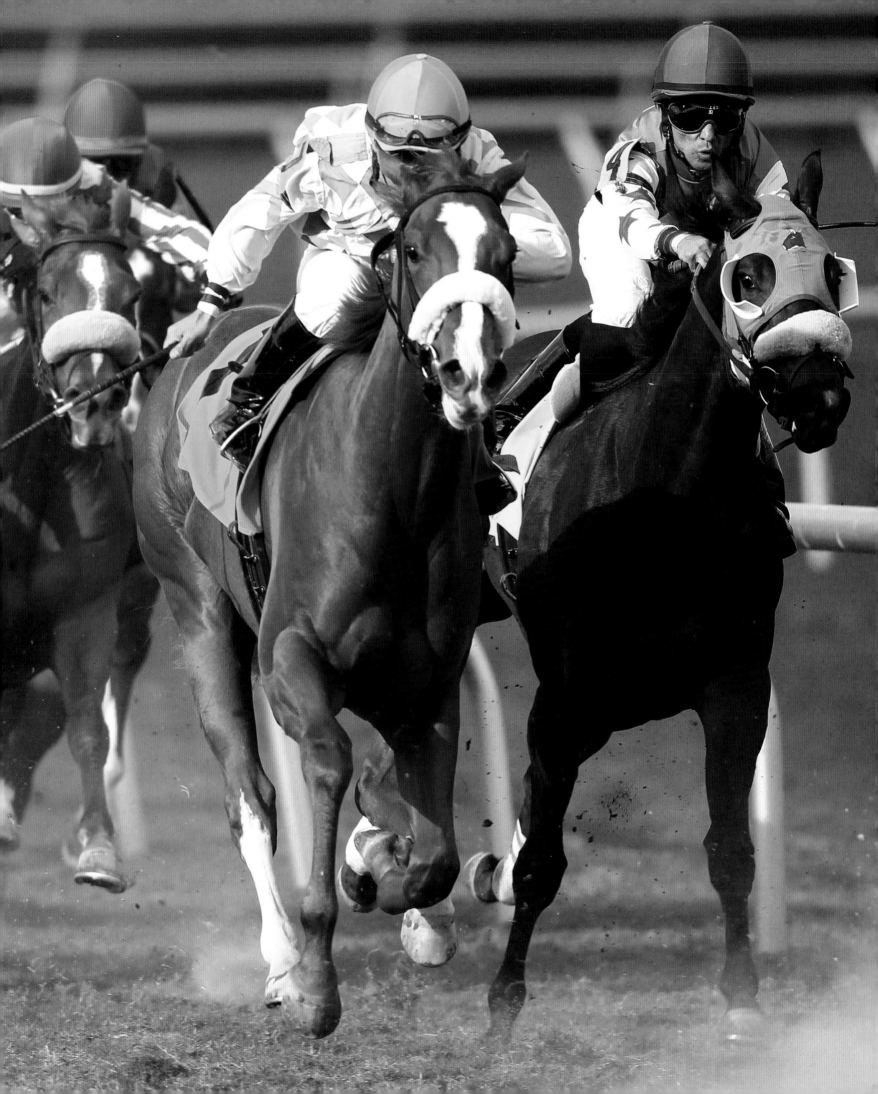

# PACE AND ACCELERATION

With the magical thrum of hooves on turf, you can feel the drumming deep in your chest before you see the racehorses storm around the corner onto the home straight, all straining to be the one to get their nose in front.

We know that the horse is a fight or flight animal and there is something glorious about its speed; as though it is running for its life because it loves to, rather than because it has to.

Betting has always been big business; large sums of money, cars and even houses have been wagered on the back of a favourite, and the romance of the racecourse has captured spectator's imagination for centuries. The glorious horses who strove to be the champions have often been immortalized in paint, becoming a popular subject with the artists of the day. In a quest for more realism in his paintings, British artist George Stubbs began a programme of dissection to gain a better understanding of equine anatomy. From the ceiling of a barn he hung a succession of horse carcasses and, over the course of eighteen months, peeled off layer after layer of tissue so that he could see what was beneath. Sketching the animal at various stages from three perspectives, he created a set of frontal, lateral and posterior views.

One of the first paintings to which Stubbs applied his new knowledge was *Lustre, Held by a Groom*, painted around 1762. The horse is standing, but movement is in his every fibre; his head is raised, neck arched, ears pricked, nostrils flaring, mouth slightly open and eyes wide; you can almost sense the blood running through his veins.

It took a further century before a photographer took equestrian art to another level. If you look at great works of art at the end of the nineteenth century, those depicting horses travelling at speed will show them with front legs extended ahead of them and their hindlegs stretched out behind. This came to be known as the 'hobby horse' or 'rocking horse' posture. It wasn't until Eadweard Muybridge experimented by getting a galloping horse to trigger the shutters of a bank of cameras in 1878 that this perception was shown to be faulty. His work proved that a horse lifts all four hooves off the ground and underneath its body at one point during the gait.

**OPPOSITE** A top-class racehorse running on the flat will reach speeds in excess of 60kph (37mph).

The fact that Muybridge went to such great lengths to reveal this is some indication of how important horses and their portraits were at that time. The 'sport of kings' was still in its comparative infancy, when racehorses were largely owned by the wealthy and ennobled. Lustre, the racehorse painted a century earlier by George Stubbs for his owner Frederick St John, 2nd Viscount Bolingbroke, was foaled in 1754. He was a chestnut colt descended directly from the Godolphin Arabian, whose bloodline still runs through generations of the most decorated racehorses in England.

It seems incredible today, but just three stallions founded the Thoroughbred, the horse that now is at the heart of a billion-pound industry. Blood of the Godolphin Arabian – sometimes called the Godolphin Barb – the Byerley Turk and the Darley Arabian courses through the veins of the modern Thoroughbred to this day. The trio brought refinement and elegance to the native stock of Great Britain and they brought another, even more desirable trait – speed.

Britain's native horses, before the advent of these exotic oriental pioneers, were largely rather common and heavy. Descendants of the great warhorses, they were mostly built for strength rather than speed, or they were the small, somewhat coarse working ponies. It wasn't until first the Byerley Turk, then the Darley Arabian and finally the Godolphin Arabian were crossed with native mares that the English Thoroughbred was born – and with it the sport of kings.

As was the fashion, all three stallions took the names of their owners. Captain Byerley obtained his fine brown charger from a captured Turkish officer during the siege of Buda in Hungary in 1688. The stallion won a race at the Down Royal meeting in 1690, and first stood at stud in England at the Byerley family seat in County Durham. The stallion later stood at Captain Byerley's Goldsborough Hall near Knaresborough in Yorkshire, where his remains are believed to be buried. Although he covered very few well-bred mares in his entire lifetime, Byerley Turk established a male bloodline that is still influential today.

The Darley Arabian came to England just fifteen years after the arrival of the Byerley Turk, possibly smuggled out of Syria by a merchant called Thomas Darley. The story goes that Darley paid 300 gold sovereigns – a lot of money at the time – to Sheikh Mirza II for the pure Arabian colt, but the sheikh had reneged on the deal. Whatever the truth, the horse arrived in England in 1704. He too stood in Yorkshire at the Darley family seat, Aldby Hall in Buttercrambe. Between the years 1706 and 1719, the stallion sired some exceptional racehorses, among them Childers – who famously became known as 'Flying' Childers – said to be 'the fleetest horse that was ever trained in this or any other country'. Childers himself sired, among others, a horse called Blaze, which went on to influence other breeds – his son Old Shales is the foundation sire of the Hackney breed. Blaze's great-grandson Messenger became a foundation sire for the American Standardbred, and his daughter, the outstanding mare Miller's Damsel, was dam of the racing legend American Eclipse.

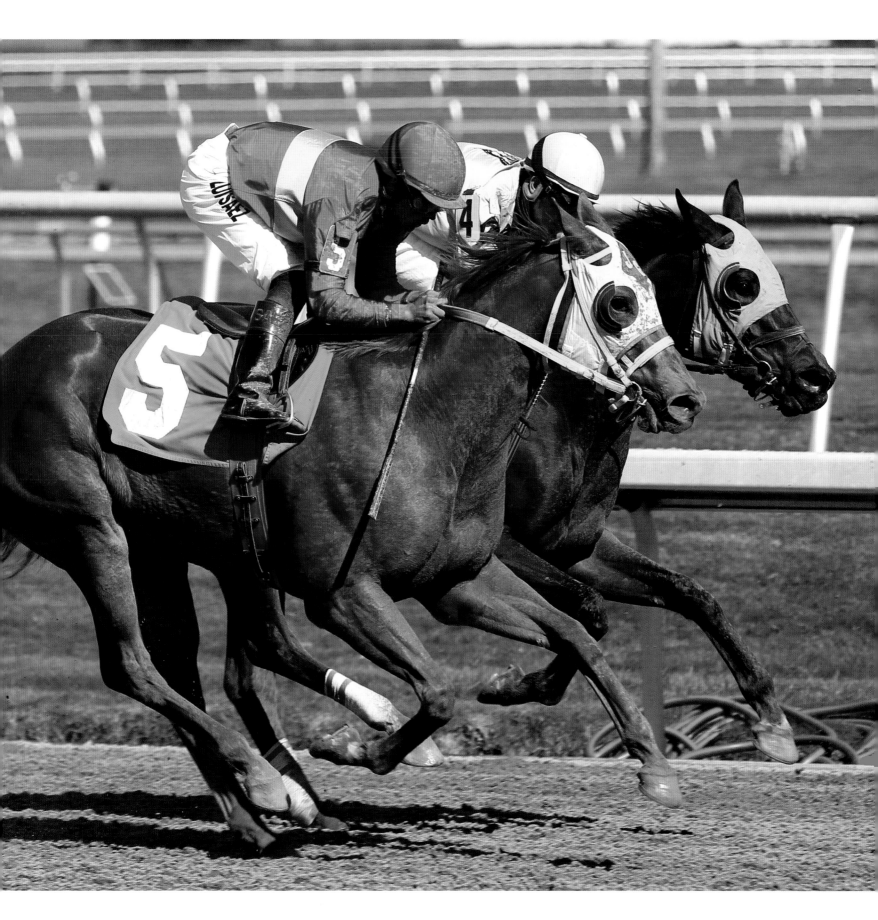

**ABOVE** Dirt racetracks are popular in the United States. Here, on the dirt track at Gulfstream Park, Florida, two naturally competitive horses race neck-and-neck – each determined to get its head in front.

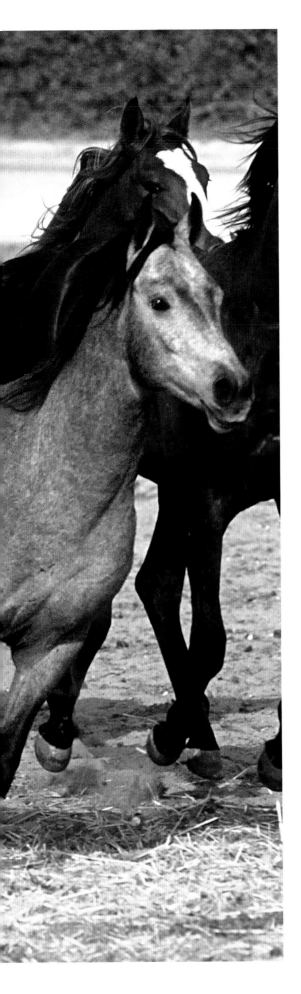

The last of the trio was the Godolphin Arabian, which was imported from France in 1729 by Edward Coke. Coke had connections with France but the story of him finding the stallion pulling a water cart in Paris is probably apocryphal. The horse was described as 'beautifully made but half-starved' and is said to have been headstrong. Once in England, the horse covered a mare called Roxana which was by the Darley Arabian, resulting in a colt, foaled in 1732, said to be 'a very elegant and beautiful horse'. That colt was named Lath. When Coke died, his stallion was bequeathed to Lord Godolphin under whose name Lath ran his first race, the 1,000 Guineas at Newmarket in 1737, beating all-comers.

Lath's sire's death was announced in the *Derby Mercury*, dated 28 December 1753: 'We hear from Newmarket that on Christmas Day last died, in the thirty-third year of his age, the famous horse known by the name of the Godolphin Arabian. He was esteemed as the best horse for getting racehorses that ever was brought into these Kingdoms, there being at present a great number of his sons that are stallions in different parts of England, and are in the highest esteem for that purpose among noblemen, jockeys and breeders of horses.'

It seems astonishing that the DNA of those three horses is still found in today's Thoroughbreds. There is some confusion about the real breeding of the foundation stallions, largely because any horse from the Middle East in the late seventeenth and early eighteenth century was said to be 'Arabian'. The Darley horse may well have been a Barb, while some believe the Byerley Turk was actually an Akhal-Teke, an ancient breed developed in Turkmenistan. What isn't in doubt was they were all 'hotblooded' desert breeds, which were prized for their stamina and lightning speed.

The modern racehorse is vastly different from those founding fathers. An equine powerhorse, today's Thoroughbred has lost the distinctive dished (concave) profile of the pure-bred Arabian, but none of its fleet-footed will to win. This aristocrat races because it wants to, not because a tiny jockey on its back makes it do so. Horses are herd animals and a packed field for a race – up to forty for the Grand National, Britain's most famous and most challenging jumping contest – is probably more a comfort than an aggravation. Horses are fight or flight creatures, but in a herd of galloping horses there will always be competition – one or two will be desperate to get their head in front. Here lies the truth about horseracing; the horse that wants to race will give it his heart and soul, the one that doesn't will refuse to do so. It certainly happens – in the Grand National in 2010, a handsome grey called King John's Castle planted himself at the start and refused to race. Paul Carberry, his partner and a highly accomplished jockey, could do nothing to make him move.

**LEFT** It is thanks to the bloodlines of the Arabian – like these youngsters at the Royal Stables in Abu Dhabi – that we have the Thoroughbred, which today carries a supremely valuable racing industry on its sleek back.

There is little more exhilarating than watching a racing field stretch across the course, each striving to be first; to be the best. Thanks to Muybridge's breakthrough with a camera, we now know that the gallop is a four-beat gait, and at some stage all four feet are off the ground. Horses can gallop for quite some time before tiring – a necessity in a prey animal – and can reach speeds of up to 64kph (40mph). The world record for race speed recorded over two furlongs is 70.76kph or 43.97mph. It was achieved by a two-year-old filly called Winning Brew at the Penn National Racecourse in Grantville, Pennsylvania on 14 May 2008. The world record for one and a half miles is 60.86kph (37.82mph) by the three-year-old Hawkster at Santa Anita Park in Arcadia, California on 14 October 1989.

Another renowned racehorse was also American. Called Secretariat, he was a rangy chestnut colt that, having lost his first race, was rarely beaten thereafter. He won America's Triple Crown – the Preakness Stakes, the Kentucky Derby and the Belmont Stakes – in 1973, posting record times and completing the hat-trick with an unheard-of thirty-one lengths margin. Such was the interest in the horse, the week before the Belmont *Sports Illustrated*, *Time* and *Newsweek* magazines all featured him on their front covers – a feat that has never been repeated. After Secretariat's victory, his owners hired the services of the William Morris Agency to oversee the Thoroughbred's public appearances, making him perhaps the only horse to have a Hollywood agent.

Secretariat stood at stud, though none of his progeny showed the same form, and was put to sleep at the age of nineteen due to laminitis. A footnote to this remarkable animal's story is that after he was euthanized, a post-mortem was carried out by Dr Thomas Swerczek, a professor of veterinary science at the University of Kentucky, who found a surprising anomaly.

'I've seen and done thousands of autopsies on horses, and nothing I'd ever seen compared to it,' he said. 'The heart of the average horse weighs about nine pounds. This was almost twice the average size, and a third larger than any equine heart I'd ever seen. And it wasn't pathologically enlarged. All the chambers and the valves were normal. It was just larger. I think it told us why he was able to do what he did.'

It is often said that the great horses have plenty of 'heart', and Secretariat had more than most. In his honour, in 1999, the United States Postal Service issued a commemorative Secretariat stamp, making him the first horse to earn the honour. In 2010 a Walt Disney film was made of his life, based on the book *Secretariat* written by sports journalist Bill Nack, who followed the horse's astonishing rise to fame.

**RIGHT** A race at Gulfstream Park in Florida; horseracing in the United States is big business. This racecourse hosts three top-class Grade I Flat races every year, including the Florida Derby which offers a purse of one million dollars.

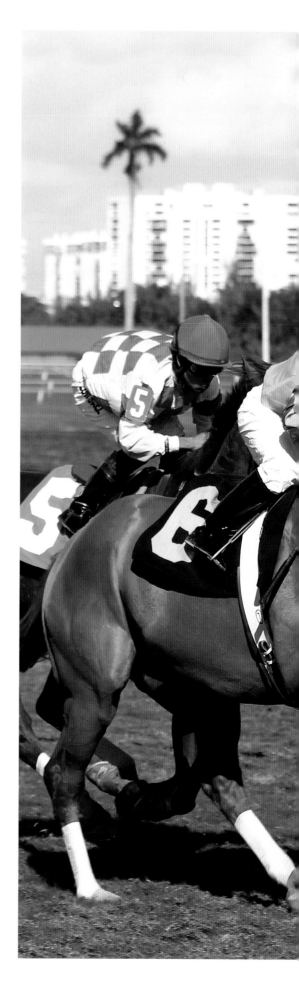

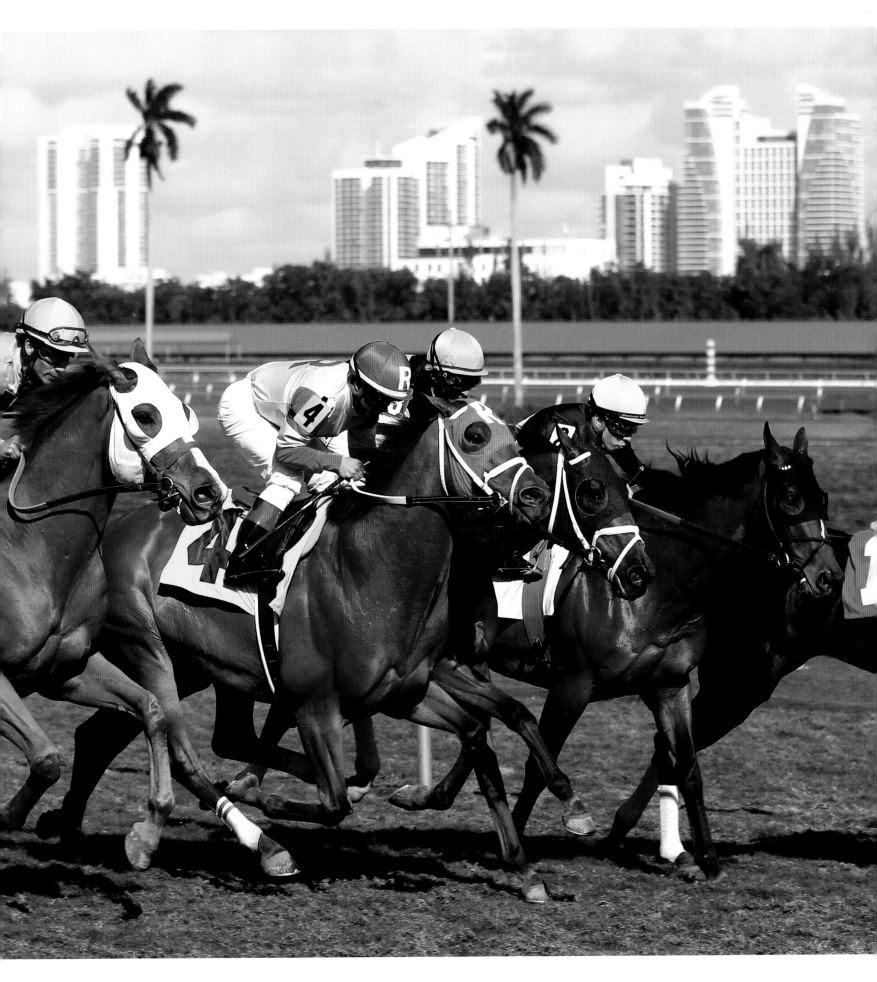

Another famous film was made about a great American racehorse called Seabiscuit, whose lineage traced back to the Darley Arabian. Seabiscuit's story was one of rags to riches. At the age of just two the horse had run thirty-five races, winning only five. He raced twenty-three times as a three-year-old, winning nine, before new owners sent him to a new trainer, Tom Smith, an old Western cowboy. Smith found the horse was tired and sore after two demanding seasons, as well as being 91kg (200lb) underweight. Seabiscuit played merry hell at the starting gate, terrified the grooms, paced his stall and refused to eat. Smith put braces and bandages on the colt's legs, put him in blinkers for training and racing to keep his mind on the job and gave him a double-sized stable. His roommates in this equine Ritz were a stray dog called Pocatell, a spider monkey named Jo Jo and his lifelong travel companion, a horse called Pumpkin.

When Seabiscuit was ready to race, Smith chose Johnny 'Red' Pollard, a jockey and partime boxer who was blind in one eye and stood 1.70m (5ft 7in) – then extremely tall for a jockey – to be his pilot. In the summer of 1936, Pollard and Seabiscuit, whom he nicknamed Pops, formed an immediate bond. They won races and became celebrities, but both jockey and horse were plagued by leg injuries. 'Old Pops and I have got four good legs between us,' said Pollard. 'Maybe that's enough.'

The pair received a standing ovation from the 70,000-strong crowd for the 1940 Santa Anita Handicap, in which the great horse swept ahead to win while running the second fastest mile-and-a-quarter in American racing history. That was his last race, after six years, eighty-nine starts, thirty-three victories, sixty-one places and sixteen track records, he was retired at the age of seven and went on to sire 108 foals. On 17 May 1947, Seabiscuit suffered a heart attack and died just before his fourteenth birthday.

In the American racehorse hall of fame, Seabiscuit and Secretariat are joined by many others – among them Man O' War, Phar Lap, Citation and Seattle Slew. They have played a part in the development of Thoroughbred, all tracing their lineage back to those three foundation sires imported to England at the turn of seventeenth century. At the same time, in America the sport was moving on apace. Previously, horse races were head-to-heads, with just two running against each other. Often these were Quarter Horses – whose name comes from the fact that they can sprint a quarter of a mile at considerable speed – but with the arrival of the Thoroughbred, races were held over longer distances. The American Stud Book was opened in 1868 and by the 1890s more than 300 racecourses had been built.

**LEFT** The Thoroughbred has lost the extravagantly dished face of the Arabian, but retains all its speed and stamina and excels in most equestrian sports.

Meanwhile in England, Newmarket became the first venue to host races, which under Queen Anne evolved into professional races with several horses that the public could bet on. Many new racecourses were opened and Ascot was founded by the Queen in 1711. The Jockey Club was established in 1750 and the General Studbook first published in 1791. All races held today in the United Kingdom are run under the British Horseracing Authority (formerly the Jockey Club) Rules of Racing.

The world-famous Derby at Epsom Downs was first run in 1780. The town of Epsom rose to prominence in the seventeenth century after a water source was discovered underground. The water held a high concentration of magnesium sulphate. This was sold as a product that became known as Epsom Salts, which at its height sold at princely five shillings an ounce in 1640. The great race came to be known as the Derby on the spin of a coin. The tale goes that the 12th Earl of Derby and Sir Charles Bunbury, president of the Jockey Club who was a guest at Lord Derby's house, spun a coin as to whether the race should be called the Derby Stakes or the Bunbury Stakes. The winner of the first Derby in May 1780 was Sir Charles's Diomed. The first race for fillies was run a year earlier and named The Oaks, after Lord Derby's country estate.

These great contests were both Flat racing; races in which the horses have to jump are called National Hunt. The Flat race roll of honour includes such equine luminaries as Hyperion, who won the 1933 Epsom Derby by eight lengths in a record time, Mill Reef, Dancing Brave, Crepello and Sir Ivor. Racing has some great stories, but it also has some sad ones – like that of Shergar. The colt had won the 1981 Derby by ten lengths, a record distance for Britain's biggest Flat race. He retired from the track and stood at Ballymany Stud in Ireland, where mare owners paid £80,000 for the privilege of having Shergar's offspring. One evening in 1983, Shergar was taken by eight armed gunmen who planned to ransom him for £2 million. But the consensus of opinion at the time was that if a ransom were paid, every racehorse in the country would become a potential target. The ransom went unpaid and the horse disappeared. It is believed that Shergar was killed – robbing the Thoroughbred world of one its all-time greats and a million 'what might have beens' had he enjoyed a long career at stud.

**RIGHT** Over a quarter of a million spectators attend the famous four-day spring festival at Cheltenham racecourse in Gloucestershire, UK. It is considered to be the highlight of the jump season.

**ABOVE** Races in which the runners have to jump are
called National Hunt in the UK. Both horse and jockey
must be extremely fit and brave to complete the distance
and negotiate fences made of brush or hurdles.

One of the most uplifting National Hunt stories is that of Aldaniti and his jockey, the aptly named Bob Champion. It is known as 'racing's greatest fairy tale'. Aldaniti was a National Hunt horse and in 1981 he won the Grand National, ridden by Champion. The horse was initially owned by breeder Tommy Barron and its name derived from the first two letters of the names of Barron's grandchildren, Alistair, David, Nicola and Timothy. He was bought by a trainer called Josh Gifford for whom he won his first race, in January 1975, ridden by Gifford's young stable jockey Champion. But Aldaniti was plagued by bouts of lameness, having suffered two serious tendon injuries and fractured hock.

In 1979, having ridden the horse in all his starts, Champion was diagnosed with advanced testicular cancer. He was given between four and seven months to live. 'You're not a bad novice chase jockey,' his doctor, a racing man, said. 'If you were on a six-to-four shot you'd give it a ride, wouldn't you?' Unable to argue with that logic, Champion began a course of chemotherapy that was brutal. Then he developed septicaemia. 'I was relieved in a way. I was glad to think I might die and wouldn't need any more chemotherapy,' Champion admitted. 'My brother-in-law drove me to the hospital at about one hundred and forty miles an hour and we were stopped by the police. He told them why we were going so fast and they gave us an escort to the hospital. I was twenty minutes from dying.'

Champion beat the odds and returned to the saddle – Gifford had promised to hold his job for him while he was having treatment – and he went on to win the 1981 Grand National with Aldaniti. A fairy tale indeed. After he retired from the saddle, Champion campaigned for better understanding and treatment of cancer, making public appearances with his great equine partner to raise funds. They undoubtedly formed a special bond, as Champion said: 'He helped me so much. When we won the National it was a lovely sunny day and I'll always remember it. We went through a lot together.'

National Hunt racing – sometimes called the winter game, as opposed to Flat racing that takes place in the summer – is demanding for both horse and jockey, even when both are in peak condition. It is split into two types, hurdles and steeplechases. Steeplechase (or chase) races are run over 2 to 4½ miles (3.2 to 7.25km) with fixed fences at least 4ft 6in (1.37m) high. Hurdle races are run over 2 to 3½ miles (3.2 to 5.6km) with smaller, less rigid hurdles at least 3ft 6in (1.07m) high that collapse easily. Steeplechases are so called because in the early contests riders would race their horses from church steeple to church steeple, jumping any obstacles in their path. It is thought that these races began informally as a way of keeping hunting horses fit between hunts. There are also hunter chases, which are for amateur riders.

The brave and determined horses who run like the wind have been moulded by centuries of careful breeding – their prowess stirs the blood and uplifts the soul. To watch the Grand National or the sport's other Blue Riband event, the Cheltenham Gold Cup, is see the world's best equine athletes at the top of their game.

But in jump racing, it's not just speed that the horse requires. We know thanks to the likes of Lastic, Optiebeurs Golo and Huaso (see Athleticism page 76) that horses are athletic enough to jump high, but they are also powerful enough to jump across considerable distances. A galloping horse on a jumping track will leave the ground in front of a jump and land as much as 6m (20ft) or more on the other side. And hopefully its pilot will still be in the saddle.

Any equestrian sport – even something more sedate such as dressage – carries a risk and that, for many, is part of the addiction – speed and a hint of danger. For the jump jockey there is a very real chance that if he hits the ground he won't get to his feet afterwards. Not only is he being propelled forwards, usually at speed, he also has a couple of metres to fall. Then, when he hits the floor, there may be thirty or more other horses jumping more or less at the same time. If, say, sixteen are behind him, that's potentially sixty-four sharp hooves edged with metal that could hit him. Jockeys learn how to fall, and how to roll away from danger as far as possible, but there is only so much they can protect. Racing is not for the risk-averse.

There is risk, too, in harness racing. You could argue that there is intrinsically more danger, as the 'jockey' sits low down in his cart, or sulky. Chariot racing is nothing new, but modern harness racing is done at a trot, so is also called trotting. We know the sport took place in The Netherlands as early as 1554 and The Golden Whip, Holland's most famous trotting event, was first run in 1777 at Soestdijk. As these races became more popular, trotters – horses bred for the contest – were much in demand. Russia produced the handsome Orlov Trotter, while in England the now defunct Norfolk Trotter was bred for road racing, possibly coming from similar origins as the mighty Suffolk horse that was developed in the neighbouring county.

Trotting races became hugely popular in the United States in the late 1700s and early 1800s. The Thoroughbred stallion Messenger, who arrived in Philadelphia from England in 1788, is perhaps best known for the exploits on the race track of his grandson, American Eclipse, but he also sired ten important trotting sires. His great-grandson Hambletonian 10 sired more than 1,300 offspring and founded an important line – all American Standardbreds, considered to be the best trotting horses in the world, can be traced back to him.

The American Standardbred is so-named because in the early years of the breed, only horses who could trot or pace a mile in a 'standard' time of two minutes and thirty seconds were admitted to the studbook. The horses are bred to compete at a specific gait – either trot or pace. Trot is a two-beat gait in which diagonal pairs of legs move together; pace is a lateral two-beat gait in which pairs of legs on the same side move together. Some Standardbreds can pace a mile (1.6km) within one minute and fifty seconds.

**OPPOSITE** In harness racing, the jockey sits directly behind the horse. The lightweight two-wheeled cart – known as a sulky – sits close to the ground so there is less air resistance to slow it down.

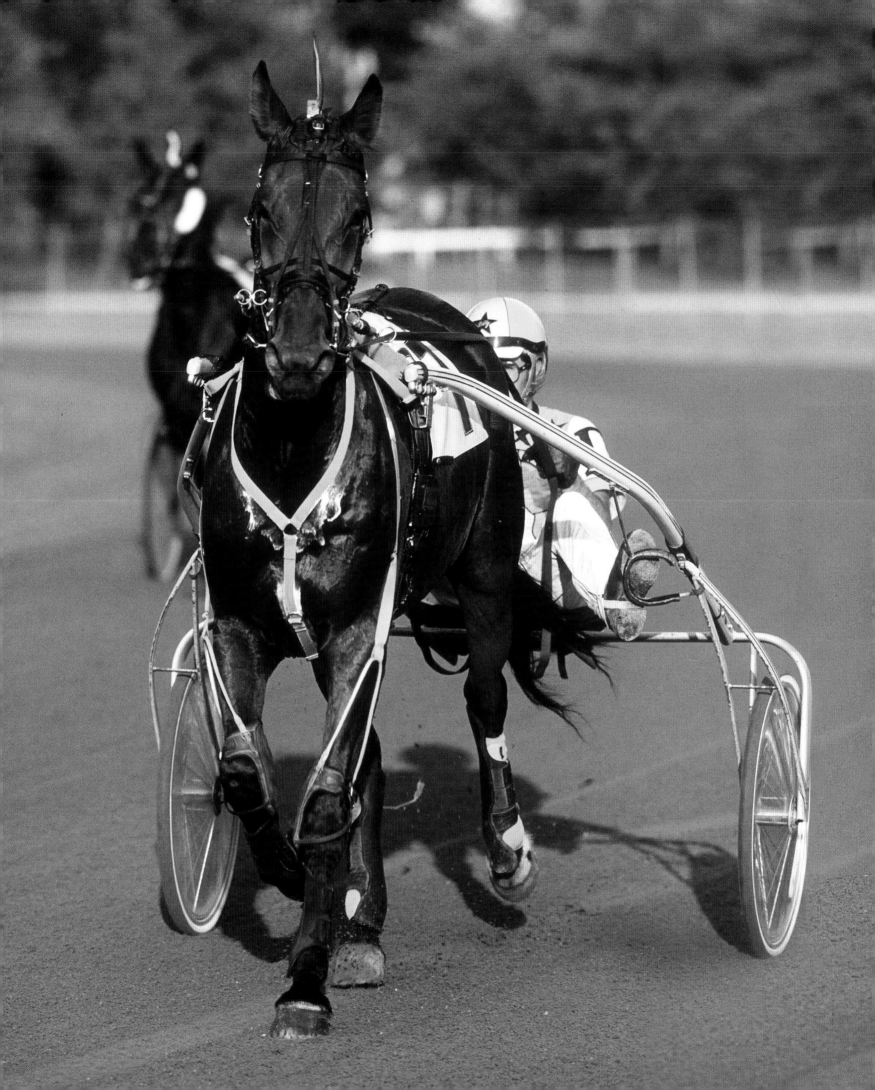

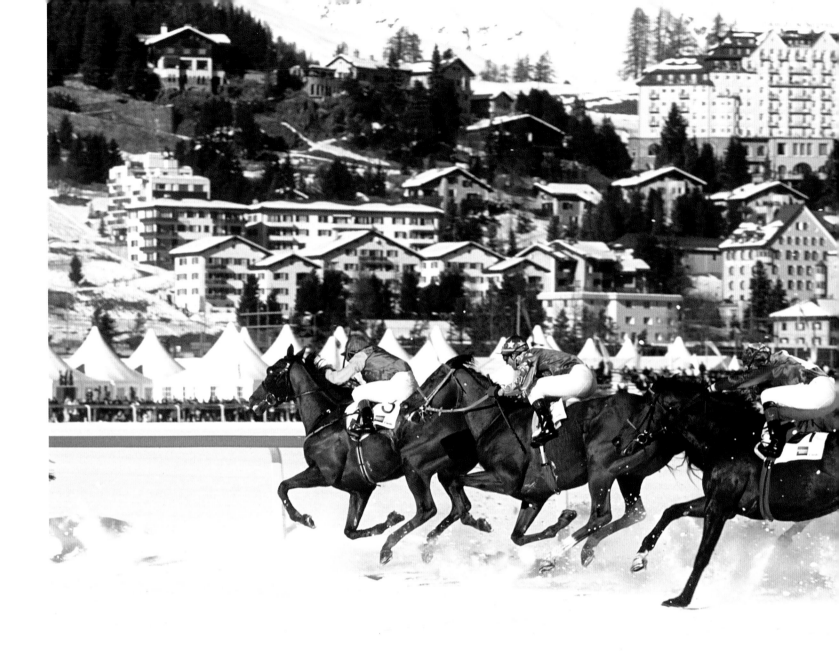

Accidents happen in both sports, despite every effort to protect the horse. In any racing, the combination of horses galloping together at speed, jumping and wet or even icy ground is a dangerous one – although all properly managed racecourses have strict safety protocols.

Now imagine if those horses were galloping on ice and snow.

Horse racing has been held on a vast frozen lake at the ski resort of St Moritz in Switzerland for more than 100 years. The festival is dubbed the White Turf and boasts the flattest and highest racecourse in Europe, some 1,800m (5,900ft) above sea level. Thoroughbreds from all over Europe, and jockeys from all over the world, take part in the races held on three Sundays in February. Against the magnificent backdrop of the snowcapped mountains, the races are watched by more than 35,000 spectators.

The races on the frozen lake at St Moritz began in 1906, when thirteen riders raced for fun from the town's Postplatz to the village of Champfer 3km (1.9 miles) away. The first organized White Turf was held a year later, featuring just one race. Today the festival is all about glamour. Racegoers dress to be seen in fashionable winter clothes and designer jewellery, while champagne flows like water. The races are varied, including a sprint and the

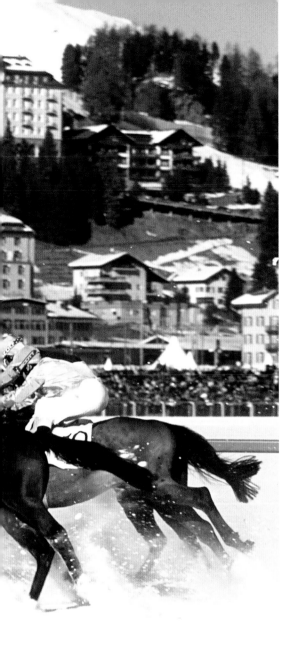

**ABOVE** Racing on snow at St Moritz in Switzerland. The exclusive Alpine resort attracts visitors from all over the world who come to watch the spectacle of top-class horseracing and polo on a vast frozen lake.

most lucrative equestrian event in Switzerland, the Grand Prix de St Moritz, which is the most highly prized race in the country.

When the colourful competitors burst out of the start gates and gallop across the packed snow past the grandstand for the first time, the 'St Moritz Roar' resounds across the racetrack. It is described as spine-tingling by those lucky few who have heard it. Racing on snow has a particular dramatic effect as the runners kick up some of the snow, creating a sparkling white cloud.

The horses cope surprisingly well with the conditions. The ice itself is a minimum of 30cm (12in) thick, but it is actually packed snow that the horses gallop on. It has to be able to support the weight of thousands of metres of tenting, plus crowds and horses. The Clerk of the Course at St Moritz takes measurements daily from December onwards to test the thickness of the ice. The horses are equipped with special winter shoes to give them grip, and a shoe designed specifically for racing on ice is being developed that glues on, so can be easily removed or replaced if necessary. As with all equestrian sports, safety for the participants is paramount and during the mild winter of 1964, all three days were abandoned.

The alpine temperatures provide their own challenge too, although the jockeys now have a heated tent to get changed in rather than a freezing hut. They then make their way to the paddock in vast velour slippers that they pull on over their lightweight race boots. 'If you don't wear them before you get legged up, the snow on your boots freezes you to the stirrup irons,' said one snow jockey. 'I got frostbite once when I wore the wrong gloves.'

But perhaps the most extraordinary spectacle at St Moritz is skijoring, in which a skier is pulled behind a galloping horse, like a frozen version of waterskiing. The name comes from the Norwegian *skikjøring*, which translates as 'ski driving'. Skiers can be pulled by a team of dogs instead of horses, but the latter ensures more speed. As one participant explained, it is beyond thrilling – if your horse is three lengths clear it means the second horse is breathing hot air into your ski jockey's ear and should it tread on a ski, it's 'goodnight St Moritz'. The wealthy crowds love it and it is extremely exciting to watch.

And if you think racing, driving and skijoring are a little tame for you taste, there is always the Snow Polo World Cup, in which the world's best players and ponies compete on a specially marked 'ground' on the frozen lake. The experienced ponies spin and gallop as their rider fights to get the ball towards the goal, riding-off opposing team members as if competing on grass in high summer.

All these disciplines – whether on snow, dirt or grass – are all about speed and trust; horse and rider come together in a glorious partnership, a match of equals. Both are both at peak fitness and both want to win; they understand and respect each other implicitly. The horse will race as fast as it can over any surface to be the best that it can be. The rider, in his quest for glory, will urge his horse on, knowing it wants to win as much as he does. It is the depth of that mutual understanding that makes our relationship with the horse such a wonderful and unique experience.

# RACING

The Bedouin people, who bred the glorious Arabian, called their horses 'Drinkers of the Wind' in celebration of their beauty and their speed. Today, those ancient bloodlines – all Arab horses are believed to trace back to just five mares – live on in the Thoroughbred, who drinks the wind as its gallops around the world's racecourses.

Horse racing is an ancient sport: history tells us that the Ancient Romans held chariot races, and many cities in the United States have a 'Race Street' dating from the era when impromptu horse races were held on them. The American Quarter Horse is so named for its ability to sprint for a quarter of a mile. But it wasn't until the late eighteenth century that designated racecourses were created specifically for the Thoroughbred to race around.

Racing is a hugely lucrative industry that divides essentially into two categories: jumping, called National Hunt, and non-jumping, called Flat racing. At its heart, it is the speeding horse that makes it possible as, fleet of foot and urged on by its jockey, it strives to get its nose in front of all the other horses racing for the post.

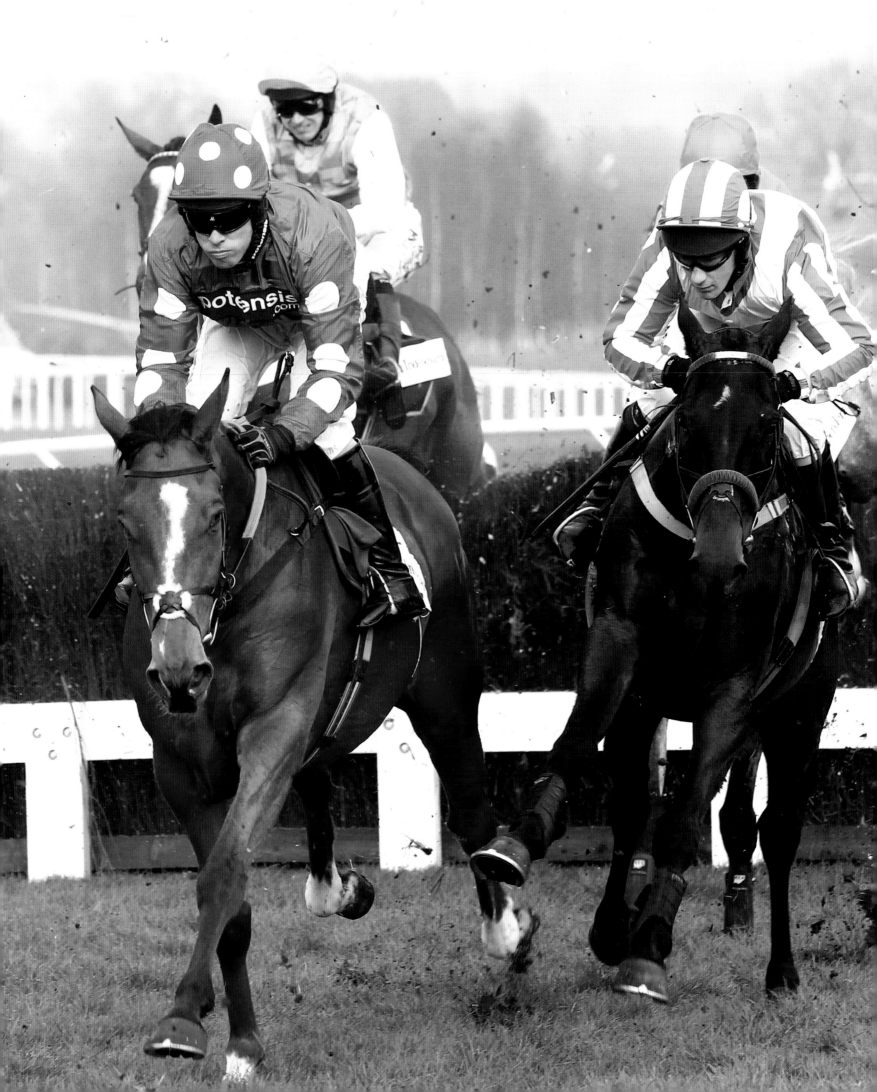

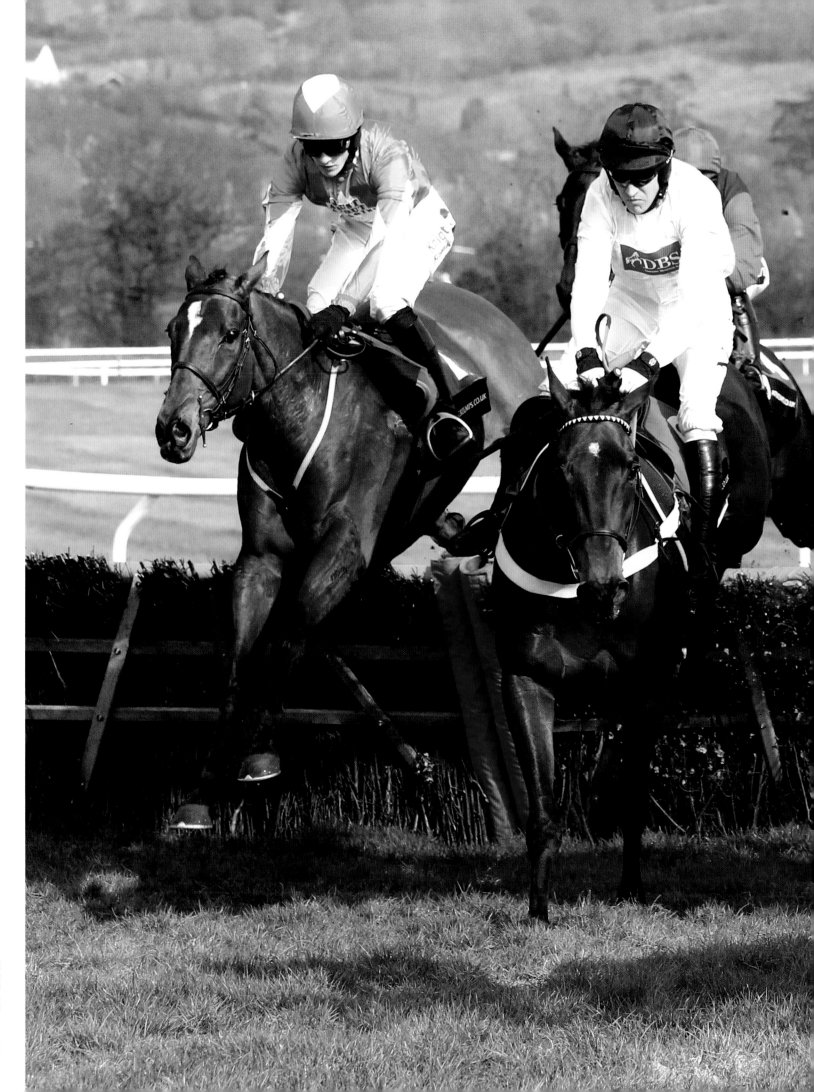

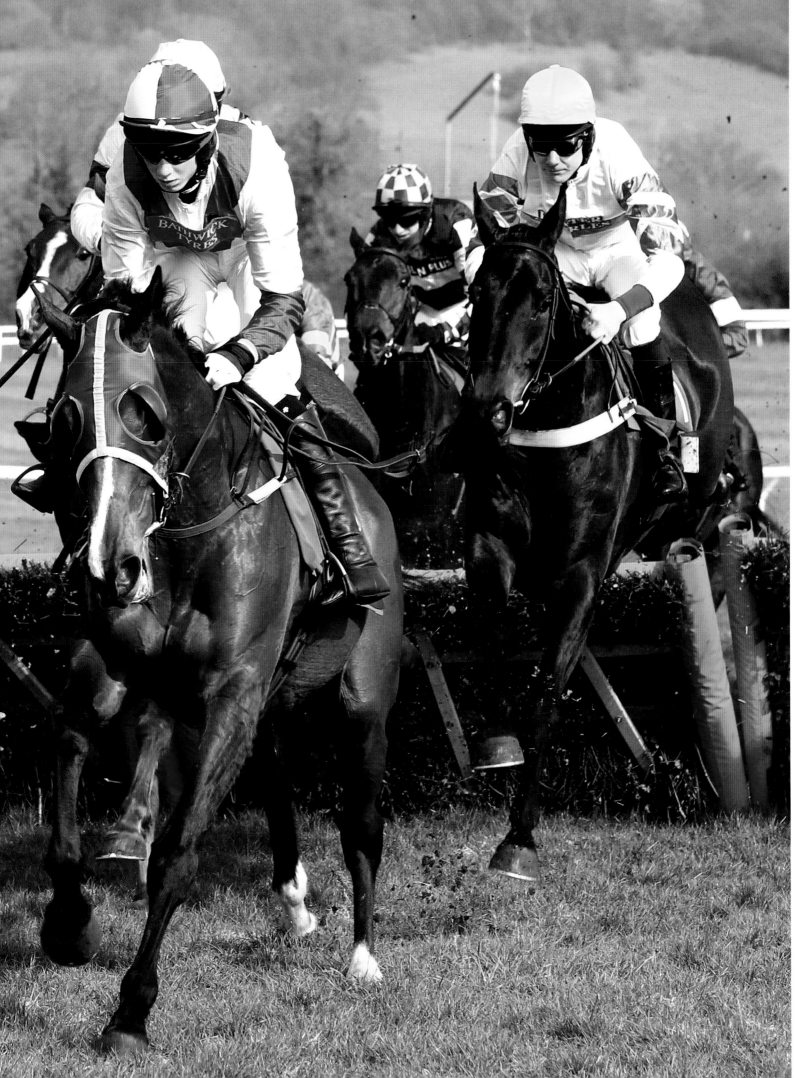

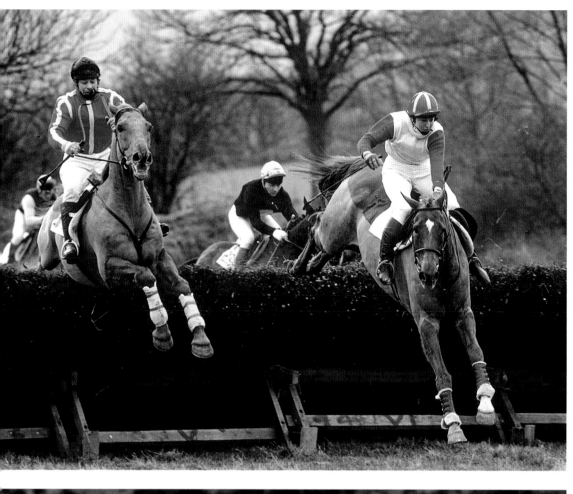

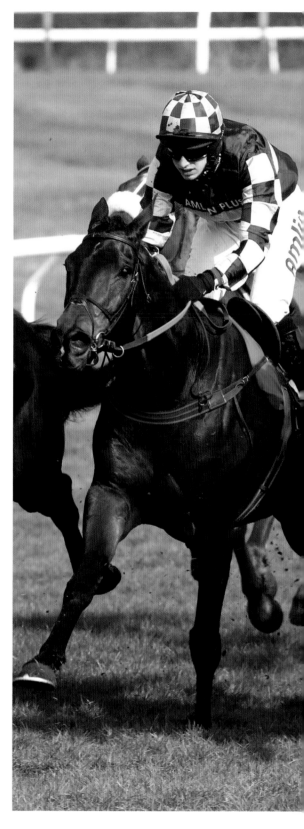

**LEFT** Before taking on the more challenging National Hunt obstacles, horses often start in point-to-point races (*top*), ridden by amateur jockeys, who will nurture the Thoroughbred's natural athletic ability (*left*).

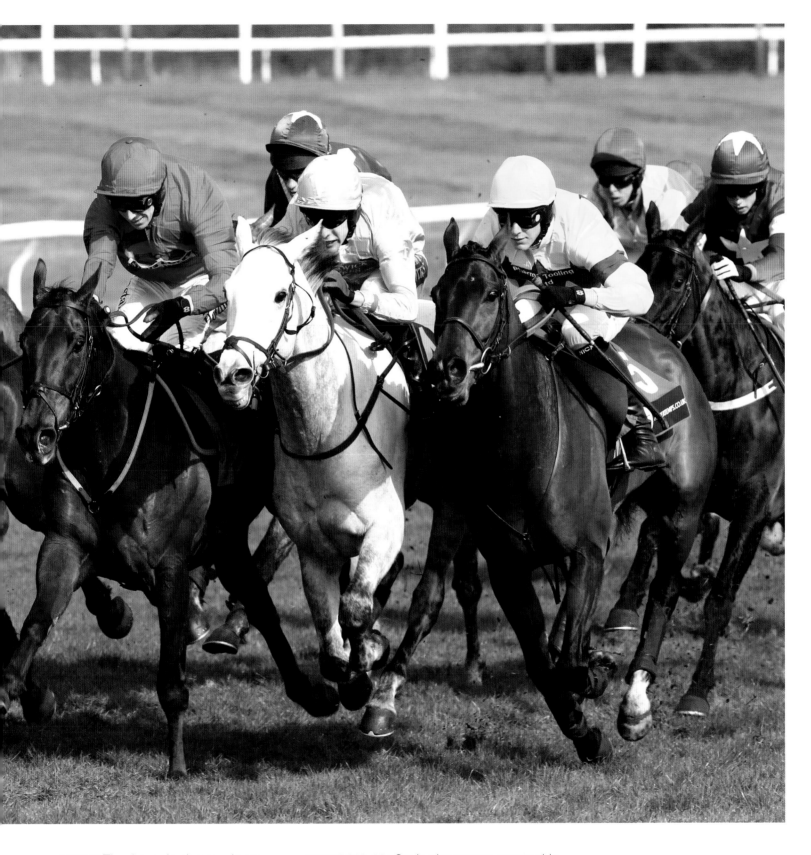

**ABOVE** The determination to win on the jockeys' faces is reflected on those of the horses – a perfect illustration of the partnership between horse and man.

**PAGES 200–201** Set in picturesque countryside, Cheltenham Racecourse, Gloucestershire is the venue for the Cheltenham Festival, a major race meeting held every March.

**ABOVE AND RIGHT** Spectators may
well imagine that horses would find being
bunched together and jostling for position
unsettling, but as a herd animal they are
comfortable among their peers, and their
natural competitiveness will make them
strain every sinew to get to the front.

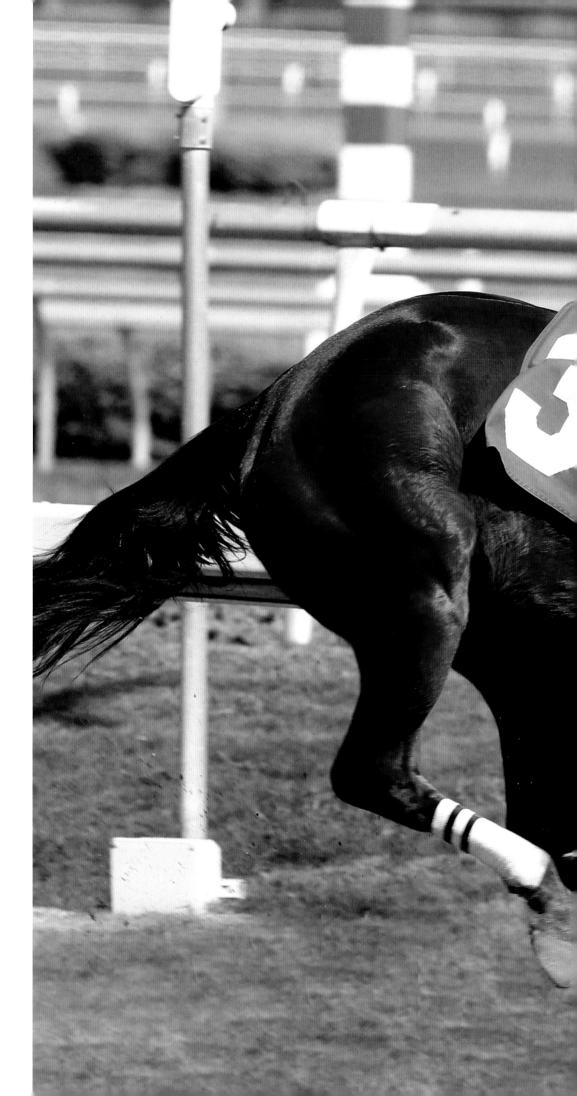

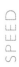
**PAGES 206–207** Racehorses burst out of the starting gates at Gulfstream Park racecourse, Florida. The turf track is 1.6km (1 mile) in circumference and more than 16,000 spectators can be seated in the grandstand.

**RIGHT** This horse has all four hooves off the ground as it gallops for the finish line. The jockey leans forward over its withers to take his weight off his mount's back.

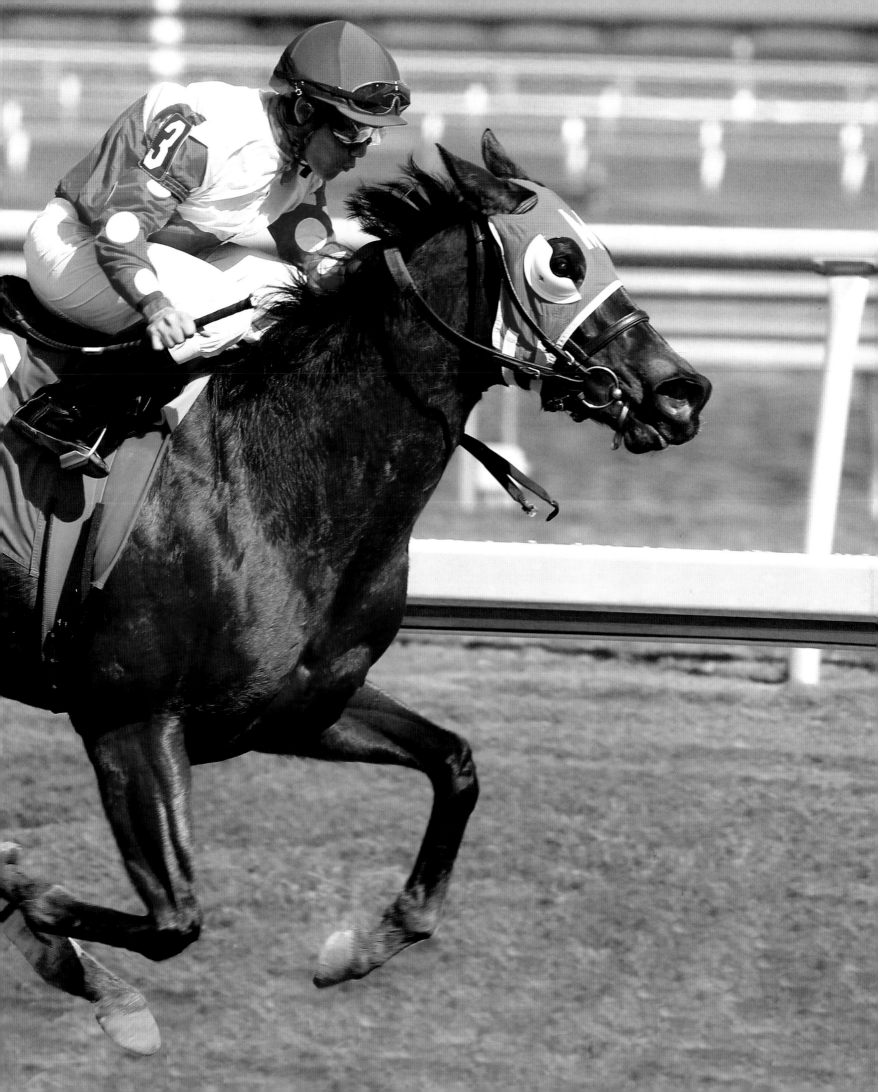

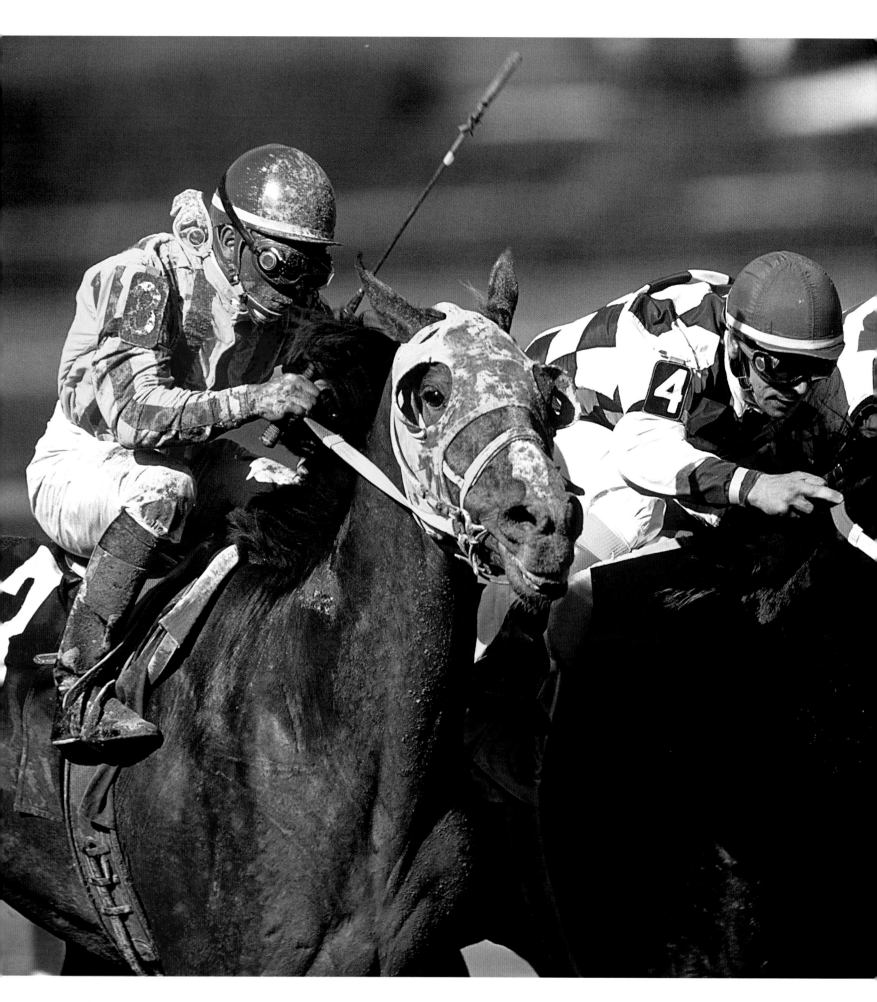

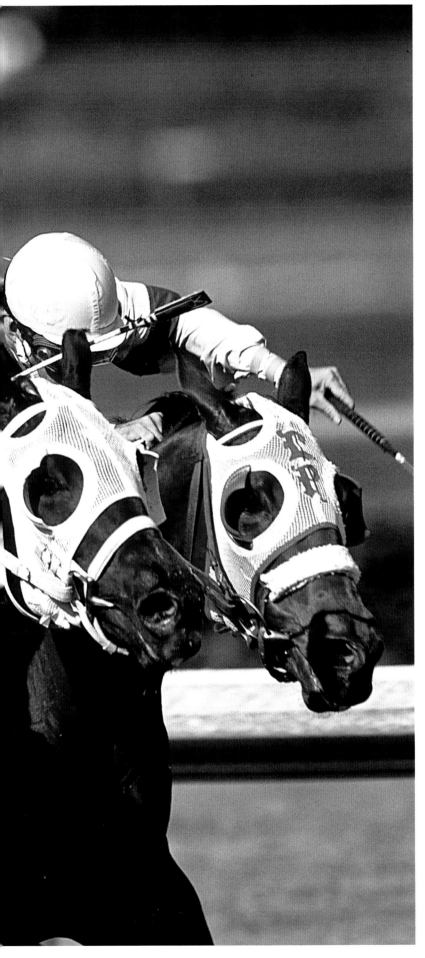

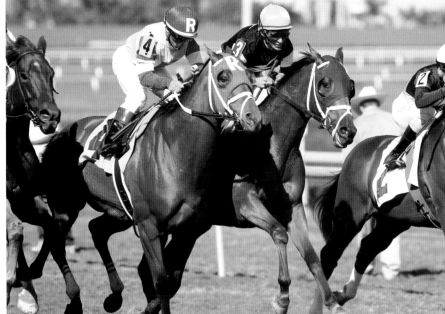

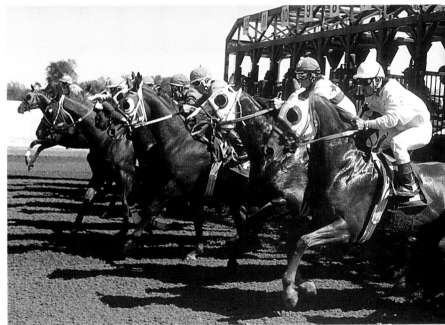

**TOP** Racing neck-and-neck at Gulfstream Park, Florida, each of these horses is determined to get its nose in front of the others, an ancient instinct typical of a herd animal.

**ABOVE** Quarter Horses burst out of the starting gate at Trinity Meadows in Texas, eager to gallop – racing because they enjoy the thrill, not because they are forced to do so.

**LEFT** Using hands and heels, these jockeys urge their horses ever faster. The mud on the horse on the left has been kicked up from the track, as American courses are usually composed of dirt rather than turf.

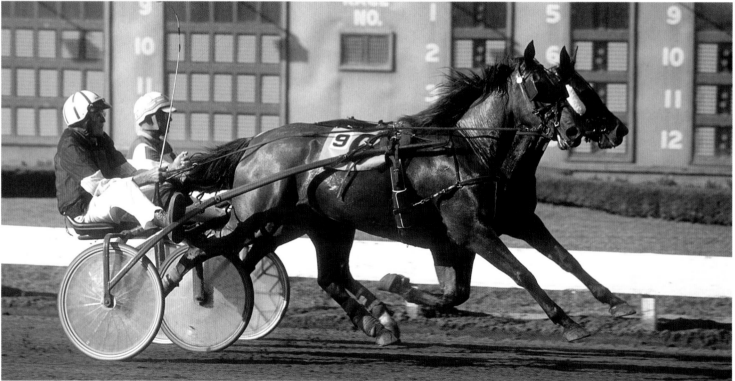

**ABOVE** The top horse is a pacer so it has a lateral gait, its foreleg and hindleg moving in unison, compared with trotters (*above*) whose legs move on the opposite diagonal.

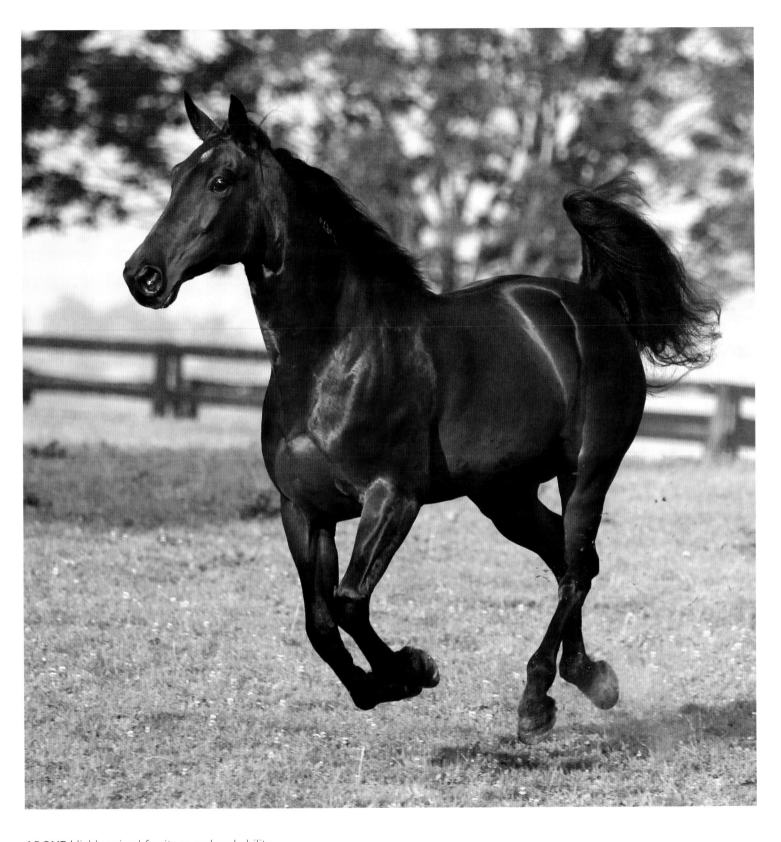

**ABOVE** Highly prized for its speed and ability in harness racing, the Standardbred also brings its exceptional talents to many other disciplines, including showjumping, eventing and dressage.

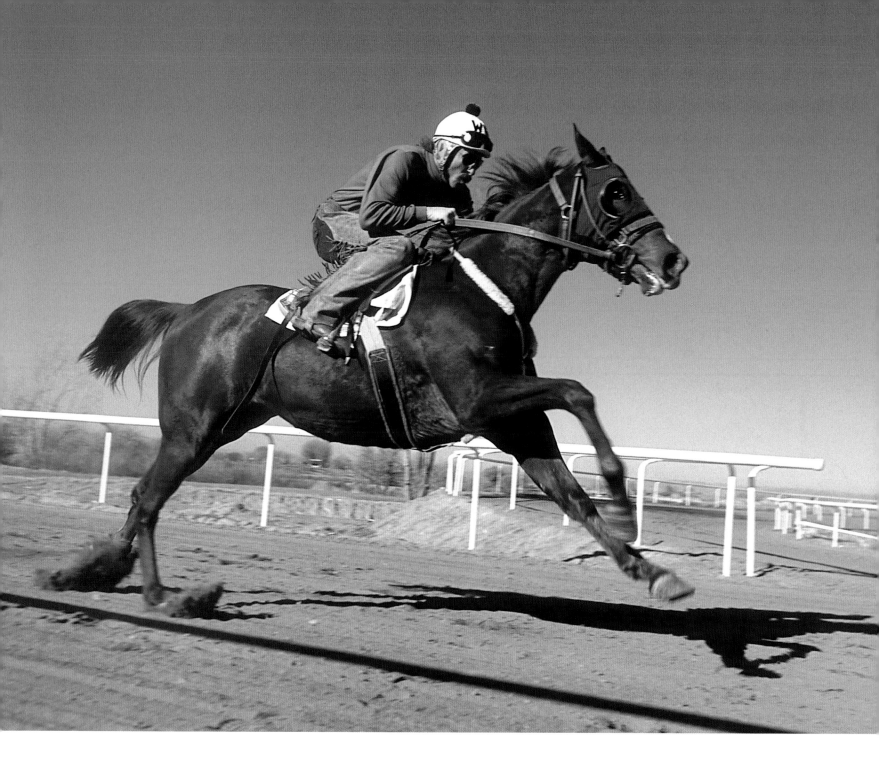

**ABOVE** A Quarter Horse training on dirt. Races were staged in America before Thoroughbreds were imported and the Quarter Horse is named for its speed over a quarter of a mile.

**OPPOSITE** The noble, intelligent head of the Thoroughbred, whose speed and courage on the racecourse have captured our hearts and our imaginations for hundreds of years.

# SNOW SPORTS

St Moritz, a glitzy upmarket ski resort in Switzerland which has twice hosted the Winter Olympic Games, is also home to a rather more unusual sport. Amid the dazzling brilliance of the snow and the glint of polarized sunglasses flashing in the sun, you will see the brightly coloured silks of jockeys – yes jockeys! The White Turf event is held every February and features exclusive horse races on the frozen expanse of Lake St Moritz.

The horses are equipped with special shoes to give them grip on the ice, which is well covered with snow. Safety is paramount, for both horse and jockey. For sheer excitement framed with glamour and style, it is the most spectacular event in the racing calendar. And if you think racing on horseback on snow is dangerous, how about skiing behind a galloping horse? Called skijoring, it was introduced as a demonstration sport at St Moritz in 1928 at the Winter Olympics. Although it didn't feature at any further Games, the sport caught on elsewhere, and the World Skijoring Championships are held in Whitefish, Montana every year.

For another unlikely sporting fixture, it's back to St Moritz – for the Snow Polo World Cup, held each January on the frozen lake and attracting up to 15,000 spectators. This most competitive of sports again highlights the exquisite partnership between speeding horse and human rider in perhaps the most spectacular winter arena in the world.

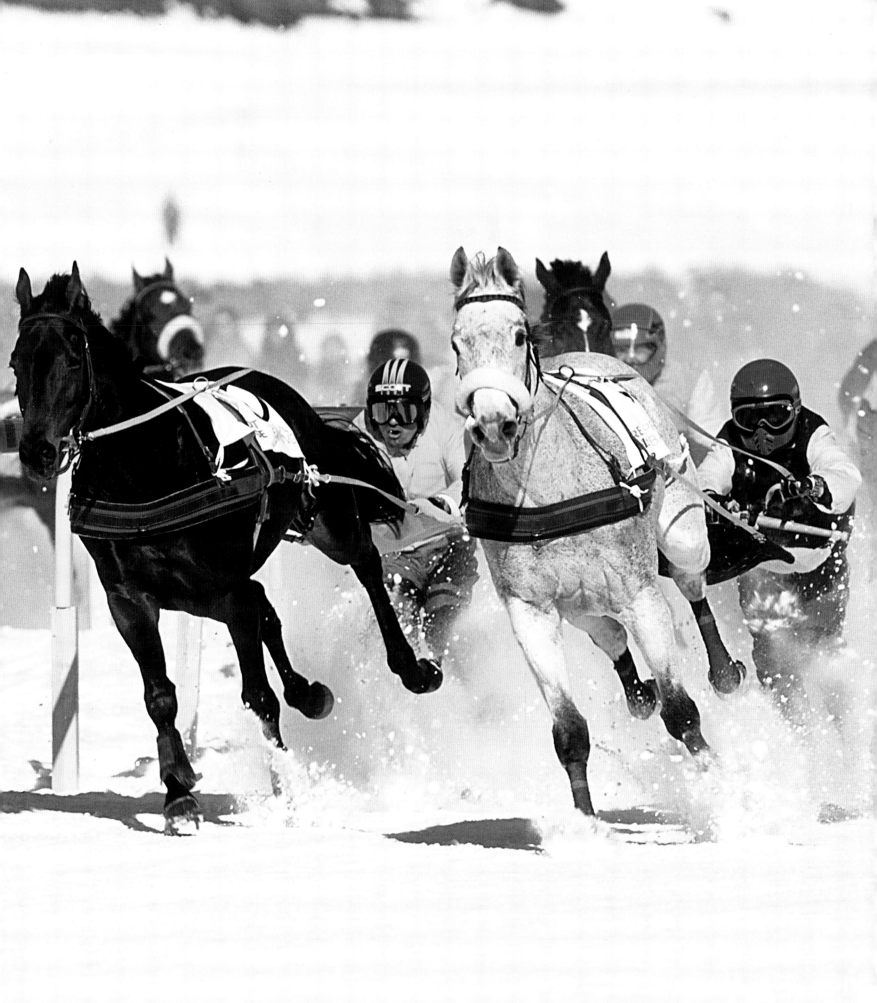

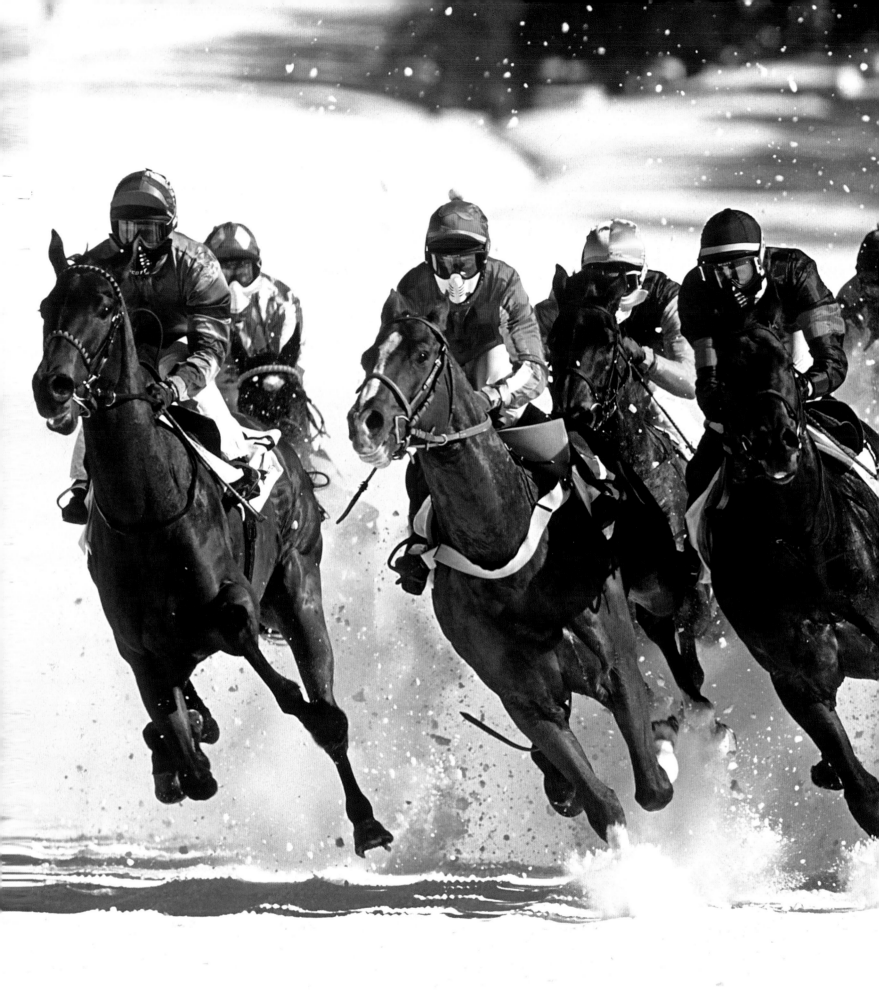

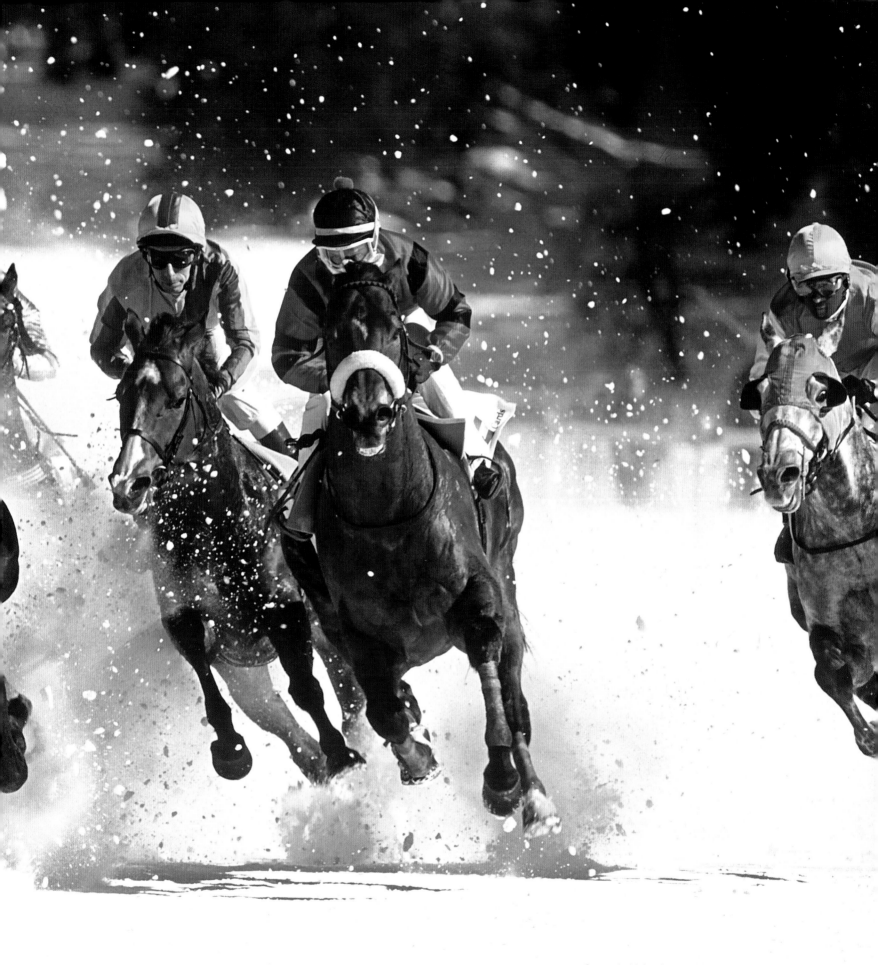

**ABOVE** Snow is kicked up as the horses and jockeys race at the White Turf festival, held every February at St Moritz in Switzerland.

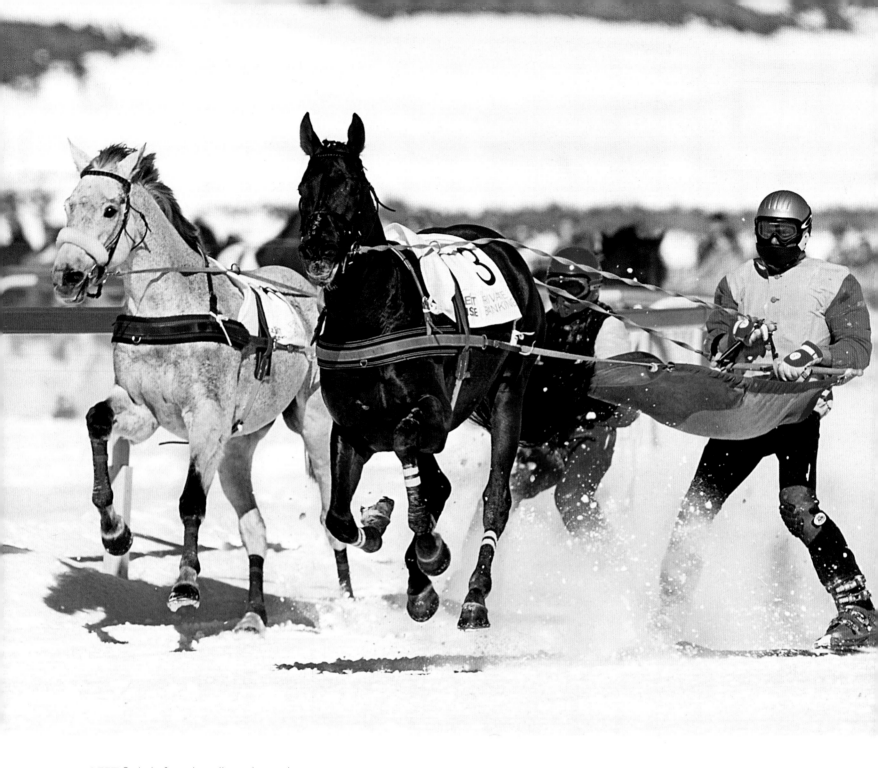

**LEFT** Strictly for adrenalin and speed
junkies, the sport of skijoring features a
skier pulled by horses or a team of dogs –
a kind of frozen waterskiing.

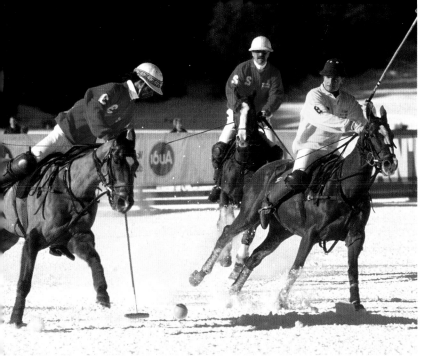

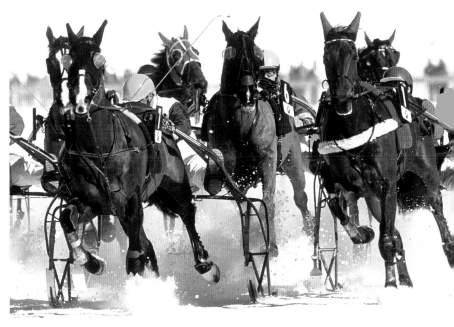

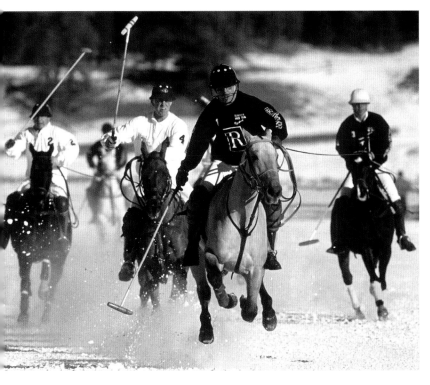

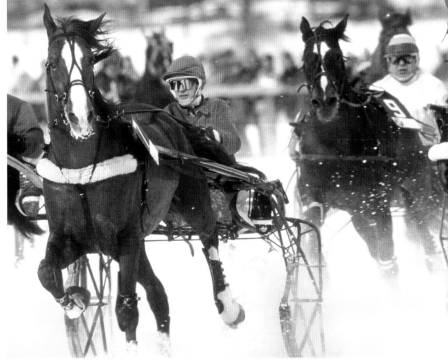

**ABOVE** Snow kicks up as a player strikes the ball (*top*) and the teams gallop towards the goal (*above*) during the exciting polo matches at St Moritz.

**ABOVE** Harness racing on the vast frozen lake at St Moritz, as drivers jostle for position (*top*) before eventually one horse begins to pull ahead of the field (*above*).

# INDEX